THE ART OF
Creative Watercolor

INSPIRATION & TECHNIQUES
for Imaginative Drawing and Painting

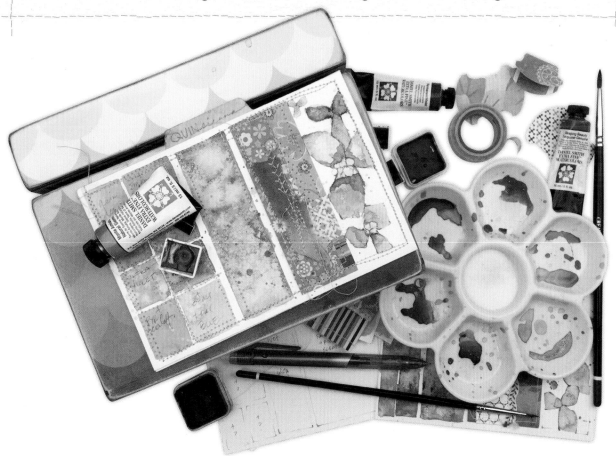

DANIELLE DONALDSON

NORTH LIGHT BOOKS

CONTENTS

DEDICATION

GRANDMA EVELYN—Thank you for the memory of the steadfast ticking of so many clocks, quiet kitchen-table coloring and a plate of cinnamon toast nearby.

GRANDPA LANIER—For each time you welcomed me with a cheerful "Hello, Doll," and a sweet-smelling rose from your little garden, thank you.

LOVE AND MISS YOU BOTH,
Danielle

INTRODUCTION

Creative Practicing: a process where we search for and find our own creative voice, our signature style. Inspired by everything, we grow creatively by practicing over and over. This leads us to the magical moment when we make our art our own.

Between the covers of this book, you'll discover an alphabetized watercolor world filled with rainbow-infused illustrations, imaginative techniques and start-to-finish projects.

With this book, you will learn to grow your own creative practice while you:

· Take an in-depth look at the supplies that are used in watercolor illustration.

· Discover the importance of developing *creative muscle memory* in your studio and your art.

· Pay attention to common creative threads in your work that can grow into your signature style.

· Learn to value your time and energy with practical solutions to move you past the parts of your process when you don't know how to move it forward.

· Organize and learn new techniques in focused, easy-to-follow ways. Use this opportunity to focus on specific subjects and techniques while avoiding boredom and becoming overwhelmed.

· Tap into your stash of paper scraps, ribbon and other ephemera to take the guesswork out of choosing colors for your illustrations.

· Get to know your watercolor palette and implement basic watercolor techniques, using a balance of control and letting go.

· Learn to play with color with alternative exercises to color chart–making.

· Dive into the details of composition and implementing it to tell your visual stories through placement and color.

· Using just a pencil, grow your small-scale drawing skills by breaking down objects and putting them back together again.

· Learn how to add depth to your work with an introduction to one-point perspective.

· Try simple ways to add hand lettering to your artwork and practice pages.

· And, most important, learn to appreciate the unpredictable nature of watercolors and the unplanned beauty it offers you in your creative process.

WHAT YOU NEED

In the next few pages, I want to share my favorite supplies—with a twist. First, I'll go over my consumables and the tools I use on a regular basis. Occasionally, I'll mention the specific brands or types of supplies and tools I use, but please use what you have on hand or can afford until you have explored the book further! Next, I'll give you a breakdown of different brush types and what they are typically used for in watercolor. Then for the twist: I'll share a important aspect of my process, the development of "creative muscle memory" and its application in my workspace. It's an integral part of my productivity and I encourage you to make it a part of yours. (So intriguing, right?) Last, but certainly not least, one of the most important pages in this book: a list of solutions for when you get frustrated or stalled in the artistic process. Because your time and energy should be valued. Always.

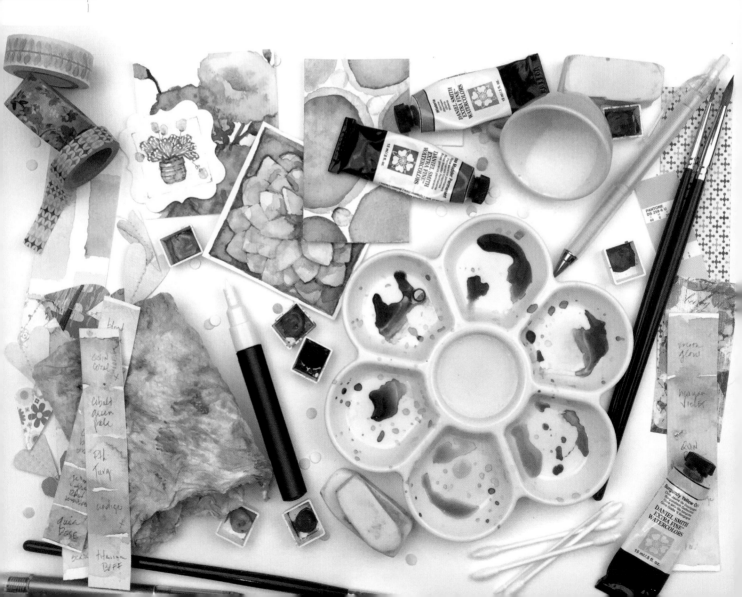

SUPPLIES | *consumables*

WATERCOLOR PAPER—As a drawer and painter of very small things, I prefer tape-bound pads of watercolor paper that are easy to cut down to whatever size I may need or precut sheets. Always buy artist-grade paper. Always. Nothing is more frustrating that taking a ton of time to draw your illustration only to be thoroughly disappointed after your first wash of watercolors. The paper should indicate a weight no lower than 140-lbs. (300gsm). In this book, I use a variety of cold-pressed (rough) papers. I know that it seems like hot-pressed paper (smooth) would make a better choice given the size of my illustrations, but I find it harder to create interesting washes with hot-pressed paper, which seems to dry faster than its counterpart. I suggest experimenting with different papers until you find a favorite.

WATERCOLOR PAINTS—I began painting with tube watercolors in high school and college (yes, it was forever ago!) but have since discovered that pan watercolors pack an equal, color-filled punch and have the added benefit of portability. In the last year or so, I discovered Daniel Smith tube watercolors, a big game changer for me. But what's a girl to do? I need to be able to grab my watercolors and go! I decided to transform my new tube watercolors into pan watercolors by filling empty half pans and allowing them to completely dry. Once dry, I added them to my pan palette. The result: perfect paint stored in the most effective way for a wandering artist! I suggest making an investment in the highest-grade watercolors you can afford. You don't need a plethora of colors to start; you can build your palette over time. And a tube or pan lasts almost forever.

MECHANICAL PENCILS—I know a ton of folks look at my art and swear that I use a pen, but I illustrate only with mechanical pencils with .3mm lead. I find they give me the most consistent lines with very fine detail and the opportunity for do-overs if I keep an eraser handy. Keep in mind that you can change the type of lead in the pencils to suit your needs. I keep some of my pencils loaded with HB (standard) and others with 2H (harder) lead. Have you ever wondered what the HB stands for? The B stands for soft and H stands for hard. As the number gets higher with the H lead, it marks harder and lighter. As the number goes up with the B, it marks softer and darker. I tend to stay in the middle, as the high-H leads dent paper more easily, making it hard to erase, and the high-B leads smudge all over the place.

BRISTOL PAPER—I cannot understate the value of pencil-only practice. It's the step everyone wants to skip, mostly because it is hard, repetitive and void of color. But if you think about it, how many mistakes could you avoid with a little practice? When I am working on object breakdowns, repetitive practice or composition thumbnails, I prefer to use loose sheets of bristol paper. It's a heavy-weight paper that's bright white and smooth.

PENS—Who doesn't love the idea of a fine-tip white marker that works? I DO! I keep a stash of white paint markers with various tip sizes handy to give my almost-finished piece a little Danielle-ish sparkle. Every so often, I sparingly add India ink-based colored markers into my work for color and detail.

ERASERS—I use two types of erasers. White vinyl erasers are available in blocks and in various sizes of clickable pen-style barrels for tight spaces. I also use kneaded erasers

because I can form them into various shapes and they don't damage paper as easily as vinyl erasers.

PAPER TOWELS—I never paint with watercolors without a scrunched-up paper towel in my hand. *Never*. Not only does it let me get just the right amount of water loaded on a brush, it also dries my brush and cleans my palette. I always use pure white paper towels because they make the prettiest paper scraps that I can use in mixed-media projects down the road.

COTTON SWABS—I often use cotton swabs of various shapes and sizes to clean edges and lift paint in fun patterns.

LIQUID FRISKET—Sometimes I use liquid frisket (masking fluid) to protect areas of my white paper while I paint. Keep a crepe rubber cement eraser handy to rub off the frisket when your painting is complete or when you are ready to move on and need to reveal what's underneath the frisket to proceed. A word of warning—liquid frisket is a brush destroyer. However, a silicone Colour Shaper works like a champ and is easy to clean and reuse!

TABLE SALT—My favorite technique when using watercolors is to sprinkle table salt on washes while they are wet. Salt makes magical things happen. I always have a mason jar full and at the ready. And if I am traveling, I will fill a mini envelope with salt, seal it and tuck it in my travel case with my other supplies.

PATTERNED PAPER, EPHEMERA, RIBBON AND LACE—I usually keep a basketful of pretty snippets of patterned paper and ephemera, a jar of ribbon and lace and a key ring of my favorite scraps of watercolor rejects nearby. They serve as inspiration for color schemes and patterns and, with clear liquid glue, I can use little bits and pieces to cover up frustrating mistakes.

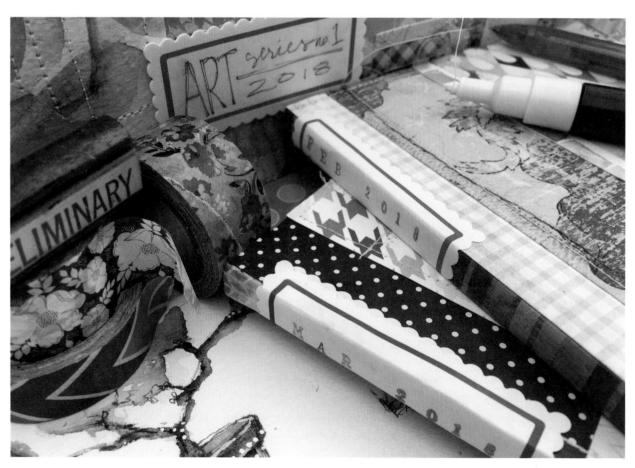

SUPPLIES | *tools*

WATERCOLOR BRUSHES—I am quite the collector of watercolor brushes, although I usually grab one or two and use them to complete an entire painting rather than troubling myself to turn to the right and grab another. Basically, I am trying to say you can collect them like I do, but you certainly don't have to. I have only one rule for brushes: Don't use your watercolor brushes for anything but watercolor. A set of high-quality round brushes, an angle brush or two and a filbert, if you want to get fancy, and you are good to go! The sizes you choose depend on how big you like to work. I have a set of kolinsky sable rounds in various sizes from no. 0–no. 8, and I can pretty much paint anything with them! To learn more about the brushes and what they do, refer to pages 8-9.

RULERS—I rarely use a ruler, but it is helpful to have one when I am trying to draw parallel lines or to measure and mark off space on my paper to ensure an even white space around my illustration. I also have a flexible curve ruler that helps me create some amazing shapes, especially with jars (as in Chapter 1). A right-angle ruler comes in handy when drawing boxes and houses. Everyone has days where they can't draw a straight line, right?

SPRAY BOTTLE—A small spray bottle filled with clean water is handy to spray on your pan watercolors to reactivate them, which makes it easier to load paint on your brush.

WATER JAR—Clean water in a jar. It helps to use a clear jar as a reminder to change the water as often as possible. Dirty water can really alter the look of your illustration, so I change it while layers are drying.

MAGNIFYING GLASS—If I am working on a particularly small illustration, I use a magnifying glass that clips onto my work surface. It even has a light, which helps my middle-aged eyes!

SEWING MACHINE—I love to turn on my sewing machine to stitch on paper scraps, punched shapes, words and other ephemera. These touches add an amazing amount of depth and visual interest.

PAINT PALETTES—I use plastic and porcelain paint palettes to mix my watercolors prior to painting them on my paper. Some artists prefer one or the other, but I have found it has more to do with how many wells the palette has and how it is divided. Sometimes I want to keep colors separate, and other times I want to mash them all together.

WHITE ERASE LAPBOARDS—The lapboard provides a flat surface to mix colors on. It can serve as a portable work surface for my art-in-progress. If I plan to add a watercolor background to my illustration, I'll use artist's tape to tape an even border around all four sides of my watercolor paper directly onto the lapboard. Doing so allows me to turn it on its side or upside down, to work on different parts of the illustration with a fresh perspective without smudging my pencil or dragging my hand through a wet wash. If I want to work on something bigger, I use artist's tape to adhere my paper to an oversized clipboard.

CRAFT DRYER—This is not your ordinary dryer and it's not a heat-embossing tool. The first will blow your watercolors all over the place and the latter will burn your paper. Made by Ranger, the Heat It Craft Tool is a must-have for impatient watercolorists like me. Inquiring minds have asked if it changes the outcome of my work, and I am happy to say I have not seen a difference—except in my attitude, of course.

BRUSHES | *parts, sizes and shapes*

The hairs of the brush are referred to as the *head*. The top of the head has two parts: the *tip* and the *belly*. The head is made up of a natural hair from animals, synthetic bristles or a combination of the two.

Kolinsky sable is the highest end of the brush spectrum in terms of cost. They're superabsorbent (meaning they hold lots of water) and they hold their shape well. Red sable is typically less expensive and a really good alternative to kolinsky sable.

It's common to find brushes made of squirrel, ox, goat, and even pony hair. They can be combined to create a camel brush. Weird, I know. Each type of hair has benefits and drawbacks, but in the end, I go by how these brushes feel. The descriptions of each are easy to search for and find on the Web, and I will admit, some of them make me picture animals getting their hair plucked, so let's not dwell on the specifics for too long.

Synthetic brushes are made with nylon and polyesters. Some high-quality synthetic brushes come very close to natural fibers, but at a much lower cost, which is great for the watercolor newbie or those on a tight budget. You'll also find blended synthetic and natural hair brushes that are easy on the pocketbook.

The metal portion of the brush is called the *ferrule*. It connects the head and the handle. The handle can be made of wood or synthetic material. The brand and size is typically printed on the handle for reference, although I have found it wears off over time, so make a note of it if you love the brush and will want to replace it.

In my experience, you get what you pay for, so if you really like watercolor, I suggest investing in a smaller number of middle-of-the-road to high-quality brushes that will last for decades. I still have brushes from college, and that was more than thirty years ago! Grab a narrow jar, label it "watercolor only" and keep them separate from all your other brushes. And always store them with the handle down. If you travel with them, take care to protect the heads. It's hard to recover from bent or stray bristles.

Brush sizes range from 0000 all the way up to 50. The smaller the number, the smaller the brush. There's often a bit of a difference in sizes based on the manufacturer. Can you imagine the cost of owning all the sizes in all the different brush shapes? If you are purchasing brushes for the projects in this book, spend most of your brush budget on a few high-quality round brushes, ranging in size from no. 0 to no. 10, and a couple of angle brushes (¼-inch [6mm] and ½-inch[13mm]). That should cover most projects and give you a good start on painting bigger if you choose to do so in the future.

ANGLE—Angle brushes find their way into my work a lot. They create great graduated washes and crisp edges and corners. Based on how you turn them in your hand, they are versatile and can create thin lines and fun circles.

DETAIL—Script/liner/rigger brushes are generally very narrow with long hair and a pointed tip. Each type varies, but I have found that they basically have the same function in my illustrations. Because they hold a good amount of water, they are great for continuous lines, lettering and detail work. Because the hairs are longer, they can be tricky to use and take lots of practice. Spotter brushes are extra-short rounds. These don't hold a ton of water but are easier to control. It's vital that these brushes are soft and maintain their shape, so invest in high-quality sable.

FLAT/ONE-STROKE—A flat brush is usually square, but it may also be rectangular. Although it is my least used shape, I need it when I want to paint a large background or a shape that has straight edges. This shape doesn't require the accuracy or delicacy of other shapes, so save some cash and buy a good synthetic or synthetic blend.

FILBERT/OVAL—Filbert brushes are oval shaped with medium to long hairs. This is another one of my go-to brushes because, like the angle, turning it in my hand at different angles gives my work a loose, yet controlled touch and results in softer shapes rather than sharp angles. It holds a lot of water, and if it is made from natural hair, the hairs stick together, making it easier to blend areas.

DAGGER—The fanciest brush shape by far, this is (to me) a combination of an angle, a round and a liner all in one. Again, it holds a lot of water and can be used to paint an illustration from start to finish. With that said, it is the hardest brush to learn how to control and manipulate.

ROUND—Round brushes are, by far, the most versatile and easy-to-use brushes—the proverbial workhorses of the brush world. You can use the tip to add the smallest of lines and details, and the belly to create sweeping washes and soft shapes. It really does it all. This is the shape to invest in.

MOP—Mop brushes have lots of soft hair that will hold a large quantity of water, and they are good for painting washes in large areas. I use this brush a lot to gently loosen and sweep away eraser bits and salt without smearing my pencil work.

SUPPLIES | *creative essentials*

You'll need just a handful of tools and supplies for all the techniques and projects in this book. Watercolors may be complex to learn, but the materials needed are easy to keep handy.

It will be helpful if you precut watercolor paper in a variety of the sizes listed below. You'll want to have the papers handy while you work on various projects in the book. I encourage you to use scraps or the paper sizes listed to the right. For the start-to-finish projects, you'll use 5" × 7" (13cm × 18cm) or 5" × 5" (13cm × 13cm) paper unless otherwise noted.

To complete the exercises and projects in this book, you'll also need several watercolor rounds, ¼-inch (6mm) and ½-inch (13mm) angle brushes and a liner or detail brush at minimum. I encourage you to get at least one of each of the shapes listed on pages 8-9 to test them out and see what works best for you.

Artist-grade watercolors (pan or tube)

Watercolor-only brushes

Artist-grade paper (140-lb. [300gsm], cold pressed)

> **Strips** (no smaller than 1" × 4" [3cm × 10cm] and no larger than 3" × 6" [8cm × 15cm])
>
> **Rectangles** (no smaller than 2" × 3" [5cm × 8cm] and no larger than 5" × 7" [13cm × 18cm])
>
> **Squares** (no smaller than 2" [5cm] or larger than 5" [13cm])

Mechanical Pencil (.3mm lead) and white vinyl eraser

Mixing palette with wells (or white erase lapboard if you prefer)

Clear jar/clean water

Paper towels

Table salt

Ruler

Scissors or paper cutter

WORKSPACE | *set up for success*

CRE·A·TIVE MUS·CLE MEM·O·RY

Noun. *The ability to reproduce a particular artistic process or movement without conscious thought, acquired as a result of frequent repetition of that movement.*

Due to the nature of watercolors, there are times when working at a faster pace is required. If I am spending a lot of time searching for the pink I want to drop into a wet wash, I have lost my opportunity to build on it. If my wash is almost dry and I am searching for my salt to sprinkle into it, I have lost my opportunity to witness the magic salt makes. The solution? Creative muscle memory.

In order to get the most of my creative muscle memory, I set up my basic workspace the same way, no matter where I am. Whether I am teaching, filming a video or just working in my studio, my basic tools are placed in a way that allows me to circumvent the thought process and tap into creative muscle memory. The correct pink is labeled, and the palette is placed directly to my left. My water is placed just above it, and my salt and mixing trays are placed directly above my work. Even my trash can is always to the right under the table.

Think of your workspace as a clock, and ask yourself, do I tend to work clockwise or counter-clockwise? Try setting up your space so your supplies are in the natural order you will work in. Mine is paint, water, salt and mixing palette, and jar of most-used brushes. Coffee or drinking water is always there too, separated from my jar of water because I always end up dipping in the wrong container. Stop giggling—you've done it, too!

This isn't an exact science, and I don't always follow my own rules, but when I do, it allows me to use my brainpower to make some swell art.

HINT
muscle memory mindfulness

Start paying attention to where your hand goes when you are concentrating on the illustration on your desk. If you reach out to grab a tool or material and it's not there, your noggin is telling you that you need to consistently put that thing in that place.

I keep my paint palette and water to the left of my work area. My paint palette holds well over 100 Daniel Smith colors and rests on a lazy Susan. It makes it easy for me to spin with my left hand and load paint into my brush with the right.

It's worth the investment to buy a table-top paper towel holder. I have a tendency to walk off with my paper towel in my hand and then leave them all over the house. Hence the need for handy paper towels.

I keep two mason jars with my paintbrushes nearby. One contains all of my round and oval brushes, and the other contains all of my flat and angle brushes. Keeping them handy will serve as encouragement to grab different brushes and try them while you work.

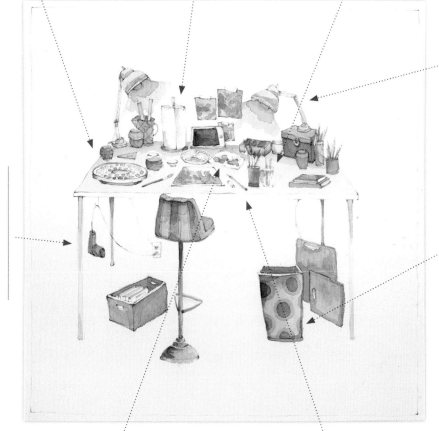

Great lighting is necessary when you draw as small and light as I do.

I keep my craft dryer plugged in and hanging right next to my chair so I can grab it and speed up the drying process. I am a very impatient artist!

I always keep my tall trash can just to the right of me under my table so I can sweep salt and scraps off quickly to keep my space clean while I work.

My mixing palettes are always directly above my illustration/painting area and close by my palette, clear water jar and small dish of salt. It is important that you aren't reaching from one side of your space to the other or you might drip something on your work.

My table is at the perfect height just for me (I am only 5'2" [157 cm]) to work while standing, or I can sit on my adjustable bar stool. It really helps my back, shoulders and neck to change things up throughout the workday.

CREATIVE PROCESS | *study, prepare, practice & imagine*

STUDY—For me (and let me repeat that: *for me*) study is the process of gathering inspiration from *everywhere*, then taking that inspiration and studying it. What are the materials? How is it composed? Are the color choices purposeful? How do light and shadow affect it? How does it make me feel? Is there a story to be told? The most important question I ask myself is, can I draw and paint this with the creative tools I already have or do I need to practice a technique or learn how to draw something new first?

PREPARE—I don't consider myself a particularly spontaneous person. Honestly, it used to bother me a lot when I was younger that I couldn't just jump into stuff without thinking it through. It felt like a lifelong personality flaw. But then I had kids and jobs and "big artist goals," and my propensity to plan became one of my biggest strengths. Preparation is not just about having the right supplies. It's about my mind-set, workspace and intention I bring into my studio time. And it's about setting up attainable, but just-out-of-reach goals. Prior to starting projects in this book, take some time to be sure you have positioned yourself (literally and figuratively) to enjoy the process and feel successful in your growth as an artist. Ask yourself, am I tired/hungry/grouchy/overwhelmed? If so, will a little creative TLC help? Do I have all the supplies/time I need to learn this technique/skill/process?

PRACTICE—I grow as an artist only if I put my time into practicing the same thing over and over. It may mean revisiting old lessons from college or a new online class that will give me the new skill I need to create the art I have in mind. Often it means pulling the object or scene apart first and practicing one piece at a time. For example, if I want to draw a house with trees on an island, I'll practice drawing a bunch of houses and then trees. Yay for creative muscle memory!

IMAGINE—I have officially earned a treat at this point of the process. It's time to give a little "Danielle-ish" twist to the new techniques or skills I have added to my creative toolbox. Now I get to add imagination with proportion, composition, color choices and details. Could my trees be pink with scallops? Yep! Shall I add stilts to my house? Of course!

SIGNATURE STYLE
what's yours?

Your signature style is made up of all the bits and pieces of your art and process that are unique to you. It's the thread that ties your work together. The most frequently asked and hardest question I receive as an artist and instructor is "How do I develop a signature style, and when I think I have one, how will I know for sure?"

I wish I had the step-by-step process to give you, because I would gladly do it. Alas, I can only give you this advice . . . Study. Prepare. Practice. Imagine!

Where are you in the process of finding your signature style?

1. Send a text or e-mail to someone you love outside of the creative world. Include your piece of art and a piece of mine (or any other artist who has inspired you), and ask them for honest and constructive feedback: Do these look the same or different and why?

P.S. Asking your mom or BFF may not be the best choice because they love you so much that they might leave out the constructive part of the feedback.

2. Set aside all notes, handouts and sketchbooks. Turn off the class video and close Pinterest or the book you're currently reading. Can you create in your newfound style/direction without all the other stuff? Was it super hard and frustrating? Easy as pie? Can you set it aside for a second time and create something similar with a smile on your face?

3. Make a list of the similarities and the differences between your art and the art or artist you have been studying (and emulating). Make note of the supplies used, the color palette, the attention to detail, overall composition and other little details. How is yours different?

SOLUTIONS | *your time and energy are valuable*

I want to empower you to value your time and energy more than a piece of paper or a canvas. As explorers of all things creative, we tend to want to get to the good parts superfast. Usually that means skipping the first three steps of my creative process, and grabbing some supplies with the intention of creating a masterpiece. And sometimes we've done all the steps but have given our best hours of the day to cleaning the house. Some days we have trouble drawing a stick figure. No matter what, if that masterpiece has turned into a hot mess, value your energy and time by pausing to take a deep breath. You've got this!

HIT REWIND—The most obvious and irritating solution is to take a few steps back in the process you are learning and study, prepare or practice a bit more. This might mean waiting until you don't have a cold. Or it might mean grabbing a book on the process instead. Do you need better light to add detail with more clarity? Tomorrow's a new day! Did you draw a horse that looks like a sloth? Grab your sketchbook and settle into your comfy spot on the couch. Break it down and figure it out.

LET. IT. GO.—Allow yourself the opportunity to value your time and energy by tossing work in the trash. We tend to invest ourselves in our art so early in the process that we don't allow ourselves to just let something go. It isn't working. It's not like what you imagined. Let. It. Go. Your time and energy are worth more than the product you discarded.

PICK AND CHOOSE—Save the best parts of an old, ugly or worn-out piece. You can do this by cutting it apart and adding your favorite bits to your stash and throwing the rest in the trash. This is highly therapeutic.

COVER-UPS—Cover up an old or sad piece altogether, either with paint or paper. You can also cover up the parts you don't like anymore with paint, patterned papers and ephemera. They all work well and give you a multitude of new surfaces to paint on, allowing you to incorporate the bits you preserved and blend them in with the new. This is my favorite technique with panels and canvases, and it works well when the piece is not your favorite. See an example of this in my piece titled *A Is for Art Supplies*. See the patterned paper under the mixing well? Yep, there is an ugly version right underneath it!

WORK-AROUNDS—Identify the part of a piece that bugs you, then dig into your trash stash to fix it. This allows you a more positive solution than painting over a little spot or reworking it, which usually leads to only one thing: hating it even more. That spot already had *your* attention, now it has everyone else's too! Instead of letting go of the little spot that didn't work and focusing on the rest of the piece, you managed to turn the little spot into the focal point of the piece. I am not sure why we are programmed to do that, but we are. And that stinks. Allow yourself the time to mull it over and think of how to make it shine rather than disappear. At the very least, set it aside and take a break. Then come back and work around it.

WALKAWAYS—Take the opportunity to set a piece aside and disconnect for a while. If your creative brain works anything like mine, you will imagine a brilliant solution after you give yourself a little bit of grace and a decent amount of time. Some of my best ideas come after I have stomped away, only to come to me when I turn in for the night and my head hits the pillow. But if that doesn't happen, tuck the project away behind a box somewhere. You will discover it down the road, and a new technique or supply will be just what you need to finish the work with a smile.

ORGANIZED PRACTICE

I don't consider myself a "journal" kind of girl. I am not a diary keeper, and I have panic attacks about creating my life's masterpiece on the back of an ugly practice page. Coupled with my love of organizing and possibly a smidge of perfectionism, I sought a creative solution that would help me practice more often. And, in turn, help me become a better artist. The solution? Super colorful, obsessively organized creative "storybooks" that I can fill up with all sorts of fun stuff.

In this chapter, you'll discover a plethora of benefits to developing a similar kind of organized creative practice.

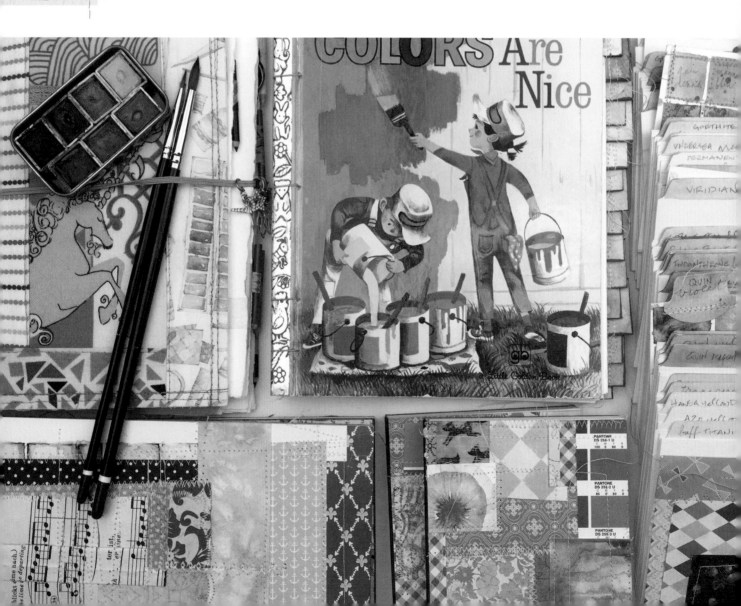

TAPE-BOUND WATERCOLOR PAD | *daily practice*

Daily practice is pretty much an impossible goal for me, and I do this art thing full-time now. So, give yourself a break if you're falling short of your goal. Life doesn't always cooperate. Try a monthly practice with a limited number of pages.

At the end of the year you'll have a lovely set of twelve volumes that you can save as a set or take apart, keeping what you love and tossing what you don't. And the best part? You can remove the sewn covers and reuse them on a new set.

PREPARE | *supplies*

Liquid Glue

Pad of Watercolor Paper

Paper Trimmer

Ruler

Scissors

Scraps of Patterned Paper

Sewing Machine

Washi Tape (wide width)

IDEA

Use the back of each page in your tape-bound pad to practice your drawing or paint color swatches, and create a more finished piece on the front of each sheet. After finishing the piece on the front, turn it over and add more notes about what you learned and liked. Writing down discoveries and notes about what worked and what didn't helps get that information to stick in your brain's memory bank, creating muscle memory from the practice.

1 Add Washi Tape to the Spine
Using a small amount of liquid glue, place wide washi tape down the length of the spine of the pad. Wrap the excess around the front and back covers.

2 Measure the Cover
Bend back the cover to identify the natural crease. Measure the cover from the crease to the edge, and from top to bottom.

3 Sew Scraps of Paper Together
Sew together scraps of patterned paper as shown in my example (above) to create a paper collage. Don't worry about sewing perfect edges; you'll trim them in the next step. Just be sure your collage is larger than your measurements of the cover in Step 2.

4 Trim Collage and Glue to Cover
Using a sturdy paper trimmer, trim the sewn collage to the size measured. Adhere the trimmed collage to the front of the tape-bound pad with clear liquid glue all the way to the edges. Place it on a flat surface with the cover side down and weigh it down with several books. Allow it to dry overnight.

5 Trim Collage and Glue to Cover
On a decorative file label or scrap paper, stamp or hand letter the month and year, and adhere it to the spine.

HANDMADE JOURNALS | *reward-yourself practice*

If you struggle with disciplining yourself to learn something extra hard, buy or make a Reward Journal. Think of it as a creative punch card. First, set a goal and a reward. For example, I would really love to make time to learn about drawing repetitive floral patterns infused with colored ink pens to create a tone-on-tone look. I'll gather inspiration and study ten different flowers. Once I have studied them, I'll practice drawing and painting them using colored markers and watercolors. Then I'll practice combining them on a small scale to create imaginative patterns. My reward? I get to treat myself to a pretty bouquet of flowers from my local farmers market and new markers that coordinate with them!

IDEA

Another bonus of making this book is that you can have so much fun personalizing it. Made by a dear friend, the book shown here includes a Moleskine journal in the middle of a ton of superheavy watercolor paper so I can keep track of inspiration. I add notes about stuff that worked and stuff that epically failed and even a list of the flowers and ink colors I want to add to my collection when I reach my goal. And look at those supercute mini pencils! I used a long piece of washi tape to add them to some of the watercolor pages to serve as tabs.

Jen Osborn | www.themessynest.com

ALTERED BOOKS | *color practice*

If you love color as much as I do, this is an easy way to create a practice book that focuses on a plethora of colors. I can fill the pages with objects that are the color of the tab, like shamrocks and frogs in the green section. Or, I can infuse it with my imagination by drawing a series of animals and painting them lovely shades of green.

HOW TO

This book was deconstructed then reconstructed with signatures of artist-grade watercolor paper by a sweet friend of mine. I painted a long wash of color in rainbow order (approximately 4" × 12" [10cm × 30cm]). Once dry, I cut them into strips horizontally and folded them in half. I inked the edges and placed them two pages apart. I adjusted them on the edge of the pages until I could see all of them. Once I was happy with the placement, I glued them in place.

Tricia Alexander | www.tricia-alexander.com

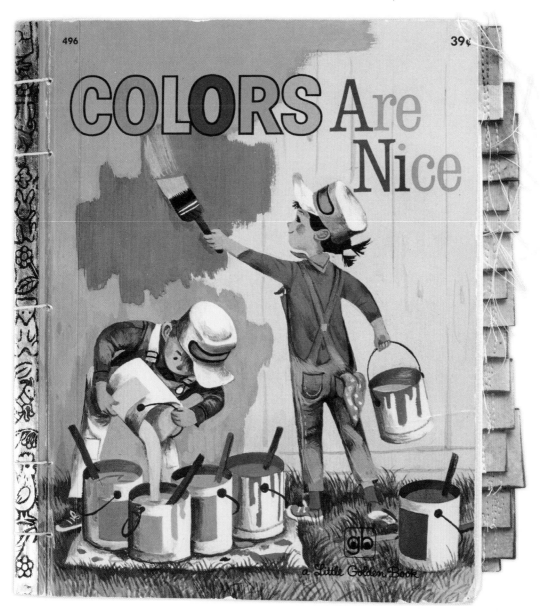

LOOSE-LEAF PORTFOLIOS | *abc practice*

Portfolios are my favorite way to organize my creative practice. Especially if you throw in an ABC theme. I get to work on one letter at a time, on one sheet of paper at a time. And when I am done, I have an amazing book of work. Some of the pages are even frame-worthy! All of the ABC-inspired layouts in this book were created using the following parameters:

ALPHA PRACTICE | Several of the pages in this book are based on objects that begin with a specific letter. You would think coming up with objects that begin with a specific letter would be easy, but I have found it to be quite challenging. These pages are a great way to get you out of your comfort zone and illustrate things you would never do otherwise. What if you can't think of anything? Try doing a Web search and choose images. It will give you lots of ideas and a photo reference to go by.

REPETITIVE PRACTICE | A handful of pages are all about drawing and painting one object over and over. This type of practice allows me to create muscle memory while drawing, with the bonus of infusing the object with lots of imaginative detail and color choices.

SUBJECT PRACTICE | The letter W is a great example of subject practice. I knew that objects starting with W might be hard to find so I chose to illustrate Winter instead! Creating a Subject Practice journal is great for events like birthdays and weddings, seasons and favorite hobbies.

COLOR PRACTICE | This book includes a page for each color in the rainbow, plus teal (because I love teal and desperately wish I could see a real rainbow with it included! A girl can dream, right?). These pages focus on objects that are the specific color. Sometimes I add a smidge of imagination in the form of objects that are not the color, but I wish they are.

NESTING PRACTICE | Learning how to compose objects on a page takes a lot of practice. There are tons of amazing books and classes out there, so I'll keep it simple and just focus on the type of composition that I use in a ton of my art and in this book. I liken "Nesting" (a Danielle-ish term for tucking stuff together on a page to create a pleasing composition) to what you might see if you arranged the objects on a table and had a bird's-eye view, with a bit of imagination thrown in.

PERSPECTIVE PRACTICE | There's no way around practice when it comes to learning perspective drawing. If you want to draw things like mason jars and unicorns, or portraits and landscapes, you must take the time to study perspective drawing. Back in the day, I took a basic perspective class that met six hours a week for an entire semester. With only a ruler, a drafting pencil and a big pad of white paper, we learned the math, were shown the steps and drew until we couldn't look at another building without seeing the vanishing lines in our sleep. It was, by far, the most important class I ever took. And the most boring. And the hardest. I double-dog dare you to create a practice book that focuses on one-point perspective to start. You'll be so glad you did.

COMPOSITION PRACTICE | I would consider composition practice the most advanced form of practice in this book. It takes everything you'll learn with the other practices and smooshes them all together.

Alpha practice gets you drawing and painting lots of new things. Repetitive practice builds creative muscle memory, which gives you more confidence in your skills. Subject practice helps you to see that there are more imaginative components you can add to your visual storytelling. Nesting practice leads to better visual awareness of white space, a key component to good composition. Perspective practice teaches you how to add depth to a scene by not only using color choices, but choices in size and placement of objects. Composition practice takes all of the pieces from the other practices listed and blends them all together. Each ABC page throughout this book was carefully composed to draw you in and tell you a visual story.

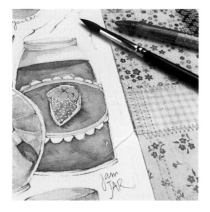

ABC | *practice breakdown*

If you are looking for specific examples of these practices, I have included this handy list for you! All the ABC pages include nesting practice and perspective practice. You may notice that some of the pages could easily fit into a different type of practice, but I have listed them where I feel they fit best. (But good for you for noticing!)

ALPHA PRACTICE
- E is for Elephants
- J is for Jars
- N is for Narwhals
- & is for And

REPETITIVE PRACTICE
- C is for Couches and Chairs
- F is for Ferns
- K is for Kittens
- L is for Littles
- M is for Mermaids
- P is for Posies and Petals
- Q is for Quotes

SUBJECT PRACTICE
- A is for Art Supplies
- D is for Danielle
- H is for Home
- S is for Sky
- U is for Unicorn
- W is for Winter
- X is for X Marks the Spot
- Z is for Zoo

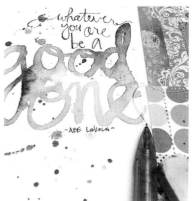

COLOR PRACTICE
- B is for Blue
- G is for Green
- I is for Indigo
- O is for Orange
- R is for Red
- T is for Teal
- V is for Violet
- Y is for Yellow

SCENE PRACTICE
- B is for Blue (sailboat)
- H is for Home (dollhouse)
- J is for Jars (mason jar)
- K is for Kittens (full page)
- S is for Sky (full page)
- W is for Winter (snow globe)
- X is for X Marks the Spot (full page)

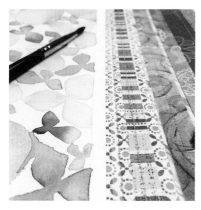

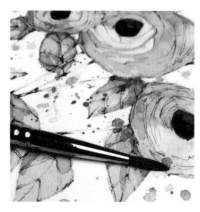

ORGANIZED PRACTICE | *inspiration blocks*

STUDY | choosing the bits and pieces—Throughout this book you'll be using your stash of patterned paper, ephemera, lace and ribbon scraps to help you along in your journey to become a more skilled watercolorist and illustrator. Although I place the most emphasis on the colors included in the scraps you choose, I want to share some insight that might help you choose your inspiration with more confidence.

- **What the heck is an inspiration block?** If you have looked through the pages of this book, you'll notice that each of the alphabet pages has a block of scraps that have been sewn together. Yep, that's an inspiration block! I began making them to serve as a starting point from my mixed-media illustrations and, over the course of the last few years, I have discovered their hidden teaching power. When you sew together a mishmash of scraps, you have created a reference tool. Just the inspiration you need to practice identifying and mixing watercolors.

- **Don't overthink the choosing process.** The more time and energy you spend on coordinating your stuff, the less you have for your creative practicing time. If it all matches perfectly, you have automatically limited the colors you can pull from to fill your mixing palette. So just grab a stack and go, my friends! The more pattern and color the better.

- **Let's not forget the patterns!** The patterns on these scraps can serve as an inspirational reference tool as well. Take note of the repetitive patterns, the simplicity or the intricate detail, and infuse them into your drawing practice. Need inspiration to add imaginative pattern to your illustrations? Reference the inspiration pieces you have gathered. It's another wonderful way to tie your elements together.

- **Inspiration blocks can be simplified and serve as mats for finished illustrations.** You'll use the same process to build them, keeping in mind that only the outer edge will show.

- **An inspiration block has a creative superpower.** What is it, you ask? It takes care of the color choices while you work on your watercolor illustrations. Shazam!

PREPARE | gather inspiration—If you don't have a bin or a basket of scraps, now is the time to gather one. Cut up that patterned paper you have been saving for a rainy day. Take those old postcards you bought at the flea market and add them to the mix. Snip the ribbons in the basket on your shelf into little pieces that won't get tangled. Old sheet music, vintage paper dolls and lace doilies can be snipped into pieces and added to the fun as well. And you know those days when you feel like being creative but are too tired to do anything? That's a perfect time to grab storybook pages and cut out words and phrases you might want to use.

PRACTICE | trust the process—Let's gather some inspiration in a new way. Place three small rectangular containers on your desk or table. Add scraps of patterned paper to one container, scraps of ephemera to another, and bits of lace, fabric and ribbon to the last. Without looking, pull three pieces from each container. Be sure to rummage around a bit so you don't know what you are choosing—and don't swap anything for something else. Next, take your inspiration and a pair of scissors to your sewing machine and make a small Inspiration Block. Feel free to cut fun shapes out of the paper, like hearts, scallops and circles. Also, don't think too hard about the placement. If you are stuck on how to assemble them, just flip through the pages of this book to get ideas. If you don't have a sewing machine, glue the scraps together and pencil the stitches on, if you like.

IDEA

If your particular portfolio has a clear spine, you can follow the steps on the next page to create a color-filled insert. Be sure to keep the layers to a minimum since the spine needs flexibility to be able to close the portfolio.

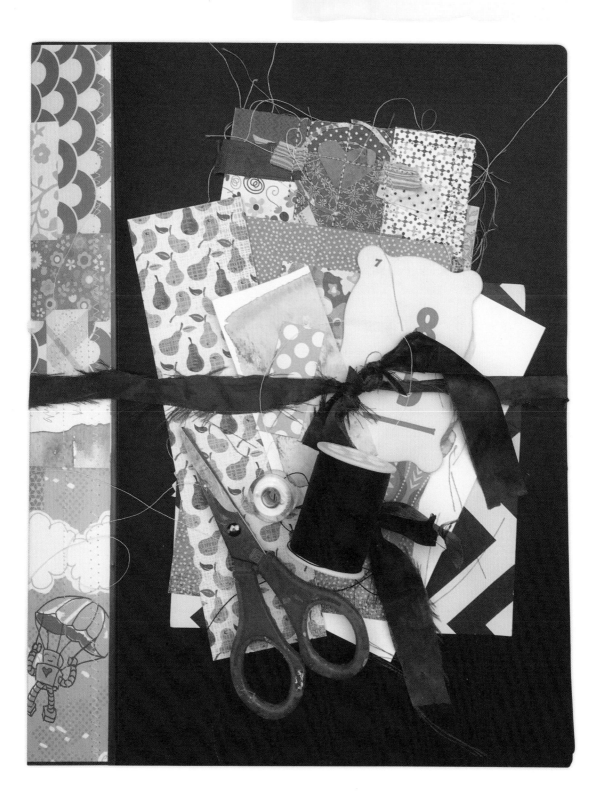

ORGANIZED PRACTICE | *abc inspiration blocks*

Inspiration blocks are a great addition to your loose-leaf page practice. When creating the ABC pages for this book, I created all my inspiration blocks for each sheet of watercolor paper ahead of time. Apart from the pages assigned to color practice, they are made up of a mishmash of patterned paper scraps, bits and pieces of my old work, practice work and ugly failures, plus some ribbon and ephemera to make it even more interesting.

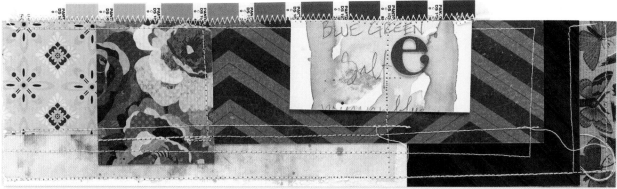

Inspiration block from E Is for Elephants

1 **Gather Inspiration and Determine Size of Inspiration Block**
Gather tons of scraps and determine the size of the inspiration blocks you'll be adding to your watercolor paper.

2 **Cut Tracing Paper**
Cut tracing paper or newsprint paper to a predetermined size. If you are creating an ABC portfolio like mine, you'll need twenty-seven sheets (A–Z plus *and*).

3 **Assemble Inspiration Blocks**
Using various stitches, add bits and pieces of paper or ephemera to a sheet of the tracing paper. My sewing machine is preprogrammed with a ton of stitch varieties to make it easy to switch while I am sewing. If you don't have an easy way to change stitches, use a straight stitch. Typically, I start on the right edge and work my way around. Then I fill in the middle with extra layers. Do *not* overthink this step, just grab and go! Use lots of patterns and colors. Don't forget to add ribbon if you want some texture, too.

4 **Assemble Color-Specific Inspiration Blocks**
To create the color-specific pages (blue, green, indigo, orange, teal, red and yellow) gather a stash with various shades of each color and repeat Step 3 for each color.

5 **Add Details**
Add alphabet stickers to, or hand write a letter on, each page and insert into the portfolio.

PREPARE | *supplies*

Art Presentation Portfolio (with clear sleeves for artwork)

Clear Liquid Glue (optional)

Craft Dryer (optional)

Creative Essentials (page 10)

Lace, Ribbon and Fabric Scraps

Letter Stickers

Tracing or Newsprint Paper

Paper Cutter

Patterned Paper and Ephemera Scraps

Scissors

Sewing Machine (optional)

STORAGE CLIPBOARD | *on-the-go practice*

One of my favorite ways to procrastinate when I have a big deadline is to peruse through office supply stores, home improvement stores and hobby and craft stores with an artist's eye. I'll meander down each aisle and ask myself, "How could I use this to organize my practice or infuse it into my art?" It's like a treasure hunt every time!

This storage clipboard is traditionally used by service people who need to write up orders on-site. But who says it can't serve as a travel workstation for an artist? It holds watercolor paper, mechanical pencils and brushes inside, clips your paper in place and gives you a smooth surface for illustrating and painting.

Since ABC-organized practice is a favorite of mine, I simply added tabs to the stack of watercolor paper, stitched the edges and placed alphabet stickers on the tabs. Be sure to place the paper in a stack and add the tabs without adhering them first so you know they'll they line up correctly.

HOW TO

To assemble your own clipboard, trim down the paper to fit, then add blank tabs and an alphabet or number sticker. If you like, add a stitched border around the edge of each page.

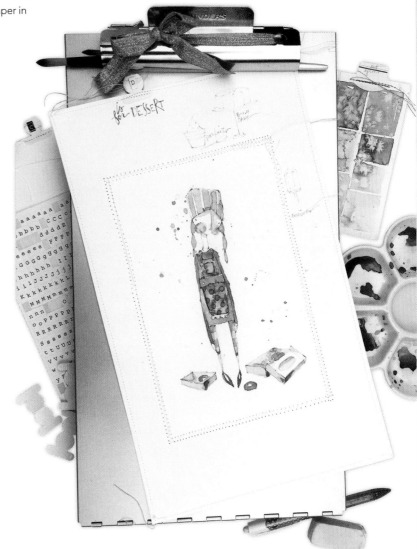

RECIPE CARDS | *template practice*

Creating a template is a recipe for success. Get it? Just like with Grandma's scrumptious apple pie recipe, a template takes the guesswork out of the process. It allows you to enjoy the painting process and the results. And, if you just can't say no to making color charts, this may be a better way for you to channel that creative energy.

Color recipe cards are a quick way to learn how a specific color interacts with other colors. Does it dominate other colors when mixed? Does it dry quickly? Is it transparent or somewhat opaque? Does it react to salt? Do you like it as a stand-alone color, or does it look prettier when mixed with others?

IDEA

Templates, like my recipe card, help free your imagination. How could you create a template like my recipe card for a subject you like to draw a lot? I often draw small landscapes with little buildings on cake stands. I could create a template to indicate placement of land, water, building(s) and the sky. I have created a template that includes a guideline for placement along with a list of things I typically include in these illustrations. This process allows you to skip the step of laying out your composition and takes you directly to the fun part of the process—choosing the little bits and pieces you'll draw and paint. By the way, this is a great way to create a series of illustrations.

For this creative color practice, I have drawn a recipe card template that allows me to test each color out. I keep this card in the back of my recipe box (see recipe box on page 1, created by Kelly Brannan at TheAdornedAbode.com). I begin with sewing and adhering a mini inspiration block. The main color of the block should be the color I am focusing on. The other colors in the block will guide what colors I choose to mix with my focus color. On the left, I paint a color grid using my focus color, then mix it with colors from my palette that I've matched to my inspiration block. Next, I paint a multicolor wash with a sprinkle of salt. To the right of the inspiration block, I draw and paint my signature blossoms with a wet-into-wet wash.

After it dries, I make note of the brand, focus color, supporting colors and anything else I want to remember about the process or results. I have found that if I write them down, I have a better memory of the color when I create an illustration and don't have to refer to the card.

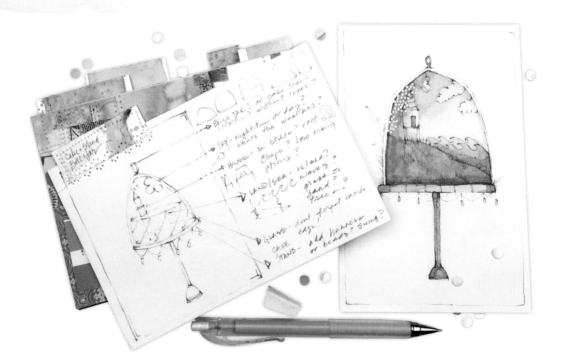

FILE SORTER | *daily practice*

To grow as an artist, it's important to infuse every day with something creative, even if it is only for five minutes. It's equally important to know that it's OK to set your art aside and deal with life stuff. It happens. Working full-time, caring for children or parents, the common cold or just a complete lack of confidence or mojo are common occurrences that can put us on pause. Again, it happens.

Try to get out of the mind-set that honoring your time as an artist means that you need to pick up some sort of pencil, pen or brush or that by walking away from your supplies, somehow you are not as committed to growing as an artist as much as others are. I want you to use this daily method as your inspiration gathering tool. No sketching, doodling or mark making is necessary. Each day file something away in this file sorter: a coaster with a cool logo from your favorite pub, a printout of a photo your daughter sent you in a text, a leaf from a walk you really needed to take, a quote from a randomly selected page in a book you have been meaning to read. You get the idea. Fill it with bits of inspiration, and when you need encouragement, sit in your studio and pull out the treasures from the date that correlates with the current date and see what you can imagine with them.

HOW TO

Illustrate and paint a repeat of petals and posies (see chapter 5) to fill a sheet of watercolor paper that is slightly bigger than the cover of the file sorter. Once dry, place the illustration on a flat surface, illustration side down. Place the file sorter cover side down and trace around the edges with a pencil. Cut with scissors or a paper cutter. Because the file sorter will be handled daily, the cover needs to be protected. Carefully place a sheet of clear contact paper over the top and trim if necessary.

COLOR PRACTICE

I love color. Every tint, tone and shade. I even love the complete absence of color—white. I love all the muddy, beautiful colors in between. I always have been in awe of Mother Nature—she has the best eye for color I have ever seen. And we humans are great at coming up with ways to expand that palette. We are surrounded by color-filled inspiration everywhere we look. If you are anything like me, there's not a corner of your world that you don't notice. My creative brain is constantly taking notes and filing them away. But, before we can translate all those mental notes into color-filled illustrations, we need to spend some time learning about watercolor and how it works (and doesn't work).

In this chapter, I share my version of watercolor basics. We begin with the basic washes, techniques and fixes that I use in my work. Then we work through a few exercises designed to give you the insight and confidence necessary to start mixing watercolors like a champ.

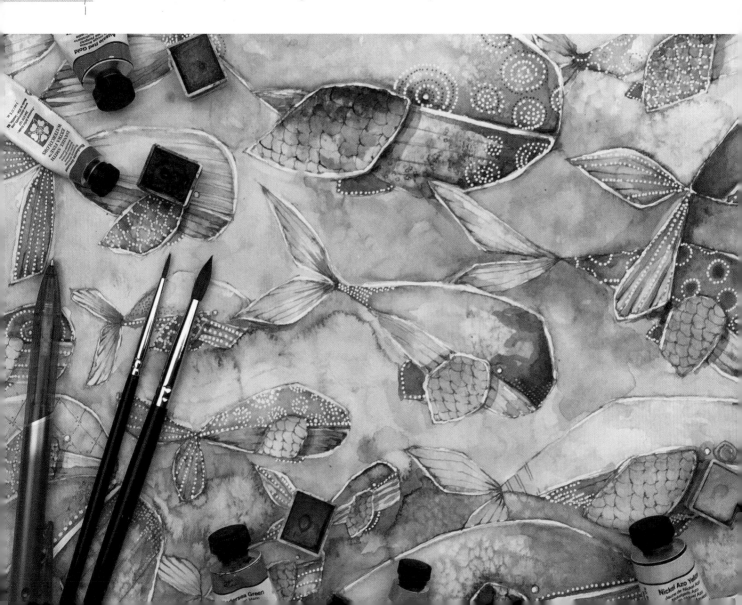

STUDY | *basic washes, techniques and fixes*

Controlled Wash

CONTROLLED WASH

My controlled wash is all about a moderately wet brush on dry paper and is definitely the wash I use most. It is used to paint areas of my illustrations that I want to fill with a somewhat even layer of color. It's like a flat wash, but with a little less need for a perfectly even color. I like to use this technique to paint small shapes in my illustrations where I need to control both where the paint goes and the amount of coverage. This allows me to drop more of the same color into the wash, drop in other colors, or sprinkle a little salt while it dries. If you decide to add salt to your wash, the wash must be wet and adding the salt should be the last thing that you do.

Don't confuse this with a dry-brush technique. Typically, a dry brush has a high ratio of paint to water, allowing the most control when adding fine detail, like blades of grass or wood-grain lines. I consider dry-brush painting a pretty advanced skill because you can create a ratio of paint to water that will end up looking like acrylic paint. So, we're going to skip it!

To practice the controlled wash, choose your favorite brush (big brush=big area, small brush=small area) and premix your paint and water, then dry off your brush. Now load the brush with a moderate amount of your paint and water. It should not drip on your paper. Your goal is to have enough paint and water in your brush to cover a specified area on your illustration without creating a raised pool of water on your paper. You should be able to tilt your paper and see a shiny area where it is still wet, but nothing should drip. Managing the amount of water and paint loaded into your brush will help you avoid hard edges of color when it dries. If too much water remains in the area where you placed your paint, simply take the corner of a paper towel, and without touching the paper, let it soak up the excess water. This wash should give you just enough time to gently drop other colors into the wash and to move the color around a bit.

For comparison, the upper left corner of my example is a flat wash. You shouldn't see any lines, marks or variations. Below that is a controlled wash—which is as flat as I get. It has a little more water and a little less perfection than a flat wash. The top right is dry brushed and on the bottom, I've painted a controlled wash with salt added.

Check out *K Is for Kittens* and *Z Is for Zoo*—both are filled with great examples of controlled washes.

Sloppy/Wet Wash

Graded Transition Wash

(SLOPPY) WET WASH

My wet wash is where the most magic happens. It's where wet paper meets a wet brush.

To practice this wash, premix your paint and water, then clean your brush with water. Reload your brush with water only. Paint the designated area or shape with clear water. Now load the brush with a moderate amount of your paint and drop it onto your wet paper. The color will bloom and expand immediately. Cool, right? Now try splashing paint to create more blooms. You can add as many colors as you like, blending them together as you go. If you end up with pools of water on your paper, dry off your brush and let the tip or the side make contact with the water. It will soak up the excess water. Repeat the process, adding color and subtracting water as needed until you are happy with the result. Another option is to simply splash several colors into the clear wash of water and let it dry. The amazing thing about this kind of wash is that even if you tilt the paper, the color will go only where your original water wash is. Add salt if you like, then sit back and watch the paint dry. It truly is a magic trick I never tire of.

The left half of my sample square is an example of a sloppy wet wash where I splashed various colors of paint into a clear water wash. On the right, I left the paper dry. The dry splashes are super fun to doodle around.

Check out the background in the painting *X Is for X Marks the Spot* and the rainbow on *F Is for Ferns* for examples of sloppy wet washes.

GRADED AND TRANSITION WASHES

A graded wash is a gentle transition, or gradient, from dark to light. Graded washes are traditionally used to paint skies in landscapes. I tend to use the technique to paint larger backgrounds, often around my illustrations.

To paint a traditional graded wash, use a flat or angle brush. Premix your paint and water in the wells of your palette. The ratio should reflect the color you want at its strongest. Load your brush and paint across your designated area. Quickly clean your brush and load it with water, gently make contact with your paper towel to remove excess water and then paint across the lower third of your first pass. The water will mix with the paint and become lighter. Load and repeat, pulling less and less paint and more water. This wash takes a fair amount of practice to create a really even look.

The same technique can be used to transition colors. Rather than loading your brush with water, clean and load your brush with a different color.

In my samples, I loosen the washes up a bit by using a round brush instead of a flat or angle brush. I replace the straight strokes across the paper with a loose movement—swirling and pushing my brush instead. I often use a combination of both washes to paint large areas around my illustrations. I add water to the edges of my wash as I go, which buys me time to either mix more of the same color or transition to a different color without the edges drying. Be sure to keep your paper towel handy to soak up excess water in your brush before you add more paint and water to the paper—this will help you keep control and avoid blooms.

Glazing with Hard/Soft Edges

Watercolor Blooms

The left half of my sample is my version of a graded wash using a round brush. On the right, I have used the same brush and transitioned several colors instead of clear water. Notice the extra blooms; they weren't intentional but I think they are a pretty addition nonetheless.

A great example of my version of a graded wash is the background for *S Is for Sky*. On the same page, the rainbow is a color-filled example of a multitransition wash.

GLAZING WITH HARD AND SOFT EDGES

When working with watercolor, it's important to remember that we work from light to dark. If you have worked with other mediums, you have just entered opposite world! Glazing is the technique of adding transparent layers of color to create depth and intensify or adjust the value of the previous layer.

Hard Edges: Prior to glazing, be sure the previous wash is completely dry. To glaze a layer over a wash, simply premix and load a moderate amount of paint into your brush, and paint over the previous layer. As it dries, you'll see a "hard" edge on both sides of the glazed layer. I suggest sticking to the same color as the previous wash, or a very similar color, when you are practicing this technique. If you add a glaze of a really different color, like orange over blue, you'll more than likely end up with an odd, muddy color. Don't get me wrong—I love mud! But only when you mix it on a palette. As a reminder, I consider "mud" to be the mixing of several colors to create a neutral or supporting color.

Soft Edges: Add a glaze of color and while it is still wet, clean the paint out of your brush and load it with a small amount of water. Apply your brush to the edge of the glazed layer and loosen the paint a bit to produce a soft edge. If your glaze has

already dried and you don't like the hard edge, simply load your brush with a little water and use a gentle swirling motion to reactivate the edge and soften it. Your scrunched-up paper towel should be close by if it's not in your nonbrush hand. Since you are going from brush to paint and water, cleaning your brush and adding a bit more water, you want to moderate how much and what is in your brush.

In my sample on the left, I have added four hard-edged glazes in concentric circles. On the right, I used the same number of soft-edged glazes to a much subtler effect.

Take a look at *O Is for Orange* to see glazed layers with a hard edge. Many of the chairs and couches on C have a combination of hard and soft edges. Can you spot them?

WATERCOLOR BLOOMS

Watercolor blooms are the bomb! But, sometimes they show up in washes and distract from your illustration. To fix them, you need to understand how to create them. Blooms (as shown on the left side of this example) are created when super-wet paint, or a lot of water, is placed on a not-yet-dry wash. In other words, it's where a lot of moisture meets an area of less moisture.

To create blooms on purpose, apply a wash of color and let it dry a smidge, then gently drop a bit of water on the wash and watch the magic happen. If blooms don't appear, it just means that you didn't let the underlying wash dry enough. There are a few other ways blooms show up in your work:

· Random splashing of color or water on an almost-dry wash.

· Salt sprinkled on a wet wash and allowed to dry (this is basically a little bloom factory).

Color Lifting

- Two different color washes meeting up, but one wash is drier than the other.

- Tilting paper while a wash is still wet. This sends the pigment toward the bottom of the wash. Wait a little longer and tilt in the opposite direction, and it moves the pigment again.

Sometimes they are unwelcome marks that distract from the composition of your illustration. To fix a bloom, simply add water to your brush and gently touch the edge with a delicate scrubbing or swirling motion to reactivate the wash and remove the hard line. Sometimes it's possible to reactivate the entire wash with a small amount of water, but often you are just shifting the problem to the edges.

In my sample, I painted a wash and dropped in clear water while it was drying to purposely create blooms. On the right, I added water to my brush and applied a fix.

A Is for Art Supplies has several examples of blooms made with water, paint and salt on semidry washes. My favorite set of blooms in this book? The amethyst geode slice on *V Is for Violet*.

COLOR LIFTING

Ah, color lifting! These techniques should be used sparingly since they create textures and patterns that might be distracting to small illustrative work. The two tools I use for color lifting are paper towels and cotton swabs. Some people use sea sponges, but I think they feel and smell yucky, so they aren't a part of my watercolor go-to techniques. Sometimes color lifting tools and techniques are used to fix a problem and, other times, to create a pattern or texture.

I always have a scrunched-up paper towel in one hand and my brush in the other. The paper towel cleans and absorbs excess water from my brushes, soaks up pools of water on a wash and, when gently placed on a wet wash, lifts color creating a pattern within the wash. Paper towels with patterns, when placed flat on a wash, can create a repeat pattern. And for goodness' sakes, don't throw away those pretty, used-up paper towels. Cut them in strips and sew them together to make tie-dye ribbon.

Cotton swabs can be found in all shapes and sizes. Standard cotton swabs make great polka dots and bubbles. Microswabs shaped like teardrops clean up little spots when you paint outside of the lines, and when you press the side to your wet wash, they create a delicate pattern that's perfect for bird wings, seeds in fruit and all sorts of other stuff.

On the left of my sample, I used a scrunched-up paper towel to lift color for a batik effect. On the right, I pressed the sides of different sizes of cotton swabs to lift color and create patterns.

PRACTICE | *strips & grids of color on watercolor paper*

To discover the beauty each color on your palette offers, you need to understand how each color works (or doesn't work) with other colors. These color transitioning exercises will give you the opportunity to learn more about your palette, your brushes and working small.

In addition to learning about color, it's important that you create consistent white space around and in between the squares and stripes of color that you paint. (Because where you don't paint is as important as where you do paint!) It's also important that you work on painting straight edges and crisp corners without drawing the boxes ahead of painting. Why? In my illustrative process, it's superimportant that you control the brush, not the other way around. We will be drawing and painting in small areas, and accuracy is key. Have no fear! The more you practice, the easier it gets. These grids and squares can become quite addictive to make—you might consider dedicating an entire watercolor journal to them.

Oh, and one last request: Don't do these exercises on full sheets of paper. Working small can be a difficult transition for artists, but the more room you give yourself, the harder it is to control the watercolor process.

To get the most out of these exercises, ask yourself the following questions and make notes on your strips and grids of color on watercolor paper. Then try again!

- Did you choose the correct shape and size of brush for the exercise?
- Did you turn your brush head at different angles to make the process easier?
- Have you loaded your brush with the appropriate amount of paint and water to paint the designated area, or do you have to go back to your palette for more?
- How much paint do you need to pull from your pan to mix a transparent wash?
- Are you using enough water to create some transparency in the color?
- Did you run out of space before the transition ended?
- Did the paint dry too quickly to add salt?
- Was your paper too big? Too small?

PREPARE | *supplies*

This list includes everything you need for all the exercises in this chapter. Have lots of strips of watercolor paper and squares handy.

Craft Dryer (optional)

Creative Essentials (page 10)

Hole Punch

Key Ring

Paper

Ribbon and Lace Scraps

Sewing Machine (optional)

PRACTICE | *water to paint ratios*

If you attend one of my workshops, you'll hear me say (more than once), "If you think you have enough water, add more!" To preserve the stunning transparency of the colors in your palette, you need to make sure that the crisp white paper shines through underneath all those layers of paint.

In this exercise, you'll begin to explore premixing paint in the wells of your palette. What do I mean by "premixing" paint and water? It is the ratio of paint to water. This can be a single paint color plus water or a custom mix of several paint colors plus water. (You will see this as "paint+water" throughout the book.)

Once you have prepared your mixing palette, you'll explore paint-to-paint ratios by pulling and mixing colors from your mixing palette.

I don't have many hard-and-fast rules, but *don't* pull color directly from your paint palette without mixing it with water on your mixing palette first. If you paint directly from your palette, even if you add water to your brush, you won't know the transparency level or even what color it is.

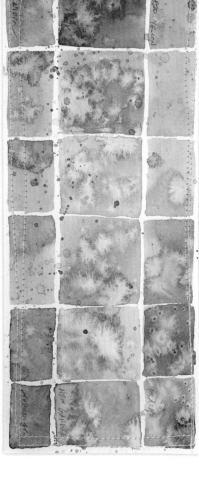

IMAGINE | *storytelling color schemes*

Once you get more comfortable with your palette and mixing colors, try pulling color from a favorite photo. You'll learn how to play with more color combinations as you work toward matching the colors. It may even serve as inspiration for an illustration or two—and it will have a secret story that only you know about!

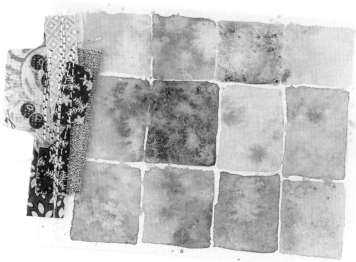

1 Prepare Your Mixing Palette and Paint a Rectangular Block of Color on a Strip of Watercolor Paper

In this exercise, I have chosen Phthalo Turquoise and Cobalt Blue Violet. Using an angled brush, prepare your palette with enough paint and water to complete the combinations. Loading your brush with a moderate amount of Phthalo Turquoise paint+water, paint a thick stripe or square of the pure color on a precut strip of paper.

2 Paint Additional Blocks of Transition Colors

Clean and dry your brush and add a small amount of Cobalt Blue Violet paint+water to your Phthalo Turquoise paint+water and paint a second stripe. Repeat this process until you have room for one more stripe. You want a subtle gradation/transition to your second color choice. Remember to wash out all the paint from the brush between each mixture. You don't want extra color creeping in as you go.

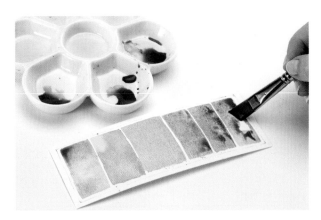

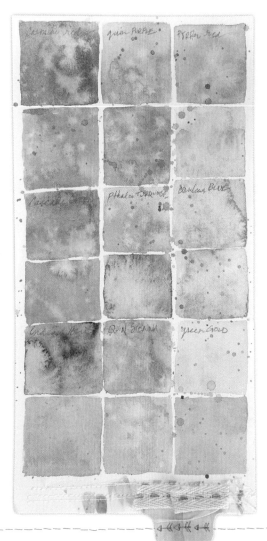

3 Paint the Final Block of Color on Your Strip of Watercolor Paper

Clean and dry your brush and use the remaining Cobalt Blue Violet paint+water to paint the final stripe. If you don't think the Cobalt Blue Violet paint+water is the pure color, mix a bit with water and paint the stripe. If your layers are still wet, you can toss in some salt to see how that affects the paint. Once the paint is dry, brush off the salt and hand-write the names of the colors outside the stripes.

Trim, layer and stitch your background papers to the color strip. Add the names of paint colors along with any notes about the exercise.

PRACTICE | *making mud (color transition practice)*

If you are coming from a mixed-media or acrylic paint world, the words "making mud" make you cringe. I get it. But watercolor works in a completely different and often mysterious way. Instead of spending our time creating a plethora of color charts to attempt to control the outcome when we paint, we can embrace the happy accidents and odd color combinations, and the role they play in making our art shine.

I consider "mud" to be the connecter of all things colorful. When I work through one of my pieces, I always (and I really do mean always) move from one color to the next by mixing a bit of the next color into the color I used previously. It doesn't matter where they are on the color wheel. The result is often mud. Either way, I rarely mix a color that I don't like. I know that the color will automatically work within the palette of my painting because it has a little bit of the last color, which is the key to color continuity in my paintings, and it's the reason I can work with every color of the rainbow in almost all my pieces. This process has become a signature of my work.

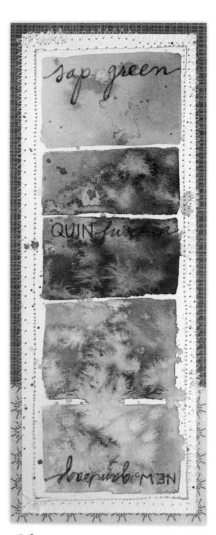

1 Prepare Your Mixing Palette and Paint the First Stripe

In this exercise, I have chosen Sap Green, Quinacridone Fuchsia and New Gamboge. Using an angle brush, prepare your palette with enough paint+water of each color to complete the combinations.

2 Paint the Pure Colors and the First Transition Color

Loading your brush with a moderate amount of Sap Green paint and water, paint a thick stripe or square of the pure color on a precut strip of paper. Clean and dry your brush and add a small amount of premixed Quinacridone Fuchsia to your Sap Green paint and water and paint a second stripe. Paint the third stripe from your well of pure Quinacridone Fuchsia. Notice the color in between—you have officially made a transition color Splash a little paint on the wet squares to celebrate!

3 Create a Second Transition Color

Repeat this process by mixing a small amount of New Gamboge into your well of Quinacridone Fuchsia. Paint the transition stripe, then a stripe of New Gamboge paint+water. If your layers are still wet, add some salt to see how that affects the paint.

Trim, layer and stitch your background papers to the color strip. Add the names of the paint colors and any notes about the exercise to use for your future reference.

COLOR PRACTICE | *paint chip exercise*

I am not an encourager of color-chart making. Water-colors work in fast-paced and mysterious ways. During the painting process, in the time you'll spend looking through charts for the perfect color, you'll have missed out on artistic opportunities that are available to you for only a short time. Don't underestimate the giddiness you feel when you mindlessly grab a color and mix it with another and create the most beautiful wash ever! Studying color should be about exploring the unknown, so don't limit yourself to colors on a chart.

If I can't convince you to give color charts up alto-gether, try creating paint chips instead. They push you to make simple combinations, are functional and look pretty, too.

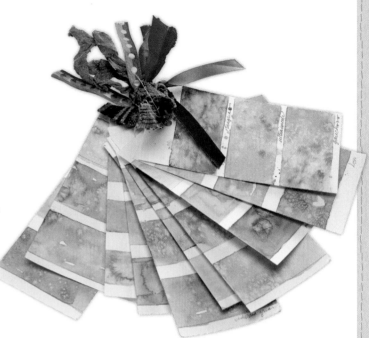

1 Prepare the Strip
Using a rectangular-shaped piece of scrap watercolor paper, punch a hole at the top of the paper. Use a ruler to draw lines across the strip, creating three areas to paint. It's easy to mark lines using the width of the ruler itself—draw the lines on either side of the ruler.

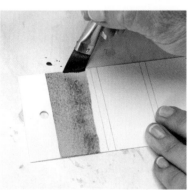

2 Add the Color
Loading your brush with a moder-ate amount of a paint+water, fill the top stripe with a color. Clean and dry your brush, add some of your second color to the well of your first color and paint the second stripe (transition color). Finish by painting the third stripe with your second color. Splash a little color and sprinkle some salt.

3 Add the Paint Names and Take Notes
Once the paint is dry, brush off the salt and add notes to the back for future reference, including the pure paint colors. For example, Quinacridone Fuchsia is a strong color and takes over other colors. For fun, you can name the mixed colors. In my sample, I hand let-tered "Ultra-Suede," "Gauchos" and "Sangria" underneath each strip, just like a real paint chip. Finish up with a key ring and some ribbon scraps. So much cuter than a color chart, right?

COMPOSITION PRACTICE

For a short time in college, I was a fine art major. It was heavenly until I realized that there was a strong possibility that I would not be able to pay my bills as a full-time artist. Being practical *and* creative has it drawbacks. I changed majors and began to study graphic design—without the aid of computers. (Yes, it was a *long* time ago!) Looking back, it was the best decision I could have made. I didn't know it then, but learning about visual communication was the best way to grow my art. While I learned the basics of composition from my fine art days, I found yet a different way of looking at composition through a graphic designer's eye.

In this chapter, I share my artist-and-designer way of creating thoughtful composition that successfully communicates my story without words.

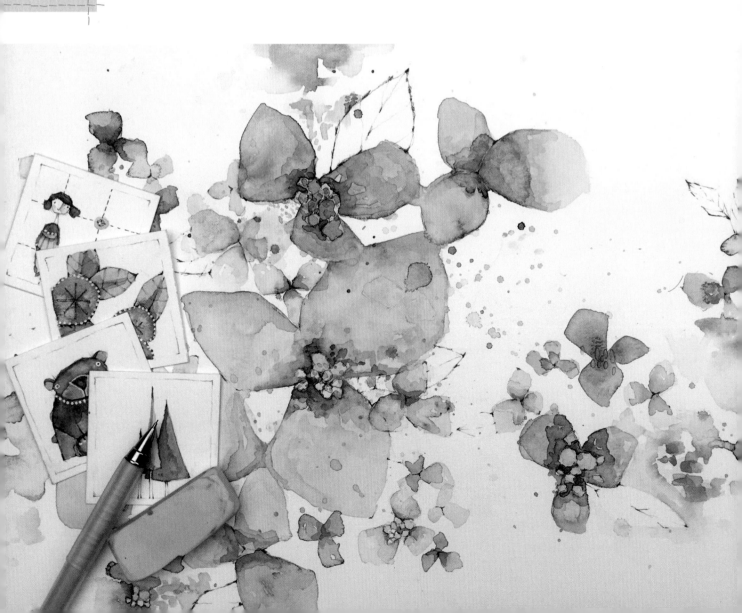

STUDY | *composition*

WHITE SPACE/NEGATIVE SPACE

Positive space is the area or areas in your artwork that include your subject or object. White space and negative space are the same thing, but I feel *negative* space is, well, negative, so I'll refer to it as white space. White space is the rest of the area in your artwork.

I learned the importance of white space as a graphic designer. Good design means giving equal thought to both white space and positive space. As an illustrator and watercolorist, white space is where the paper is still white. It's a huge, often overlooked, part of composition.

Many of my illustrations are somewhat centered with an ample amount of white space on all four sides. Notice all the little white spaces within my illustration above. In my initial drawing, I try to avoid creating trapped white space that might catch the eye of the viewer. You can see that I left a small gap between the two orange blossoms at the top. If I overlapped them, it would have created trapped white space that may have distracted the viewer. This isn't a hard-and-fast rule; it just means that considering the white space is as important as the composition that you have drawn.

RULE OF THIRDS

The rule of thirds creates a simple guide for placing your focal points. Simply place your focal point of your illustration in one of the intersections of horizontal and vertical lines. To lead your viewer to your secondary focus, choose another intersection. This easy tool creates asymmetry and allows you to place your viewer's eye at the beginning of a visual path.

In my example above, notice that I have placed my little girl's head in an intersection, followed by her hand on her skirt at another. Obviously, this is a simple example, and as your illustrations become more complex, the more you'll need to pay attention to where you place additional objects in your illustrations. The placement of each object should be carefully considered to ensure it doesn't distract the viewer or lead their eye away from your primary focal point.

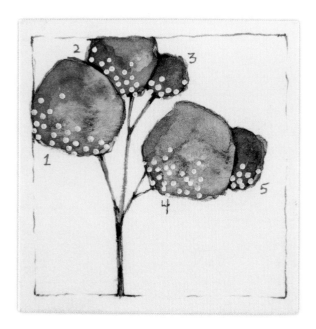

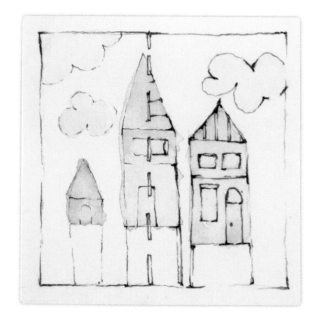

RULE OF ODDS

Viewers are drawn to art that is energetic and attention-grabbing. Creating an odd number of components (typically groups of three) is the easiest way to create this energy. Again, this is another rule that is sometimes meant to be broken. Even numbers of objects/supporting objects in your illustration can have the opposite effect on the viewer, creating confidence and stability.

Color: Every artist, textbook and website has a slightly different and significantly more complicated definition than I do. So I'll stick with my short-and-sweet version and share it with you. Color composition is the purposeful, thoughtful and balanced use of color to tell visual stories through our art.

The violet and indigo tree is numbered. Notice 1–3 are clustered together, with 4–5 separated a bit. If I were to add a third circle to 4–5 it would have created an even number overall and possibly changed the overall composition from dynamic to, well, boring. Again, rules are meant to be broken, but it's always something to consider. Do you see the variations in color within the various circles on the purple trees on the left? I added a warmer violet to the circles to advance them, and cool indigo to push the others back.

DOT-TO-DOT DRAWING

Typically, artists use a sketching, or back-and-forth, motion when drawing the foundation for their piece. When you retrace your lines, you are creating three problems with your illustration: You've made it hard to erase and preserve the integrity of the watercolor paper, you have filled up most of your paintable space within the various components, and you have lost the opportunity to add depth with visual tension.

To avoid the pitfalls of traditional sketching, I prefer to use light single lines. Think of it as a dot-to-dot drawing without the dots. Dot-to-dot drawing is not, by my definition, continuous or single-line drawing, which means putting your pencil down and never lifting it up. Imagine that the dots are invisible to everyone but you. It's your job to connect the dots using a single line from one dot to another. When you work on illustrations as small as mine, it's important that you avoid the back-and-forth sketching motion. It creates lines that are too heavy in scale and are almost impossible to erase. My first layer of an illustration is built with a series of light single lines.

Visual Tension: The addition of visual tension is the amount of pressure or width of line used in illustration (for me at least). Notice where the lines are dark and then get lighter. Visual tension is an amazing way of adding depth. This is a thing that makes my work mine, a signature of sorts.

On the far-left house, you'll see that I have drawn simple dot-to-dot lines with a light touch. On the far-right house, I have added visual tension by varying the width and pressure, typically at intersections. Notice that the visual tension looks different in each place I have added it. It creates asymmetry, which draws viewers in.

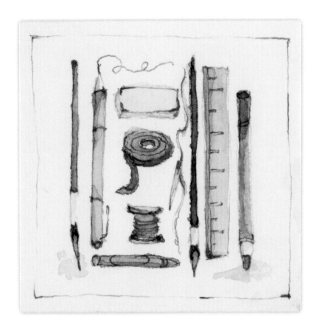

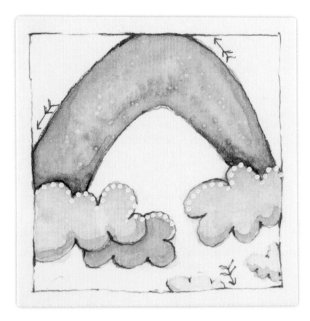

ILLUSTRATIVE NESTING

Illustrative nesting is the careful consideration of placement and spacing when illustrating from a somewhat imaginary bird's-eye view that leads the viewer from one object to another, creating a pleasing cohesive unit.

In the example, there's consistent white space between the objects (for the most part—asymmetry comes in all shapes and forms) and the group of objects as a whole on my paper. Notice that the objects vary in size, color and direction as well.

EDGE INCLUSION

While most of my small illustrations include an ample white border of paper, I still love to create art that encompasses the whole paper. One of the most common mistakes I have seen when I am teaching my students is the odd need to fit objects within the confines of the paper rather than showing partial objects. We want our viewers to think of our work as a window that they are looking through, that the beauty you have created would go on for miles and miles if they climbed through that window.

Balance: Well-composed art uses either symmetrical or asymmetrical balance. Symmetry is an equally weighted balance of elements, like a mirror image is placed next to the original image. Asymmetry uses different shapes, sizes and colors that vary from side to side but still feel balanced.

In this example, had I smooshed the whole cloud into the borders, it would change the feel and composition of the piece completely. Using the window idea, my viewers can imagine a big sky and a million clouds. *So* much better, right? Also, notice the asymmetrical balance in the shape of the rainbow and clouds from side to side.

STUDY | *doug the bear*

The Rule of Odds (page 38) is hard at work in this illustration.
1 bear | **3 trees** | **7 blossoms** | **9 painted leaves**
I didn't intentionally create the correct number of leaves, but it does show that you'll automatically start to balance your composition once become aware of the details.

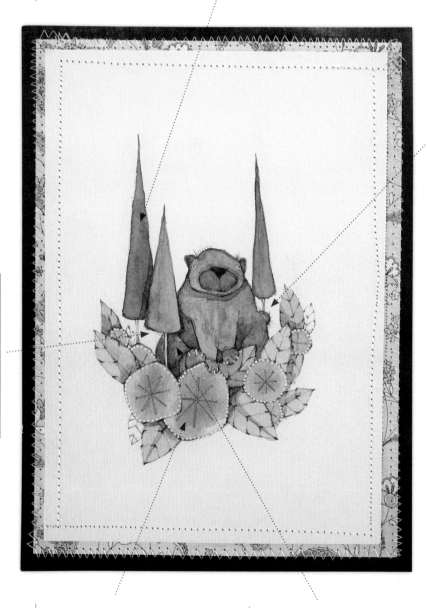

You can't always see it, but blue and violet are mixed into lots of the other colors in the illustration. It's a great way to tie different parts of the composition together.

Notice the trapped white space? I try to keep these areas to a minimum. Pay attention to them in the drawing phase so you can erase and redraw something if you need to.

Choosing warm colors for the flowers and leaves bring them forward. To me it feels like I am walking through a sunlit field of flowers toward a shady magical forest.

Tucking the bear in between the trees creates depth (and look at him holding onto that flower!).

STUDY | *composition dos and don'ts*

DO **DON'T**

COLOR

Color plays a giant role in composition in two ways. Warm colors move an object towards you. Cool colors push the object away. But take it a step further—start looking at your palette in a new way. There are warm purples and cool yellows, right? My point is that it is not as simple as one half of the color wheel being warm and the other cool. Notice that all the trees in both examples (A) are a warm version of yellow, red and purple. Now compare the two. Placing the yellow tree in front makes the grouping advance. Placing the purple in front of the grouping is visually confusing and looks flat.

A

BALANCE

When repeating objects, it's a good idea to vary the size and shape to create more asymmetry and energy. In the example on the right (A), notice the trunks are very close in size, are evenly spaced and start high and end low, like stair steps. On the left (A), the trunks vary a bit more in size and are varied in height. Little stuff like this makes a big difference.

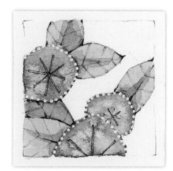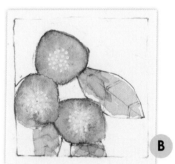

B

EDGE INCLUSION, SCALE AND LAYERING

Did you notice the full leaf and all three full blossoms shown on the right (B)? This composition leaves you with a bored viewer. Notice how much more power the piece has when the size of the blossoms are varied. Also, check out how much layering your objects makes a difference in the dynamics of the piece.

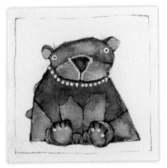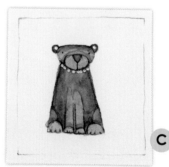

C

WHITE SPACE AND RULE OF ODDS

I know, I know, I have already explained this, but it's worth repeating. Compare the two blossom examples (B) in terms of white space. Do you see the trapped white space on the right? Totally distracting! Notice how shifting the blossom and opening the same space on the left makes a huge difference. Both examples have three blossoms but different numbers of leaves. It's a subtle change that makes a big difference in the energy of the piece. Odd numbers are powerful!

SYMMETRY VS. ASYMMETRY

At first glance (C), most viewers of my work would assume that because I center my illustrations in a bunch of white space, my work is very symmetrical, but that couldn't be further from the truth. My illustrative style is all about making stuff a little bit wonky. If you folded the illustration in half (C), you would see it's slightly asymmetrical. It's not that the bear on the right is ugly, it's just that he's forgettable. The wonkiness is what makes viewers smile!

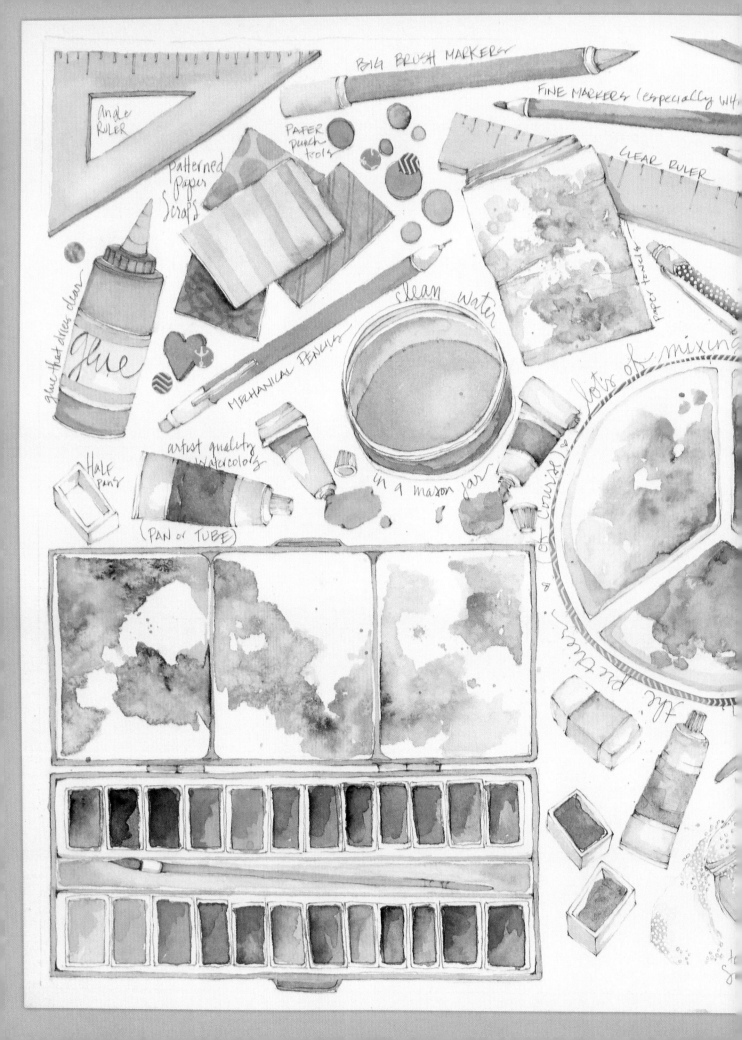

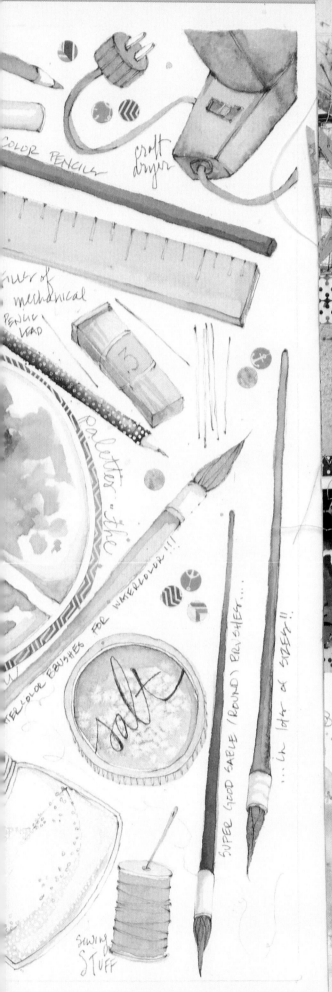

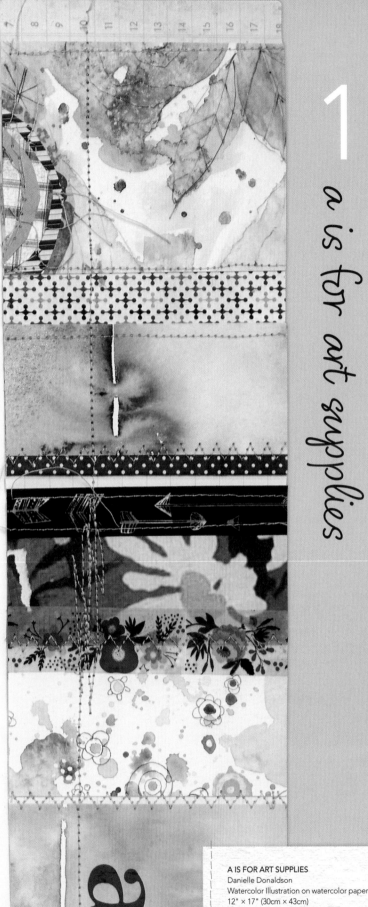

A IS FOR ART SUPPLIES
Danielle Donaldson
Watercolor Illustration on watercolor paper
12" × 17" (30cm × 43cm)

A IS FOR ART SUPPLIES

We are surrounded by so much everyday inspiration. It's on our desks, on the shelves of our cupboards, outside our front doors and in our online world. Let's gather up some goodness, grab our supplies and imagine new ways to arrange everyday stuff and translate it into beautiful art.

In this chapter, you'll learn to downsize your drawings and nest them together to create well-balanced compositions full of color.

STUDY | *a kaleidoscope of butterflies*

Which butterfly do you see first? You get to decide what your viewers see first by the choices you make. Those choices include scale, color, detail and placement.

Each butterfly was drawn to leave a fairly even amount of space between them. This keeps the viewer's eye on the butterflies rather than following the white space like a maze.

White ink is a great way to hide ugly colors. Just don't overdo it!

Did you notice I broke the rule of odds? Eight butterflies and two in each direction. Sometimes rules can be broken! The trick is knowing the rule to begin with so you can make an informed choice.

The bodies of the butterflies were all painted with "mud"—a mixture of all the colors used to paint the wings. No need to go straight to black on your palette.

STUDY | *gather reference materials*

Drawing an object is much more difficult if you rely on memory or imagination—especially if it's something new. Once I have decided on a new subject for my art, I do a little (or a lot) of research. This might include buying a new book, taking photos, creating an online inspiration board or looking up new artists. But don't get bogged down in this step of the process. Limit your time online for sure. And start practicing!

PREPARE | *supplies*

This list includes everything you need for all the exercises in this chapter.

5" × 7" (13cm × 18cm) Sketch or Bristol Paper

Craft Dryer (optional)

Creative Essentials (page 10)

Patterned Paper

White Marker

PRACTICE | *easy objects*

If you don't want to illustrate butterflies in the first project, pick a simple object that is easy for you to draw and paint. This will help you focus on the nesting and overall composition rather than the objects in the illustration. Prior to painting, grab the item or print out a picture of the item to use as reference. Then, grab a pencil and paper.

Practice drawing the objects on a small scale. If it's hard for you to draw small, cut up the sketch/bristol paper into small pieces. This will force you to draw small.

STILL STUMPED?

Try one of these:

- paintbrushes
- crayons
- leaves
- balloons with strings
- arrows
- daisies
- donuts
- tea bags

IMAGINE | *a kaleidoscope of butterflies*

Groups of nested objects are so much fun to draw and paint and are a great way to practice so many of the skills and techniques we've covered in the book so far. In this project, you'll use Repetitive and Nesting Practice (refer to page 18) to create a beautiful set of butterflies filled with color and imagination.

1 Mark Your Boundaries and Choose Your Inspiration
Using your ruler, make a small mark on each side, top and bottom of your 5" × 7" (13cm × 18cm) paper to create the boundary of the space where you'll draw your objects. This will protect your perimeters of white space while you work. Next, choose a piece of patterned paper and trim it to ¼" to ½" (6mm to 13mm) larger than your watercolor paper. Be sure to keep it close by as a reference throughout the project.

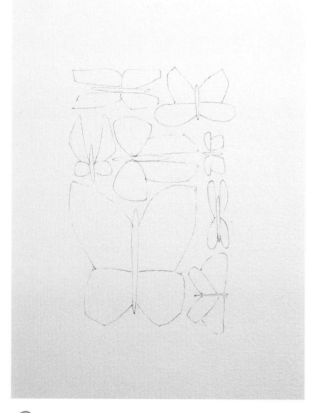

2 Choose Your Item and Draw
In this project, I have chosen butterflies because they are a fun and simple object to draw and paint. Draw your focus butterfly then draw more butterflies until your designated space is full. Be sure to vary the shapes, sizes and direction of the butterflies. When you are drawing mirror image objects, it may help to turn your paper upside down to draw the second wing. Use single lines and a light touch in case you need to erase and try again.

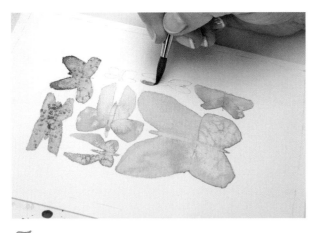

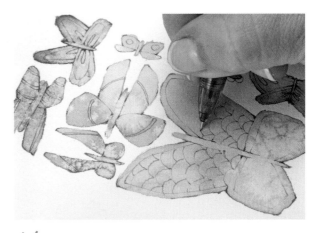

3 Add the First Washes of Paint

Start by painting each butterfly with a controlled wash. The wash should include the body and both wings. Try not to leave any white space between your wash and your pencil lines to avoid trapped white space.

Once you have painted two to three of the butterflies, gently drop the tiniest amount of the other colors you have mixed into different butterflies. For example, if your first butterflies are pink, green and blue, drop a smidge of blue and green into the pink butterfly. This is a way to tie the butterflies together—just like making mud! Continue to alternate between painting the first wash on a butterfly and adding bits of color to the butterflies that are still wet, until all the butterflies are painted. Feel free to sprinkle salt on the paint before the butterflies dry completely.

4 Add Details and Visual Tension

Let the watercolor dry or use a craft dryer (not a heat gun) to dry it. Then go over the piece with an eraser to get rid of the pencil guidelines. The paint can spread and go places you didn't plan for, so erasing lets you start over and clean up those lines based on the paint edges.

Add visual tension by going back in with the pencil and outlining the shapes, adding varied line weight as you go. Then add patterns and details to the shapes. Resist the urge to make tiny or realistic patterns. Tap into your imagination and play with scale. Try big polka dots or pretty scallops.

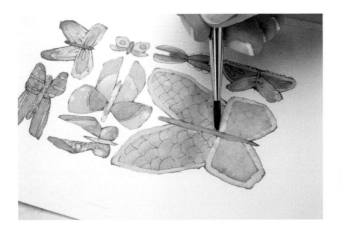

5 Add the Final Layers of Color

Using the paint that is already in your palette, glaze layers and add graded washes to small sections of the butterflies to add detail. I suggest sticking to similar colors for subsequent layers until you are more familiar with your palette. Sometimes the pattern added with pencil in Step 4 is enough. Not everything has to be painted!

HINT | mindfulness at the speed of light

To me, watercolor creates a level of mindfulness—an alternative to traditional meditation. When laying down washes, I have a small window of opportunity to add color, splashes and water, to lift color and add salt. I am constantly scanning my work to be sure I don't miss any opportunities to make it shine. This requires my full focus, and I can't think about anything else—not my to-do list, the e-mails I need to answer, or even the chocolate cake in the fridge. I am fully present. The world inside my noggin is a crazy, mixed-up, fast-paced place. And it makes me tired. So tired.

And then I literally sit and watch paint dry. After gently brushing away the salt—I let go of the control I think I have over anything and everything. I take a breath and smile. Watercolor magic. Almost every time, it becomes even more beautiful than when it was wet. And so, I realize that wonderful things *can* happen if I just learn to let go and witness life the very moment it happens.

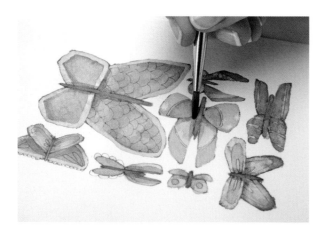

6 Add Shadows

Mix the remaining paint on your palette to create your shadow color. If it isn't dark enough for the bodies of the butterflies, add a bit of Van Dyke Brown or Payne's Gray to the mixture. Paint the bodies of the butterflies with several layers until you are happy with them. Once your art has completely dried, add shadows to the wings where the bodies connect.

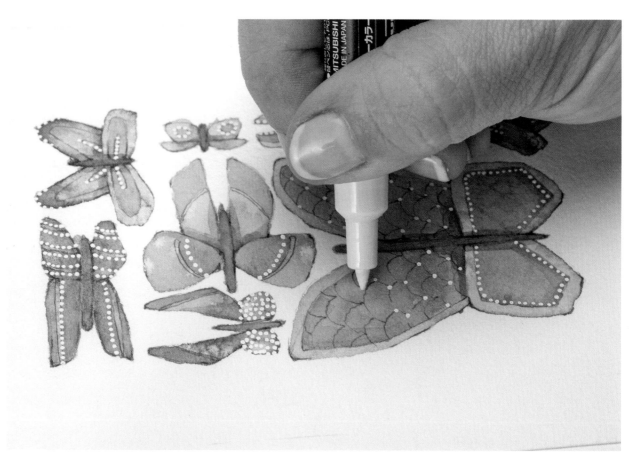

7 Add the Final Details

Use a white marker to add dots and final details to the butterflies. My favorite marker for this is the Uni Posca 1mm white paint marker.

IMAGINE | *mason jars*

If you love mason jars as much as I do, you'll love this project. Painting glass with watercolor can be tricky, so be sure to keep a jar in front of you for reference. Keep in mind you already have the highlights done—just preserve the white paper while painting.

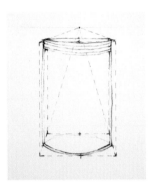

1 Practice Drawing Jars

Measure out a rectangle and draw a dotted line. This is your guideline shape for the front of the glass jar. Complete the box using one-point perspective (as shown in *C is for Chairs and Couches* on page 52). Notice how narrow the rectangle is? It must be this narrow for the ellipses to curve at the correct angle.

2 Draw the Jar

Mark the halfway points on all four sides on the top and bottom rectangles. Use these points to create your curves. Use your guidelines to create the sides of your cylindrical jar shape. At the top of the jar, add threads indicating where the lid would be screwed on. Last, draw a thin line around the sides and bottom to indicate the thickness of the glass. If the back of the jar on the bottom has a dark line, erase most of it to lighten it.

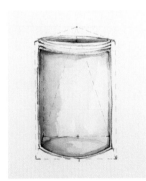

3 Add Layers of Color and Fine Details

Add layers of color to the jar to give it dimension and the glass-like appearance. This example uses a combination of controlled, wet, graded and transition washes along with hard-and-soft edge glazing. Follow the example and try to replicate it. Copying is the best way to learn

Once dry, add visual tension in pencil and highlights with a white marker pen.

Using the instructions from the *Kaleidoscope of Butterflies* project and your mason jar practice, try creating a nested illustration of mason jars.

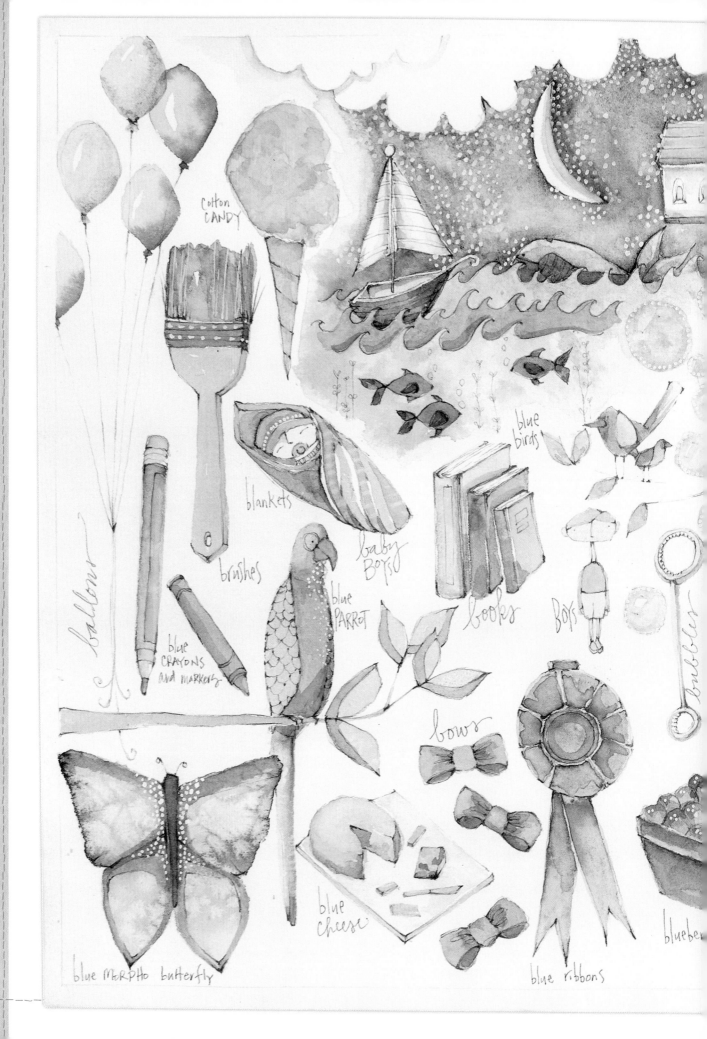

cotton CANDY

blankets

baby BOYS

blue birds

books

BoYS

bubbles

balloons

brushes

blue CRAYONS and MARKERS

blue PARROT

bows

blue cheese

blue MORPHO butterfly

blue ribbons

blueber

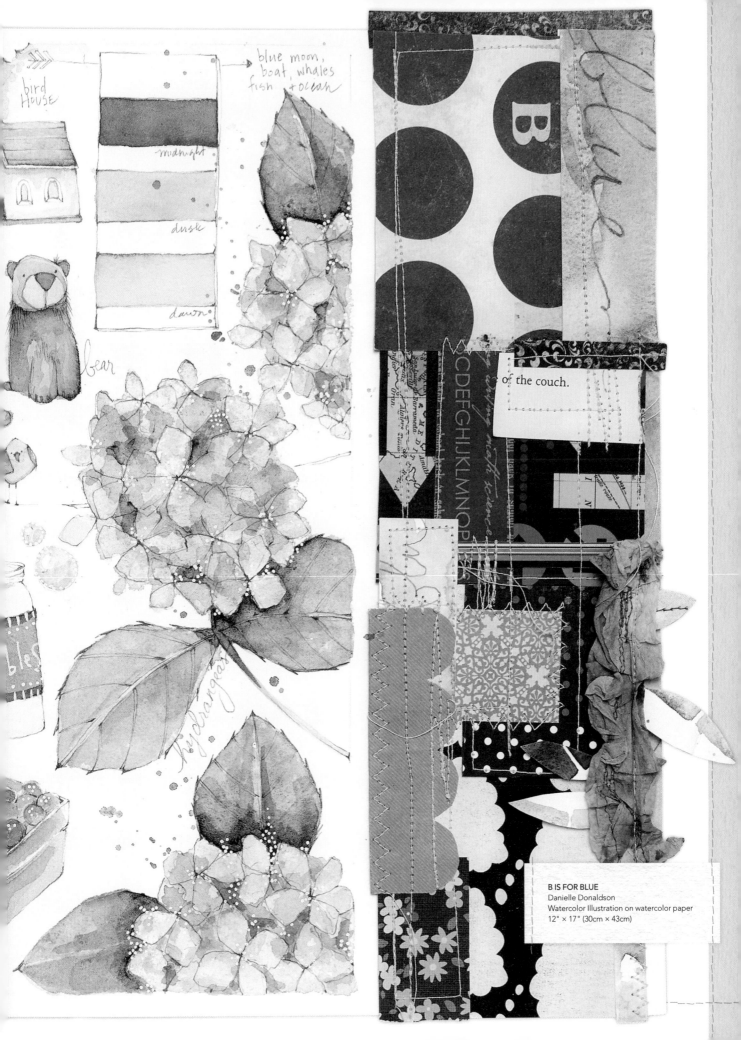

bird HOUSE

blue moon, boat, whales fish, + ocean

midnight

dusk

dawn

bear

hydrangea

bless

of the couch.

CDEFGHIJKLMNOP

B IS FOR BLUE
Danielle Donaldson
Watercolor Illustration on watercolor paper
12" × 17" (30cm × 43cm)

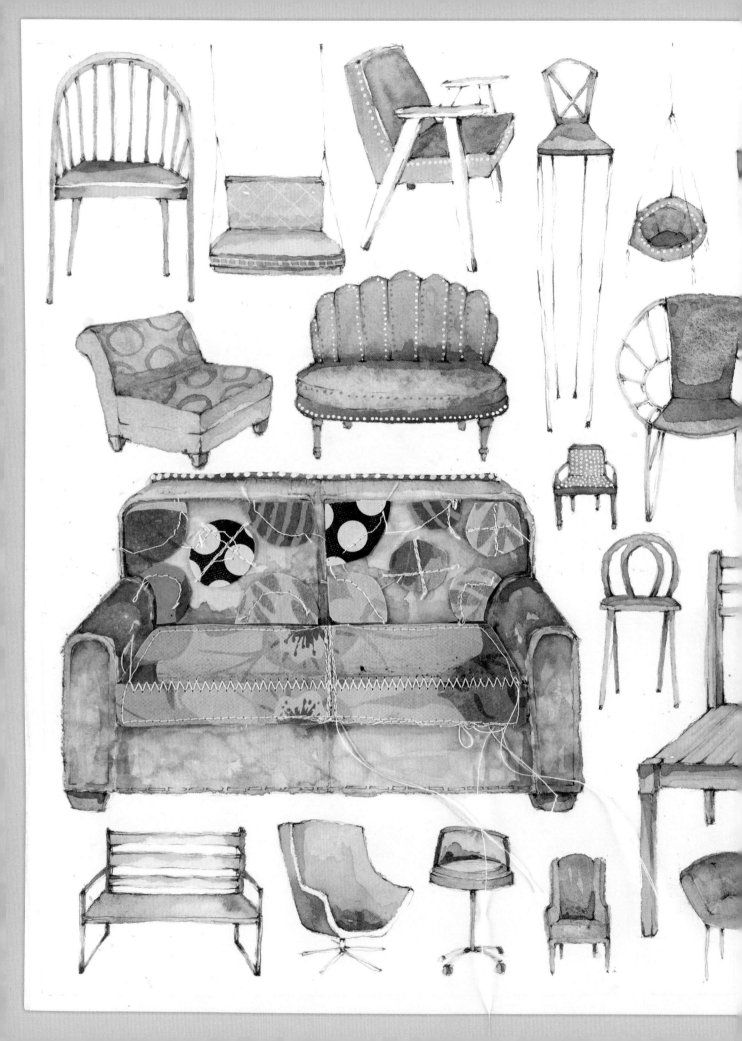

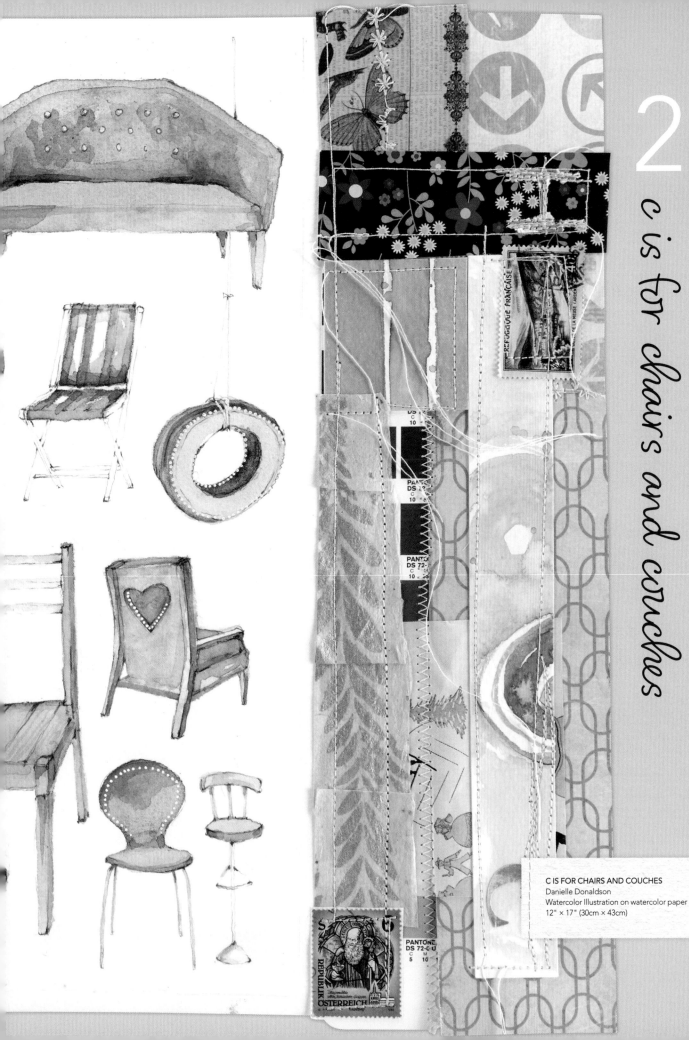

2

c is for chairs and couches

C IS FOR CHAIRS AND COUCHES
Danielle Donaldson
Watercolor Illustration on watercolor paper
12" × 17" (30cm × 43cm)

C IS FOR CHAIRS AND COUCHES

The best class I ever took was my perspective drawing class. Held at a local junior college, we met twice a week, three hours each, for five months. I wish I could remember my delightful instructor's name so I could thank him properly for single-handedly shifting my art in such a profound way. It was the hardest art class I ever took, and I despised most of it—almost every minute of it. It involved logic and math and superstraight lines and a plethora of patience.

In this chapter, you'll discover that everything you see can be broken down into boxes—everything. Some of those boxes may turn into spheres or cones, but a box is where it starts. This chapter will give you a little taste of perspective drawing. It's a concept that requires a ton of patience and fortitude to understand. But if you want to grow as an artist, it is a *must*!

STUDY | freehand polka-dot chair

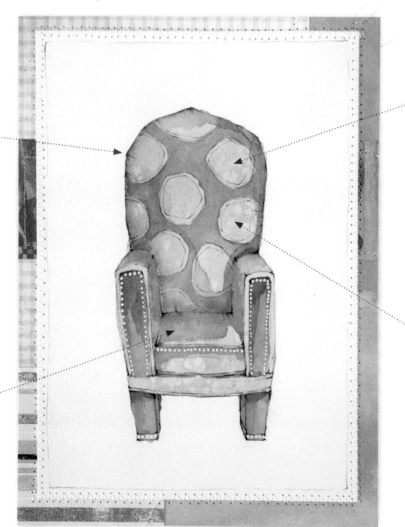

One of my favorite ways to infuse my style is to add soft angles to my round shapes.

Just because you are drawing something on a small scale doesn't mean the details need to be tiny too. Put big patterns on small things!

If perspective drawing is new to you, stick to one color and drop little bits of other colors into wet washes as you go. Warm colors toward the front, cool colors to the back.

When you add patterns, always take the time to consider if painting any part of it is going to distract the viewer. Sometimes just the pencil work is enough.

54

STUDY | *one-point perspective defined*

ONE-POINT PERSPECTIVE—A drawing has one-point perspective when it contains only one vanishing point on the horizon line. This type of perspective is typically used for images of roads, railway tracks, hallways or buildings viewed so that the front is directly facing the viewer. These parallel lines converge at the vanishing point.

VANISHING POINT—In graphical perspective, a vanishing point is a point in the picture plane that is the intersection of the projections (or drawings) of a set of parallel lines in space onto the picture plane.

HORIZON LINE—The terms "horizon line" and "eye level" are often used synonymously. Horizon line/eye level refers to a physical/visual boundary where sky separates from land or water. It is the actual height of the viewer's eyes when looking at an object, interior scene or an exterior scene.

VANISHING LINES—Any of the lines converging to a vanishing point in a pictorial perspective is a vanishing line.

PREPARE | *supplies*

This list includes everything you need for all the projects in this chapter.

Craft Dryer (optional)

Creative Essentials (page 10)

Patterned Paper (optional)

Sewing Machine (optional)

Sketch or Bristol Paper

White Marker

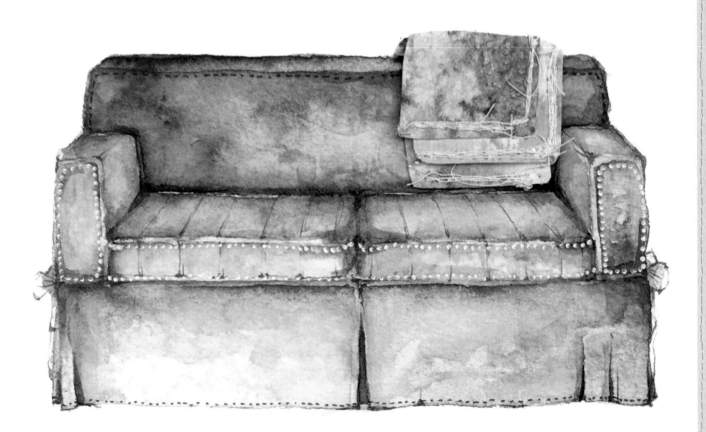

PRACTICE | *draw a one-point perspective box*

It all starts with a dot, a line and a box. I drew this exercise on blank paper. If straight lines are a challenge for you, invest in a pad of grid paper. The grid allows you much more space and guidance to draw several boxes on one page.

1 Draw the Front of the Box
On sketch, bristol or grid paper, draw your horizon line, and mark the center point. Then draw a box below the horizon line. That's the front of your three-dimensional object. Fill it in with a light wash of orange.

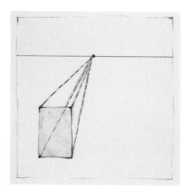

2 Draw Vanishing Lines
Draw dashed vanishing lines from the corners of the box to the point on your horizon line. Trace the dashes with a light line of green watercolor.

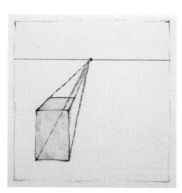

3 Complete the Top of the Box
Draw a solid horizontal line connecting the top two vanishing lines to create the top of the box. Fill that space in with a light wash of yellow.

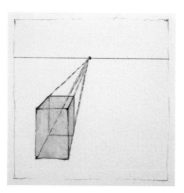

4 Complete the Sides, Back and Bottom of the Box
Using the line drawn in Step 3, draw a vertical solid line from the left endpoint until it intersects with the lower left dashed vanishing line. Repeat on the right endpoint to create the back of the box. Draw a horizontal line using the two vertical lines' intersection points to complete the bottom of the back of the box. Go over the dashed vanishing points with a solid pencil line to connect the front of the box to the back.

Add a light red wash to the left side of the box, a light violet wash to the right side, a gray wash to the back and a glaze of gray over the bottom.

PRACTICE | *draw a one-point perspective chair*

Let's take it up a notch! Take time to review my drawing in each step. Be sure you can see all the boxes as they are taking shape. Trace them with your finger or pencil, label them with numbers—anything to help your eyes focus and see the chair in pieces and as a whole.

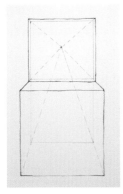

1 Draw the Boxes

Using the steps from the one-point perspective practice, lightly draw the horizon line and vanishing point. Next, draw a rectangular box as shown; this will be the seat and base of the chair. Now draw a thin box on top of the base; this will be the back of the chair.

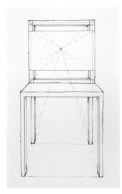

2 Draw the Chair

Draw the parts of the chair in the order mapped out below. While drawing each component, notice how they become a box within a box.

First, draw the front of the seat and legs. Second, draw the front of the chair back. Third, draw the sides of the legs and seat back. Feel free to add additional vanishing lines if you need them. Be sure to double-check all of your lines against the vanishing lines and vanishing point.

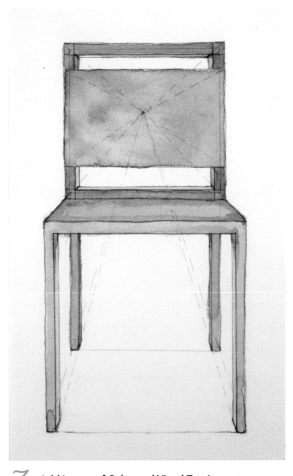

3 Add Layers of Color and Visual Tension

Premix a yellow-green, warm blue and cool green in separate wells of your mixing palette. Begin with a transitional wash over the entire chair (from top to bottom, cool green, warm blue, then cool green). While the paint is wet, mix yellow-green into the top and front of the seat and the front two legs. Keep dropping in bits of paint+water from different wells of your mixing palette to unify the wash. Once dry, add soft-edged glazes of color to further define the parts of the chair. As you add these layers, make color choices based on warm colors advancing and cool colors receding.

Once dry, erase any remaining pencil lines that are no longer needed.

IMAGINE | *freehand polka-dot chair*

Chairs and couches offer a balance of structure and softness—and are a go-to object for me to illustrate. This chair looks a bit wonky but so comfy. Not ready to draw freehand? Feel free to use a ruler and guides.

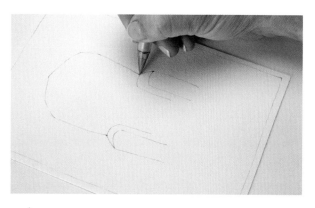

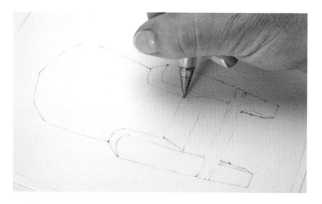

1 Start Drawing the Chair
Mark your white space on all sides to be sure your chair isn't too big. Then draw the back of the chair and the arms as shown.

2 Draw the Rest of the Chair
Add the legs. Notice that the back legs can barely be seen. Next, add the cushion and carefully erase any of the arm lines that overlap into the cushion and are no longer needed. Draw the base underneath the cushion and arms. Last, add depth to the back of the chair and erase your white space marks.

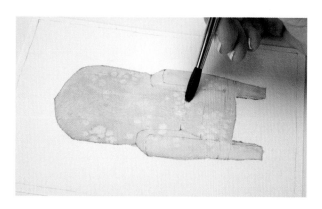

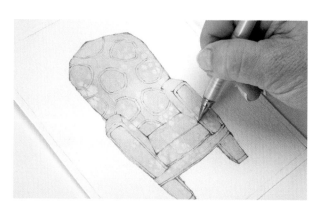

3 Add the First Layer of Color
Premix a warm blue, cool blue and warm olive green in separate wells of your mixing palette. Using a transitional wash, start at the back of the chair with a cooler blue and blend to a warmer blue on the front of the chair. Drop in a warm green on the front of the chair while the wash is still wet. Sprinkle a smidge of salt and let dry.

4 Add Visual Tension
Once dry, gently brush off the salt. Add visual tension, large polka dots and detail work with your pencil as shown.

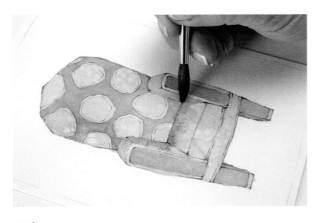

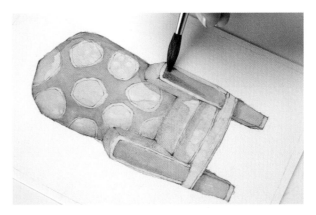

5 **Add More Color**
Add a second glaze using a warm blue (mine is a cool blue with Burnt Sienna mixed in, to warm it up) on the front of the arms and front of the seat cushion, front legs and the base of the chair. Next, paint a cooler blue (more cool blue, less Burnt Sienna) on the top of the arms and the seat cushion. Last, paint a cool blue on the back of the chair around the polka dots.

Add a soft-edged glaze with the cool blue to the back section of the arms, back of the seat and the back legs. Continue glazing additional layers with soft and hard edges to define the chair even more. Remember to let washes dry completely before adding layers. Notice that I left small areas of the first wash showing through for visual interest and depth.

6 **Add Shadows**
In my example, I felt like the back of the chair was moving forward. To fix this, I added a layer of warm accent colors mixed with a bit of the original blue (Quinacridone Burnt Scarlet, Quinacridone Burnt Orange and a touch of Olive Green). Mix the remaining paint together on your palette to create a shadow color. While the layer is wet, drop the shadow color on some edges to get depth. If you want to give it even more depth, drop in a bit of Van Dyke Brown on the edges of your still-wet shadow glaze, as shown, to increase the depth.

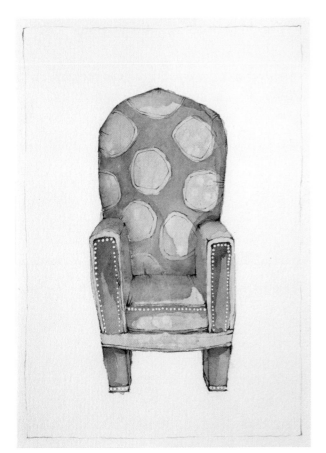

7 **Add Final Details**
Once the paint is completely dry, use a fine-tip white ink marker to add final highlights, pattern and texture. If you like, sew coordinating pieces of patterned paper together, then trim the edges so it's slightly larger than your finished piece. Finish by sewing the finished art onto sewn and trimmed paper.

D IS FOR DANIELLE
Danielle Donaldson
Watercolor Illustration on watercolor paper
12" × 17" (30cm × 43cm)

eggplant

EBONY

angsty

ECRU

emu

ewe

NEST of eggs

eucalyptus tree

egg carton

MILK

S P

scrambled eggs

eraser

ELF with ear MUFFS

embroidery

silver dollar

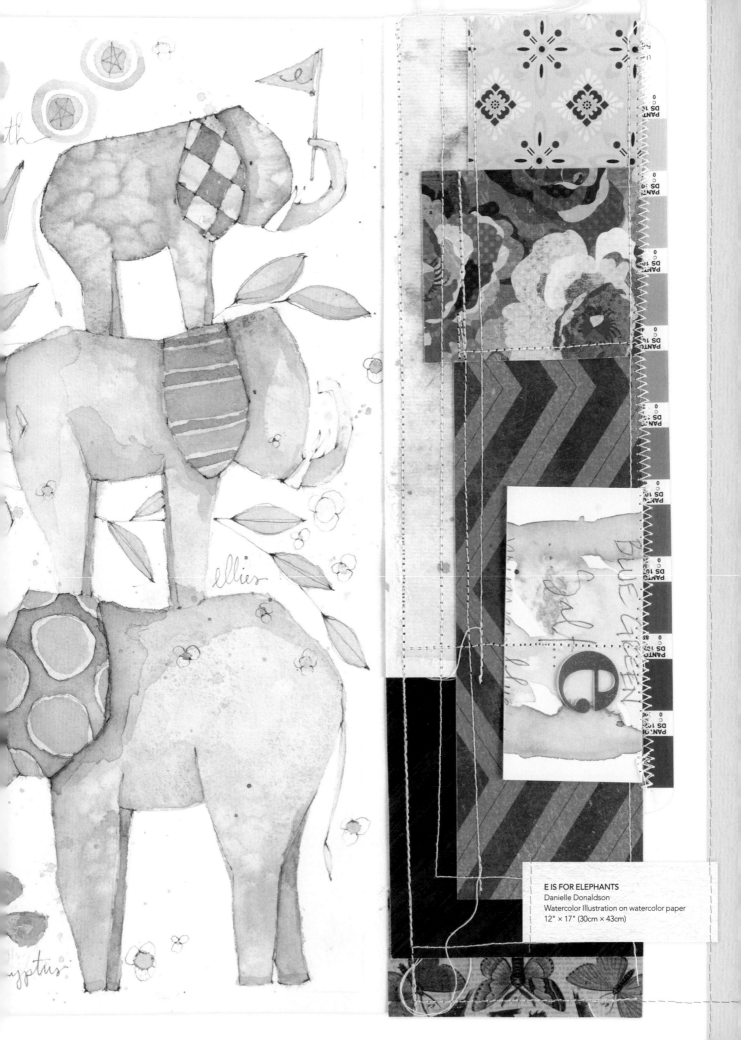

E IS FOR ELEPHANTS
Danielle Donaldson
Watercolor Illustration on watercolor paper
12" × 17" (30cm × 43cm)

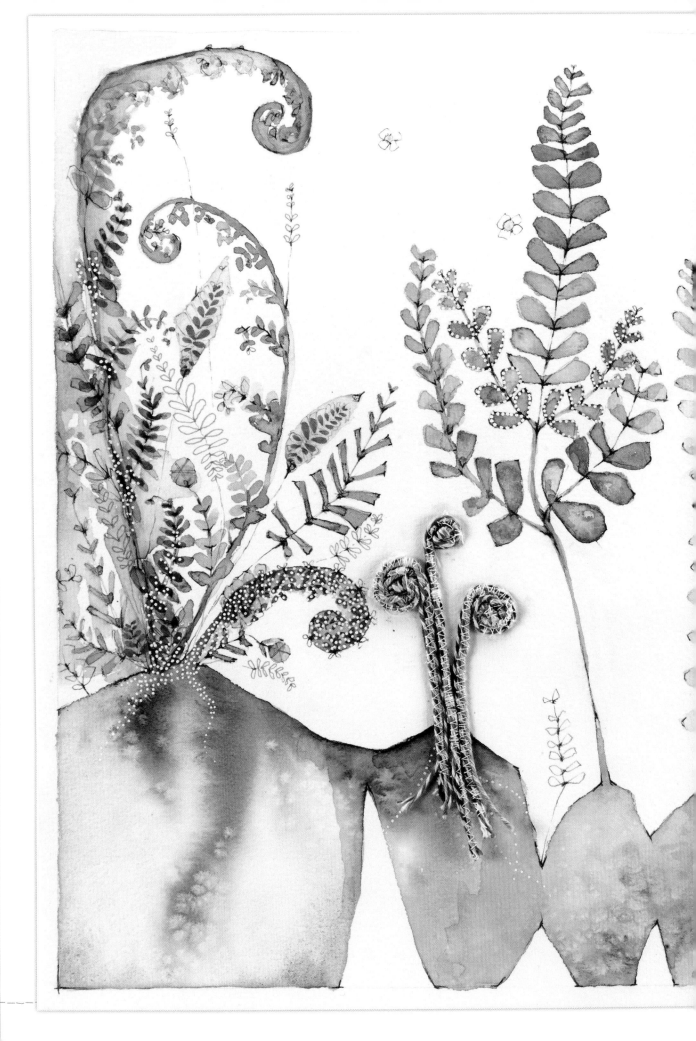

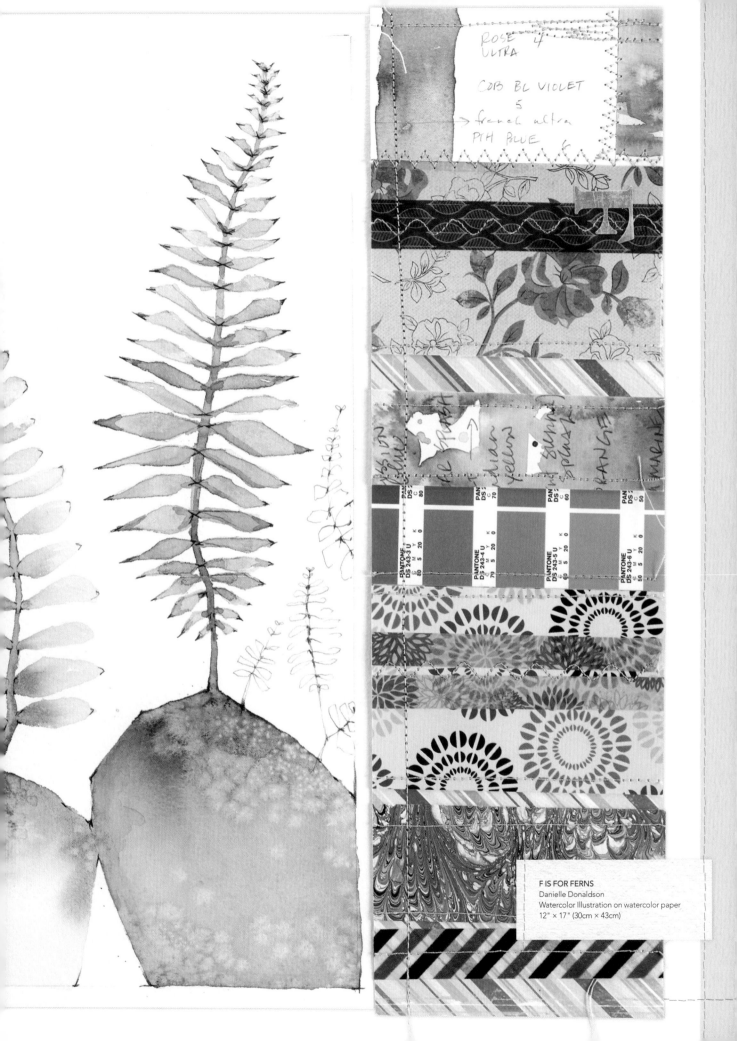

F IS FOR FERNS
Danielle Donaldson
Watercolor Illustration on watercolor paper
12" × 17" (30cm × 43cm)

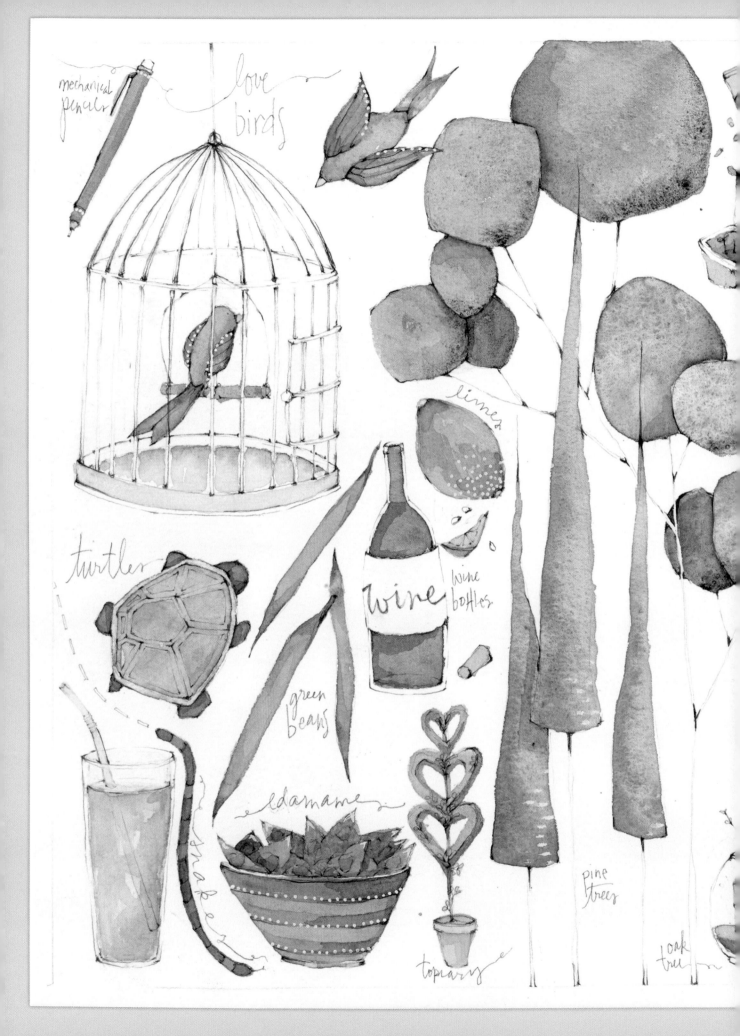

mechanical pencils

love birds

limes

turtles

wine

wine bottles

green beans

edamame

snake

topiary

pine trees

oak tree

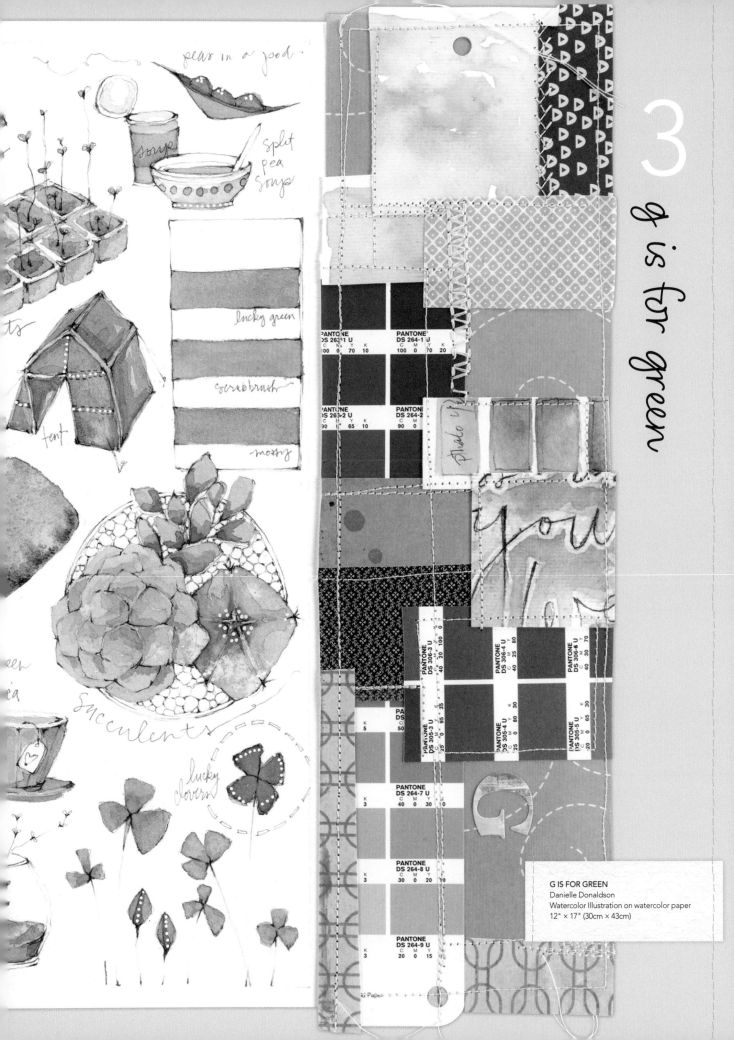

g is for green

pear in a pod

soup

split pea soup

lucky green

scrub brush

mossy

tent

succulents

lucky clovers

you

G IS FOR GREEN
Danielle Donaldson
Watercolor Illustration on watercolor paper
12" × 17" (30cm × 43cm)

G IS FOR GREEN

Green is my favorite color. It carries such life-affirming and energy-inducing emotions. And there are so many variations to choose from. The color practice pages in this book allow you to really get to know each color and how they play with other colors on your palette. What's your favorite color? How does it make you feel? What out-of-the-ordinary things could you draw and practice using only one color?

In this chapter, you'll learn to work with one color and all of its subtle variations, along with all sorts of washes, glazing and color lifting.

STUDY | *gus the green fox*

Don't get stuck in a detail rut. Use combinations of details like color lifting, pencil and penwork. Just remember to do a little at a time, then review the piece to see if you really do need more.

If you are limited to a couple of greens on your palette, take some time to do some of the practice exercises in Chapter 2. They'll help you to understand how you can successfully mix colors to create additional greens.

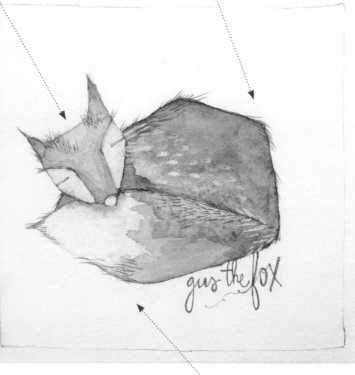

If you haven't noticed by now, I never cut off the extra thread left over after I sew a project. Why? Because life is full of loose ends. It's another hidden story and signature of mine.

Want to paint a fox in a sitting position? Simply turn your mixed-media strip to the bottom or top and refer to the fox on page 128 in "W is for Winter."

IMAGINE | *gus the green fox*

Isn't he sweet? And, oh, so sleepy! Animals are so fun to illustrate, especially on a small scale. Using an unexpected color palette is a wonderful way to infuse emotion and imagination.

PREPARE | *supplies*

This list includes everything you need for all the projects in this chapter.

Craft Dryer (optional)

Creative Essentials (page 10)

Micro-Tip Cotton Swabs

Patterned Paper, Ephemera, Ribbon

Sewing Machine (optional)

Watercolor Paper

White Marker

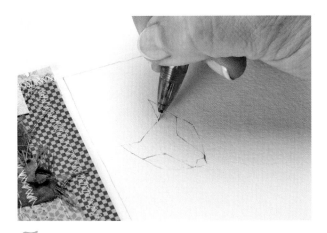

1 Assemble an Inspiration Block and Prepare Your Palette
Choose scraps of patterned paper, ribbon and ephemera in which the dominant colors include a variety of greens. Next, premix several greens in the wells of your palette based on your inspiration.

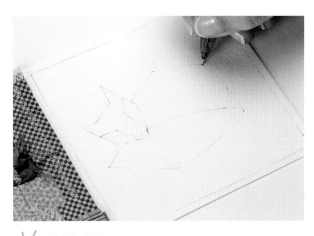

2 Attach an Inspiration Block
Assemble and sew a 2" × 5" (5cm × 13cm) inspiration block and attach it to a 5" × 7" (13cm × 18cm) piece of watercolor paper as shown.

3 Draw the Head of the Fox
Using dot-to-dot drawing, draw the head at an angle as shown. Notice that each side of the head is not a mirror of the other. It's important to vary objects from side to side to create more visual interest.

4 Add the Body
Notice the overall shape and proportion of the body to the head, as well as the combination of soft curves and angular lines. Again, remember to draw dot-to-dot.

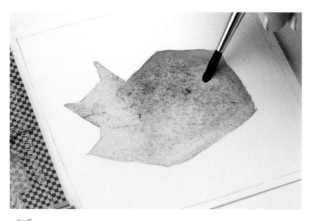

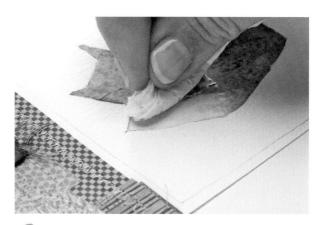

5 Add Color

Add a controlled and transitional wash to the entire fox using various warm and cool greens. While it is still wet, blend the colors and drop in tiny specks of various greens from your mixing palette.

6 Lift Color

While wet, lift the paint from the end of the tail and the cheeks with a paper towel or a clean paintbrush. If you haven't waited too long, you'll be able to pick up most of the color, leaving a batik effect.

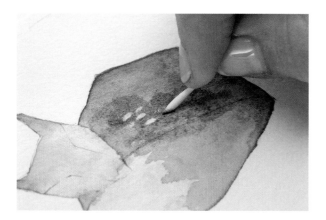

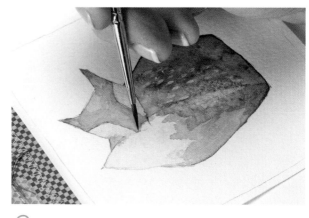

7 Glaze More Layers and Lift Color

Paint a layer of both soft- and hard-edged glazes to define the different parts of the fox (not the fine details, just general shapes). Use cooler greens toward the back of the fox and brighter yellow-greens for the face and tail to make them advance. Remember to allow each glazed layer to dry prior to starting a new glaze.

Your piece should still be wet enough to use a micro-tip cotton swab to lift color in various spots, mimicking light fur. If you still have wet areas, sprinkle a little salt on them.

8 Glaze the Details and Shadow Layers

Once the painting is dry, gently remove the salt. Using a smaller brush, glaze the head and tail to add depth. This can be accomplished using an additional layer of the same greens or a mix of all the leftover paint on your palette.

9 Add Visual Tension and Fur

Once the paint is dry, go back in with your pencil to add visual tension, fur lines and sleeping eyes. Last, add a little more detail with your fine-tip white paint marker. And for goodness' sakes, don't forget to give the fox a name and hand letter it on your finished piece!

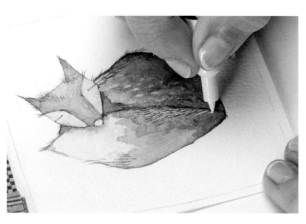

Ready to try something a bit harder? This project offers a different way to paint. You'll break the pear into pieces rather than painting the object as a whole. In preparation for the pear project, repeat Steps 1 and 2 from the *Gus the Green Fox* project.

STUDY | *a perfect pear*

A combination of lightly penciled circles with a bit of white ink creates a raised effect and adds just a smidge of depth.

If you slightly altered the shape and painted with a different color, what fruit or vegetable would you have? Oranges, tomatoes, eggplants, apples?

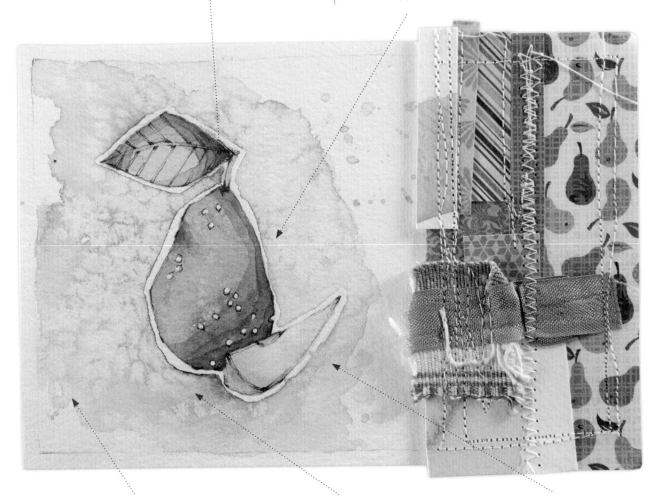

Notice how I included three of four sides in my background wash, leaving the three white areas. It's the attention to detail that makes a small but simple composition work.

(Pssst! Can you see that the pear has the shape of our cylinder work from the one-point perspective practice in Chapter 2?)

Can you see the one-point perspective in the slice of pear? If you can't, try drawing my slice on scratch paper and add the box, horizon line and vanishing point. Sometimes reversing the process helps you see the perspective better.

IMAGINE | *a perfect pear*

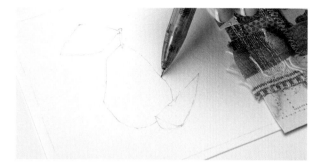

1 Draw the Pear Outline
Using a light touch, draw a pear with a stem, a leaf and a small slice of pear as shown.

2 Paint the Leaf (Controlled Wash)
Paint the leaf using a controlled wash of diluted light green that you can build up later. Let the layer dry completely.

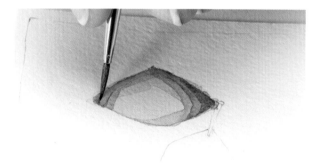

3 Glaze the Leaf (Hard-Edged Glaze)
Glaze a second hard-edged layer of green in the areas shown, starting with the widest layer. Repeat this layering process for the next three layers so each is smaller than the glaze prior to it, creating a stacked effect.

4 Paint the Pear (Controlled Wash)
With plenty of green paint+water loaded from your mixing palette, paint a transparent wash within the line of the pear shape. Drop in additional colors (like Nickel Azo Yellow, Quinacridone Burnt Orange and Rich Green Gold) while it dries. The wetter the wash is, the more the colors will play and meld together. As it dries, the paint that is dropped in keeps its shape. Don't overwork it! Sprinkle a bit of salt and let it dry.

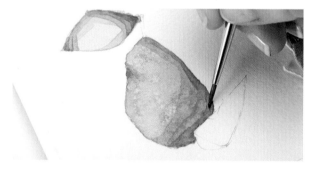

5 Glaze the Pear (Hard-Edged Glaze)
Gently brush off the salt, then glaze three hard-edged layers of green starting with the widest layer as shown. The next two layers should be smaller than the glaze prior to it, creating a stacked effect.

Next, add a transparent wash to the stem. Finish the pear with a soft-edged glaze of a shadow color where the pear meets the stem.

6 Paint the Pear Slice (Transition Wash)
Paint a wash of clear water over the entire slice. Load the brush with a lighter green and drop it into the bottom edges. If it isn't spreading the way you want, tilt the paper to encourage movement.

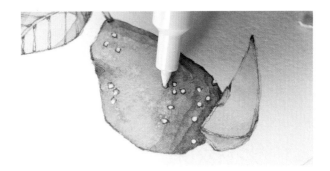

7 **Glaze the Pear Slice (Soft- and Hard-Edged Glazes)**
Once the paint is dry, glaze an additional layer or two to define the skin from the flesh of the fruit. Paint the seed. Try a combination of hard- and soft-edged glazes. Allow the paint to dry completely.

8 **Add Visual Tension and White Ink**
Use a pencil to go back over your lines, adding visual tension. Finish by adding veins to the leaf and a few dots of fine-tip white paint marker.

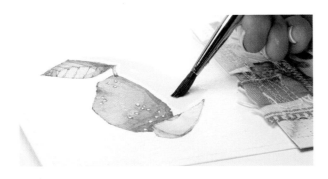

9 **Begin Painting the Background (Sloppy Wet Wash)**
Paint clear water around one side of the pear and up to half of the leaf.

10 **Add Color to the Wash (Sloppy Wet Wash)**
Drop in color close to the edge of the pear. You want a consistent, thin white gap between the background wash and the illustration. Let the watercolor spread on its own, or gently push it to where you want it. Repeat the wash on the other side of the pear. You'll have to move quickly so you can extend this wash around the object and let it blend smoothly before the edges dry. You don't have to fill the entire background.

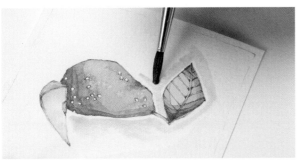

11 **Turn the Illustration and Continue (Sloppy Wet Wash)**
Turn your piece to continue the wash. This will prevent you from placing the side of your hand in a wet wash. Remember to keep the edges wet as you turn the paper to extend the wash. Drop in various greens to add visual energy and spontaneity to the wash as it spreads.

12 **Finish the Background**
While your edges are still wet, extend the background wash to the penciled edges of your illustration. Or, leave some of the white paper exposed as shown in the final piece. If the edges of your wash have dried by the time you reach it, wet the edge of the wash and swirl your brush into the paper gently. This will loosen it up and allow you to drop paint in to create a seamless connection. Sprinkle a bit of salt and let dry.

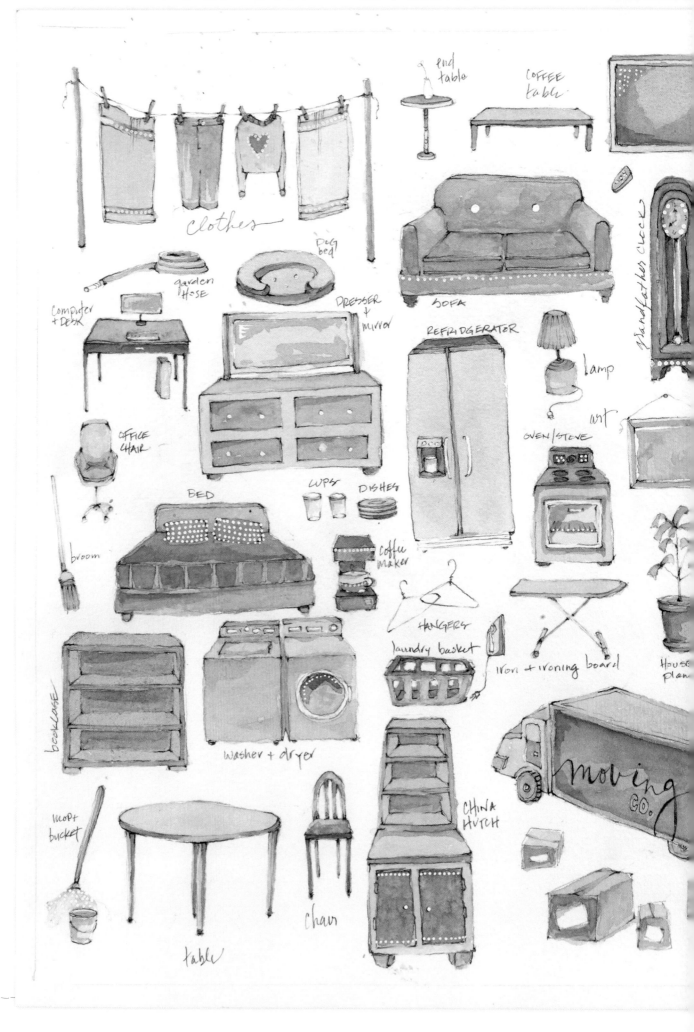

clothes

end table

COFFEE table

garden Hose

Dog bed

SOFA

grandfather clock

Computer + DESK

DRESSER + mirror

REFRIDGERATER

lamp

art

OFFICE CHAIR

OVEN/STOVE

broom

BED

CUPS

DISHES

coffee maker

HANGERS

laundry basket

iron + ironing board

HOUSE plant

bookcase

washer + dryer

CHINA HUTCH

moving CO.

mop + bucket

chair

table

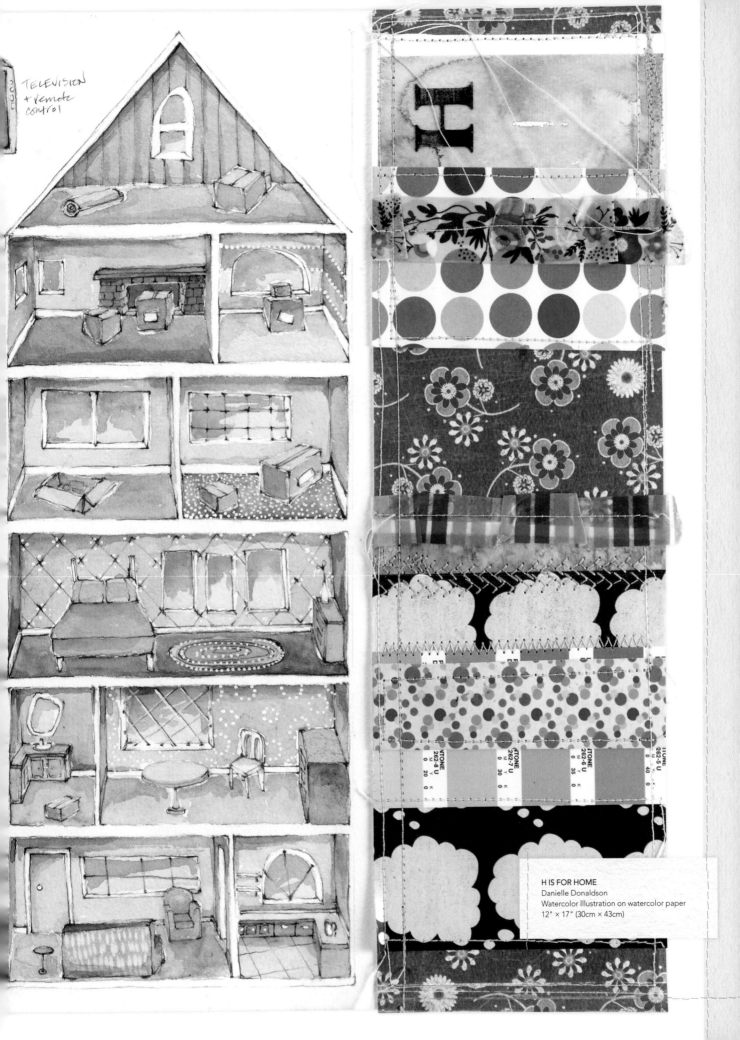

TELEVISION + remote control

H IS FOR HOME
Danielle Donaldson
Watercolor Illustration on watercolor paper
12" × 17" (30cm × 43cm)

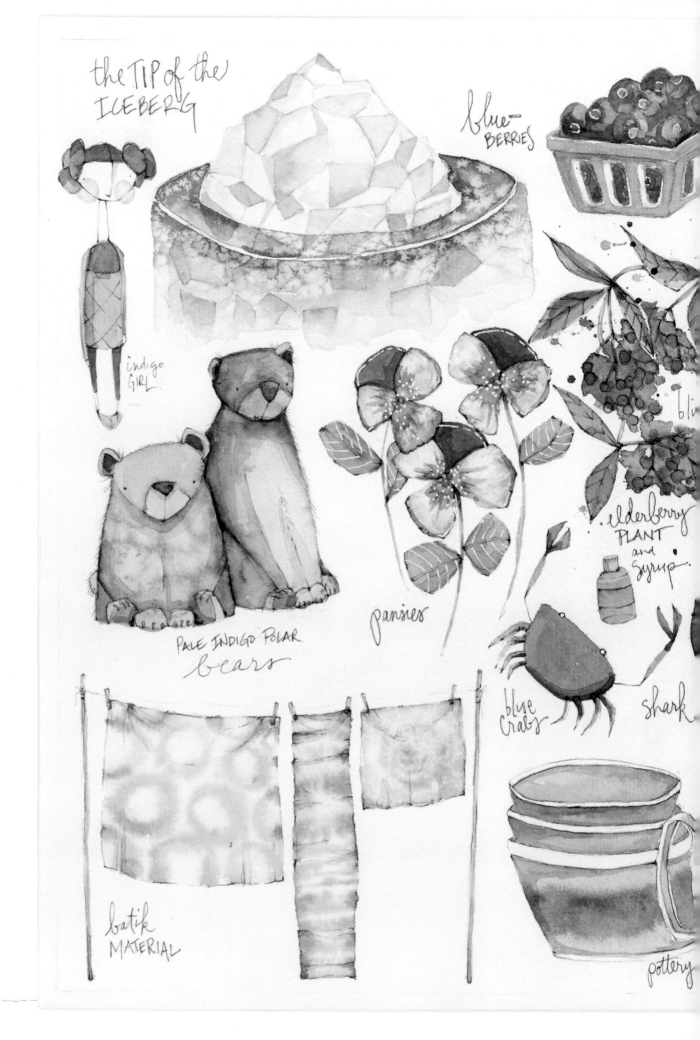

the TIP of the ICEBERG

blue-BERRIES

indigo GIRL

PALE INDIGO POLAR bears

pansies

elderberry PLANT and Syrup

blue Crabs

shark

batik MATERIAL

pottery

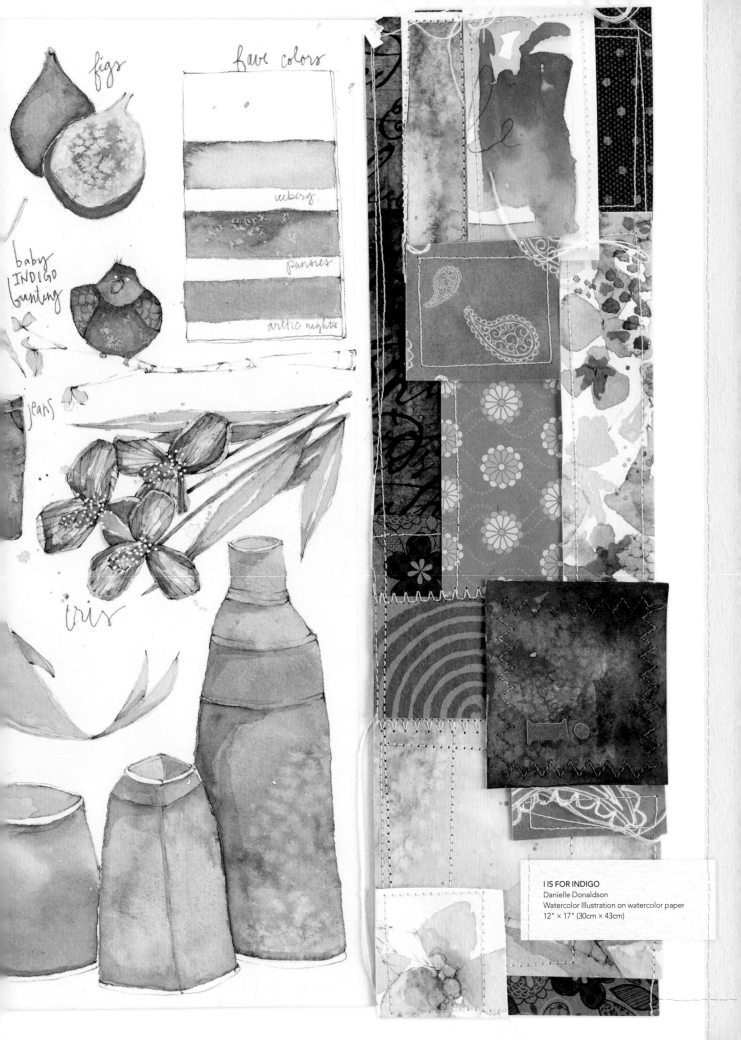

figs

fave colors

iceberg

pansies

arctic nights

baby
INDIGO
bunting

jeans

iris

I IS FOR INDIGO
Danielle Donaldson
Watercolor Illustration on watercolor paper
12" × 17" (30cm × 43cm)

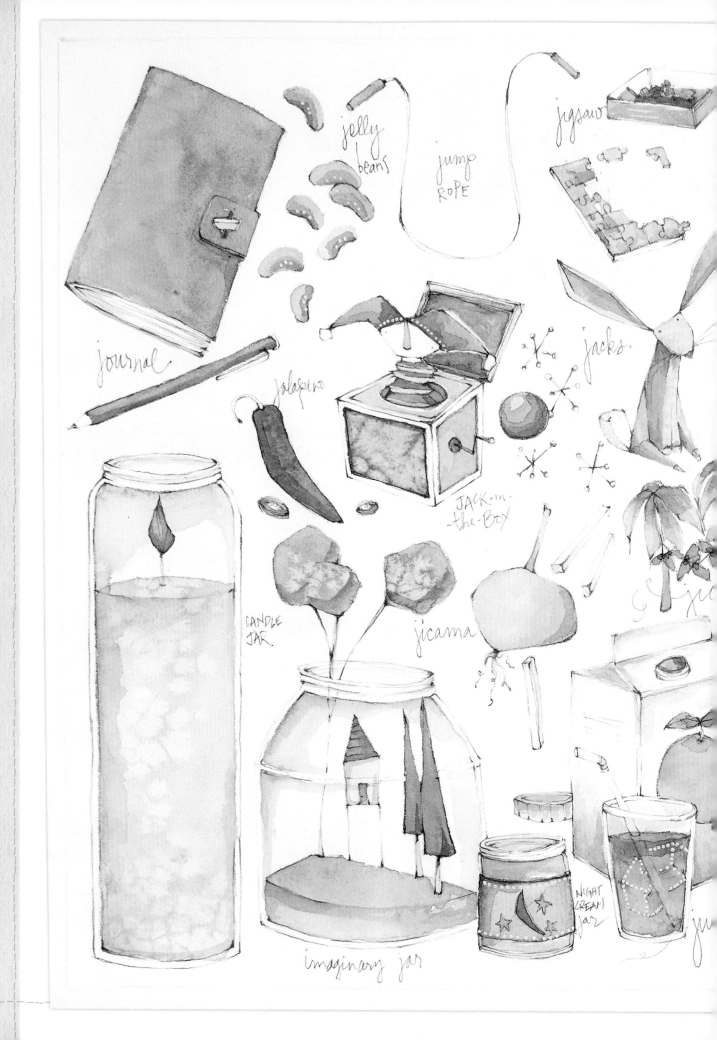

jelly beans

jump ROPE

jigsaw

jacks

journal

jalapeño

JACK-in--the-Box

CANDLE JAR

jicama

NIGHT CREAM JAR

imaginary jar

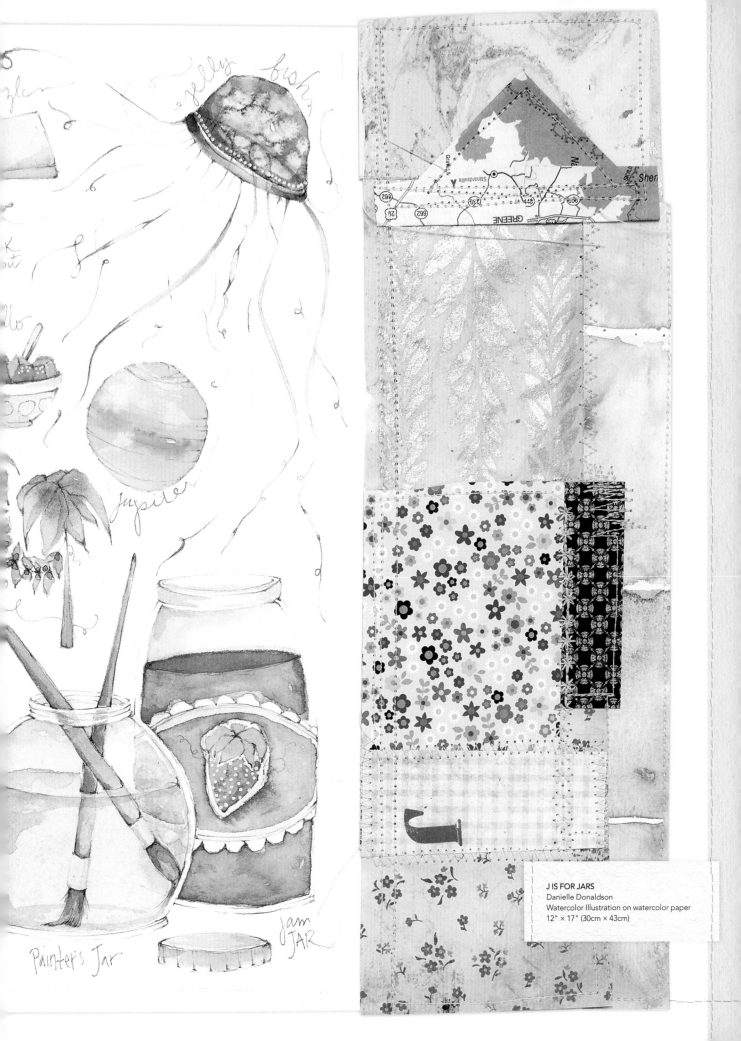

J IS FOR JARS
Danielle Donaldson
Watercolor Illustration on watercolor paper
12" × 17" (30cm × 43cm)

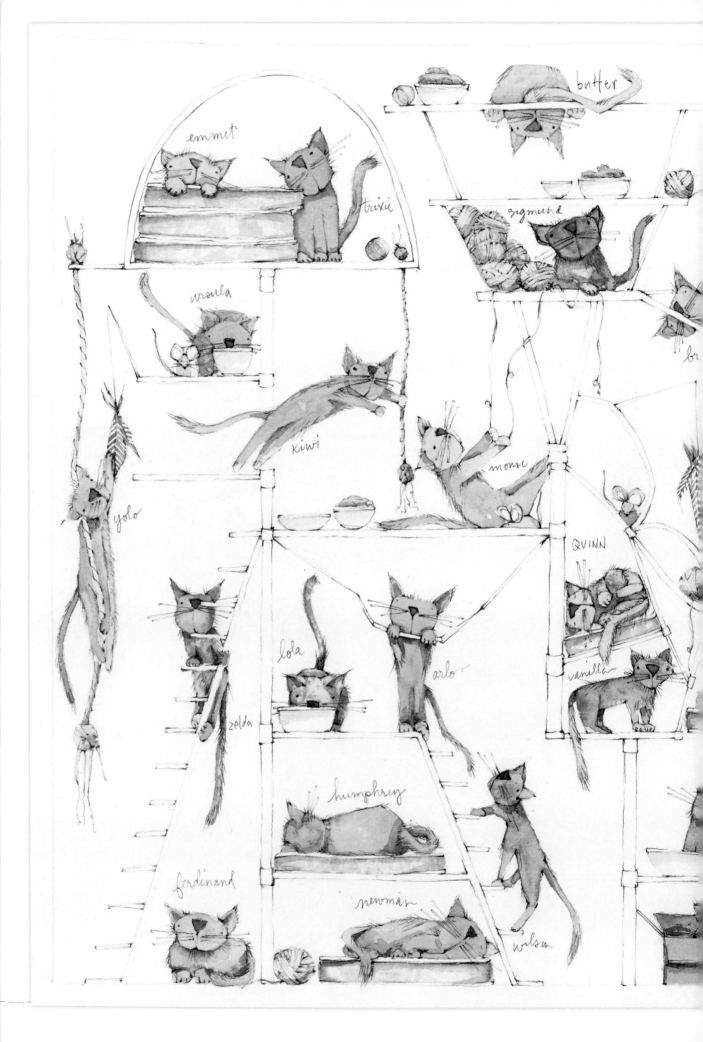

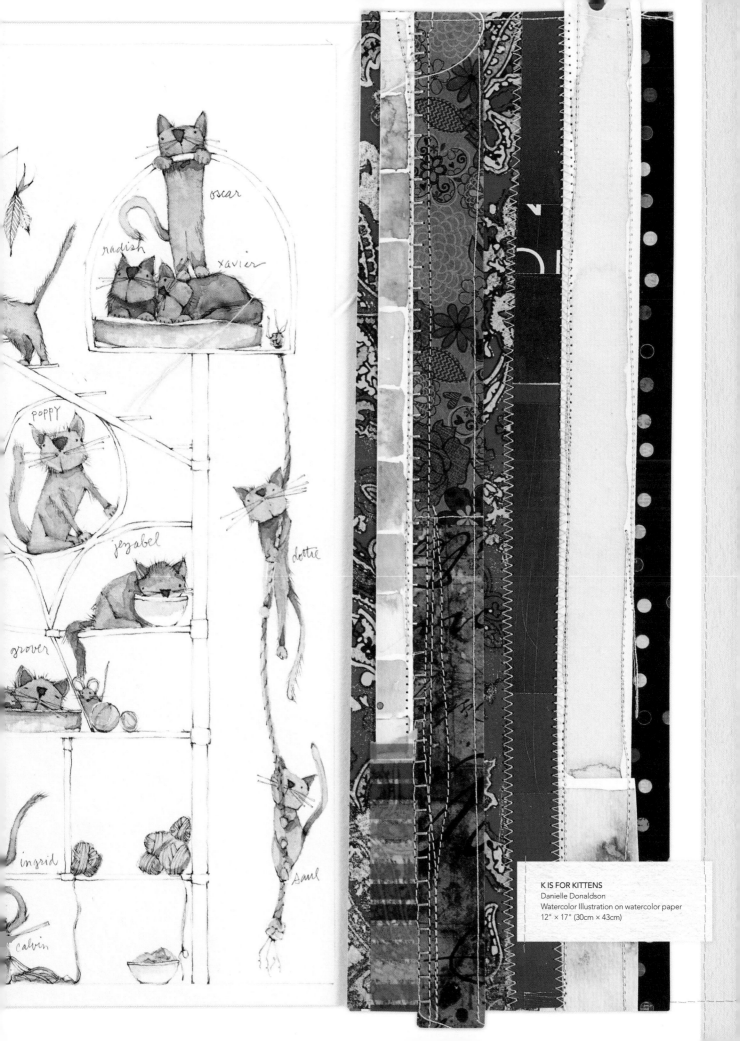

oscar

radish

xavier

POPPY

jezabel

dottie

grover

saul

ingrid

calvin

K IS FOR KITTENS
Danielle Donaldson
Watercolor Illustration on watercolor paper
12" × 17" (30cm × 43cm)

lila-mae

theo

astrid

beatrice "BEE"

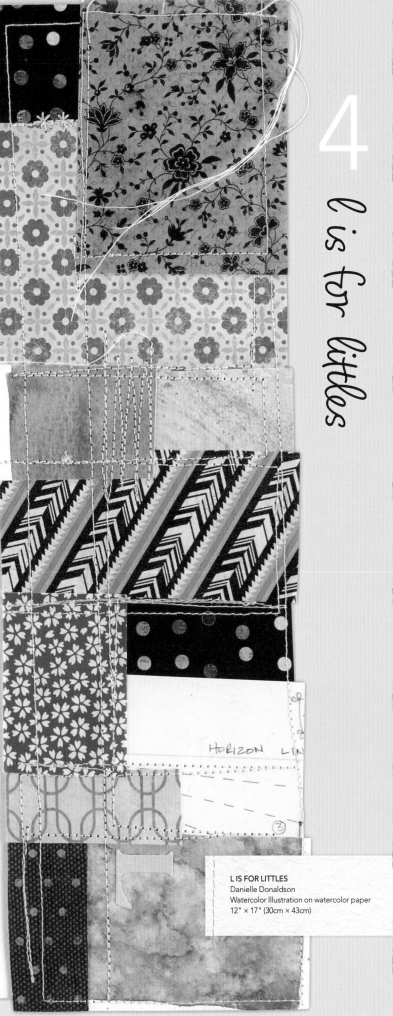

HORIZON LINE

L IS FOR LITTLES
Danielle Donaldson
Watercolor Illustration on watercolor paper
12" × 17" (30cm × 43cm)

L IS FOR LITTLES

Infused with so much love and detail, each Little carries a story with them wherever they go. To create your own little set of illustrated Littles, you'll spend lots of time breaking objects down into manageable pieces. You'll find this technique to be especially helpful when you are working toward infusing your own style into your creative process.

In this chapter, you'll learn an easy step-by-step process that makes learning to draw new things way more fun!

STUDY | *lottie bea little*

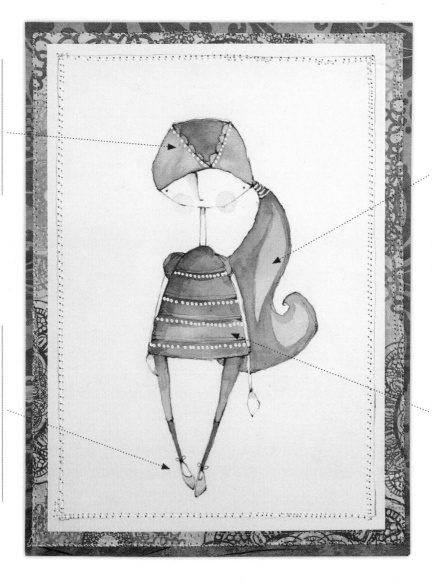

I've said it before, but it's worth repeating. Don't overdo the white penwork. It's addictive and easy to do. Oh, and keep the patterns you make simple.

Glazing layers of color and intentionally leaving specific patterns or areas untouched creates movement without any pencil work. It's subtle, but very effective.

I often leave my little shoes white since adding color in such a small space can be distracting. If you choose to paint them, make sure it is a really light wash of color or the same color as her tights.

I've carefully painted a balance between the teals and oranges, using more teal than orange. How much color you use is as important as the color choice itself.

PREPARE | *inspiration and mixing palette*

Prior to premixing your colors in the wells of your palette, choose two pieces of patterned paper. After you complete your illustration, you'll use them to create a double mat for your finished piece. These will serve as your inspiration for the colors you work with. Resist the urge to make them match; if they vary a bit, it gives you more color choices. Be sure to keep them close by as a reference throughout the project.

PREPARE | *supplies*

This list includes everything you need for all the projects in this chapter.

Craft Dryer (optional)

Creative Essentials (page 10)

Sewing Machine (optional)

Sketch or Bristol Paper

PRACTICE | *object breakdown practice*

I have found that breaking down objects into smaller pieces makes learning to draw new things so much easier.

· Studying and drawing a part of an object frees me from being overwhelmed.

· I can see what specific parts are hard for me and practice them more.

· I have options when reassembling the object, giving me the opportunity to make it fit into my signature style.

I have broken this Little practice into five pieces: the head and neck, body and arms, legs and feet, face, and hair. Draw variations of each element on five separate cards no larger than 4" × 4" (10cm × 10cm). This will help you remember to draw super small. By concentrating on one piece of the Little at a time, you can figure out what you like and don't like.

Using bristol paper, no larger than 7" × 5" (18cm × 13cm), assemble your favorite element from each card. Do you love it? If not, try some repeat practice, refining your Little until you are. If you still don't like it, go back to your practice squares and assemble a new Little. You'll find one you love, I promise!

Notice that I have added the nose but not the eyes. In my process, I add the eyes later, when I add visual tension. Why? The eye marks always dig into the paper a bit, which makes them hard to erase if I want to reposition them. You might consider adding facial features at the very end of the project.

IMAGINE | *lottie bea little*

It's time to add some sparkle to your little person's world. Follow the steps and watch her (or him) come to life right in front of your eyes.

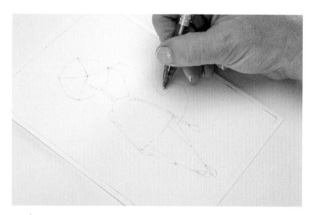

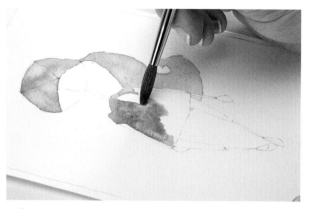

1 Draw a Little
On a 7" × 5" (18cm × 13cm) piece of watercolor paper, pencil a small mark on all four sides as a reminder to keep your illustration within the marks and preserve white space around it. Lightly draw your Little character based on your practice work.

2 Add Paint
Load your brush with paint+water from your mixing palette. Paint a controlled wash on the entire shape of the hair. Follow with a controlled wash on the dress and then the legs. It's best if you start with large shapes in your first wash. You can break it down into smaller shapes in later washes.

I left the face, neck, arms and hands paper white in my version. If you would like to add a skin color, I suggest painting the lightest, most transparent wash to the entire Little prior to painting any of the other shapes.

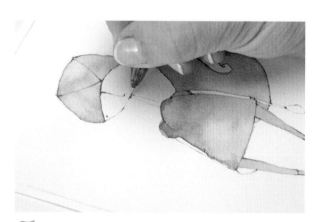

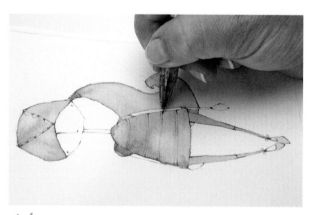

3 Add Visual Tension
Once the paint is dry, carefully check the edges of your washes. If you have slivers of white space, gently reactivate your edges with the smallest amount of water and pull the wash to your pencil line. Or, erase the pencil lines of the shapes that have washes and reline them with your pencil. Trapped white space is distracting to the viewer.

Once you have updated the lines, add visual tension to the illustration.

4 Add Patterns
Add detail with your pencil. Remember, the smaller the pattern, the more difficult it is to paint with watercolor without it becoming opaque. If you create tiny patterns, I suggest not painting them with additional colors at all. Let the pencil work shine!

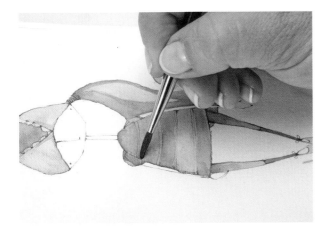

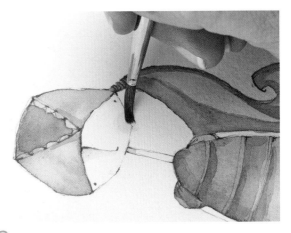

5 **Glaze Additional Layers**
Using the same colors you mixed and painted with on the first layer, glaze an additional layer to build up depth of color. Once dry, continue glazing layers of color to add interest as desired.

6 **Create Shadow Color**
Instead of using a new color, mix the leftover paint on your palette to create the color for your shadows. Add shadow to the nose, under the chin, where hands and wrists meet and where the dress meets the top of the legs.

Add a small circle of color to the cheeks. Use a cotton swab to pick up excess color, so they aren't too dark.

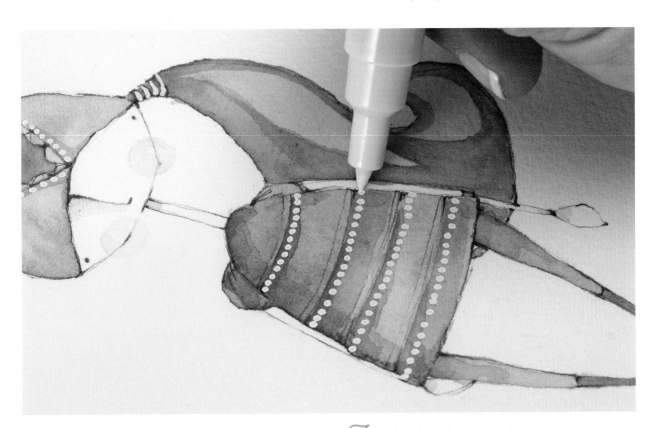

7 **Add Final Details and Assemble the Project**
Finish with your fine-tip white paint marker. If you waited to add facial features, go ahead and add them now.

Trim, layer and stitch your background papers to your finished illustration. Add your signature and date. Your very own Little is complete!

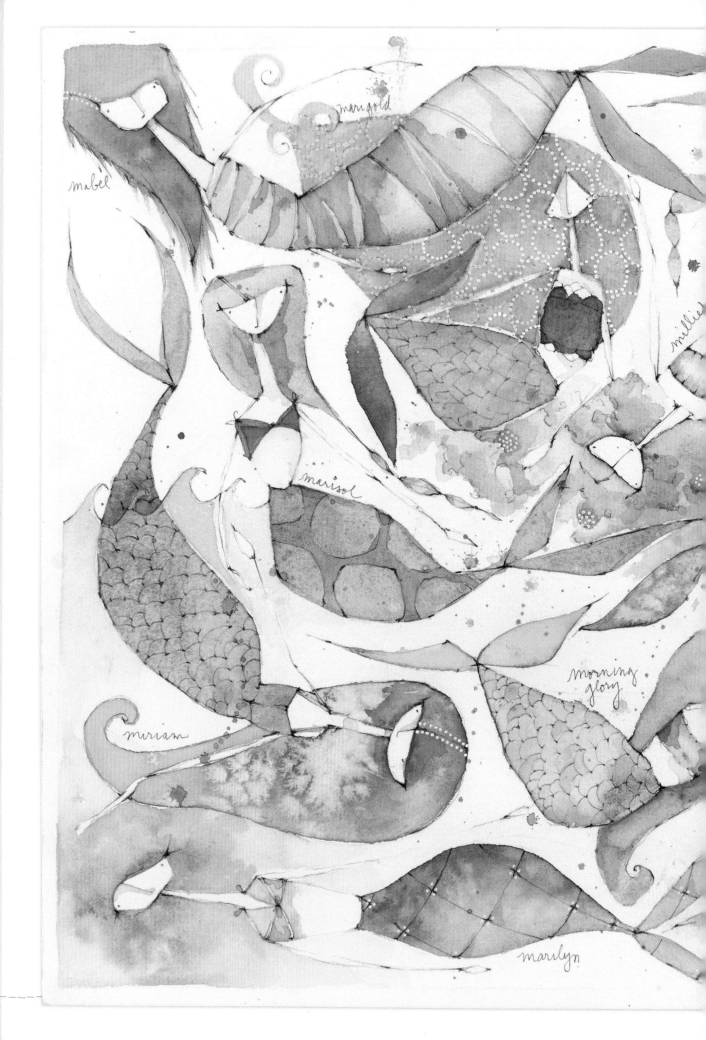

marigold

mabel

millie

marisol

morning
glory

miriam

marilyn

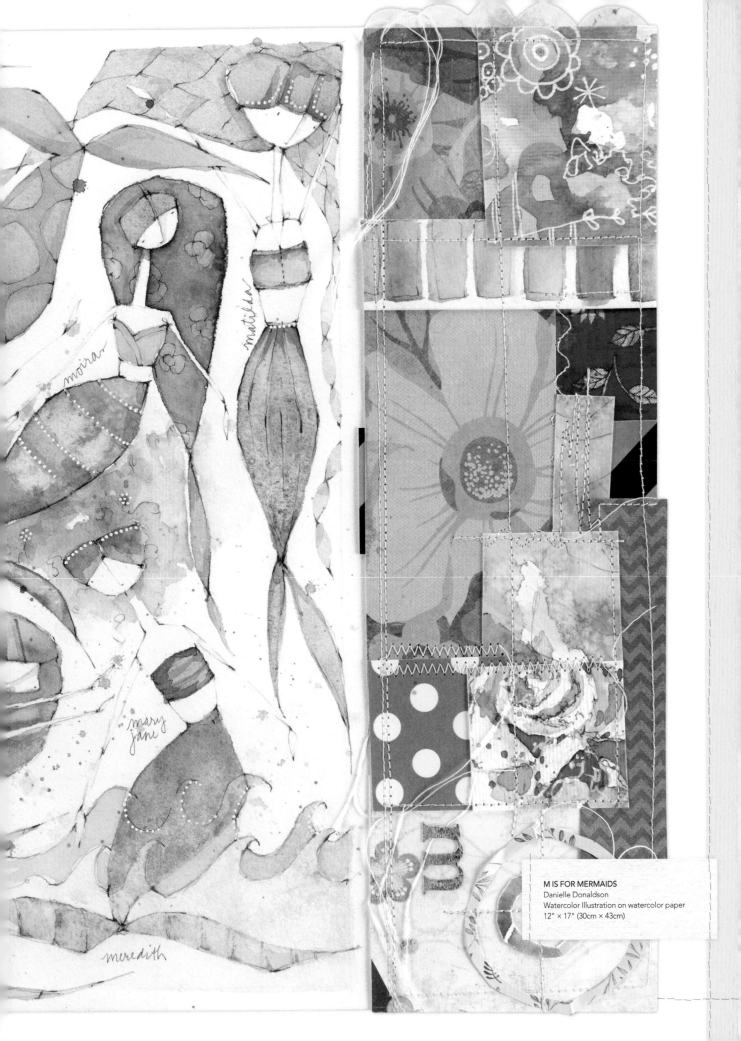

M IS FOR MERMAIDS
Danielle Donaldson
Watercolor Illustration on watercolor paper
12" × 17" (30cm × 43cm)

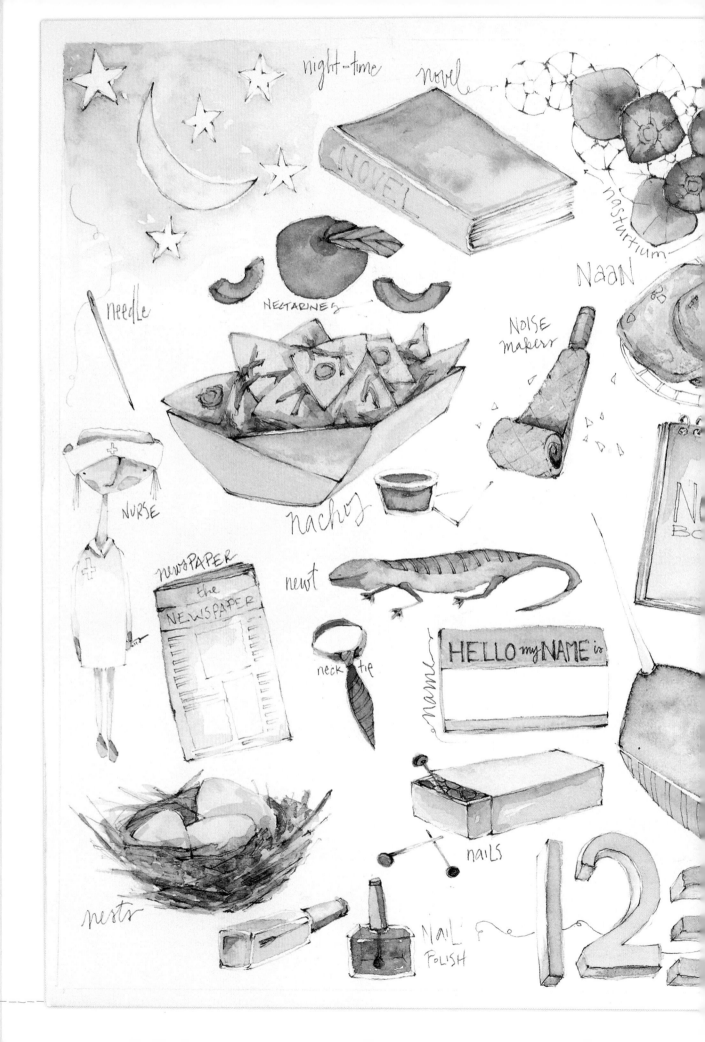

night-time

novel

NOVEL

nasturtium

NaaN

needle

NECTARINES

NOISE makers

NURSE

nachos

N...
BO...

newsPAPER

the
NEWSPAPER

newt

neck tie

name

HELLO my NAME is

nests

nails

NaiL POLISH

1 2 ...

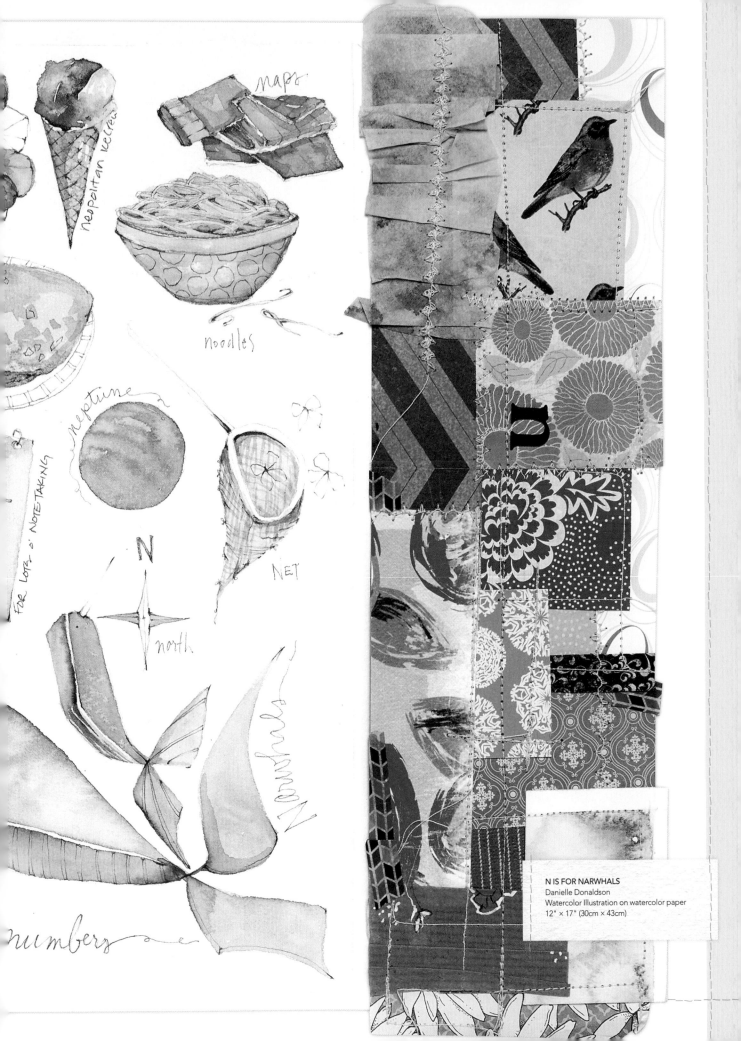

neapolitan icecream

maps

noodles

neptune

NET

N
north

FOR LOTS OF NOTE-TAKING

Narwhals

numbers

N IS FOR NARWHALS
Danielle Donaldson
Watercolor Illustration on watercolor paper
12" × 17" (30cm × 43cm)

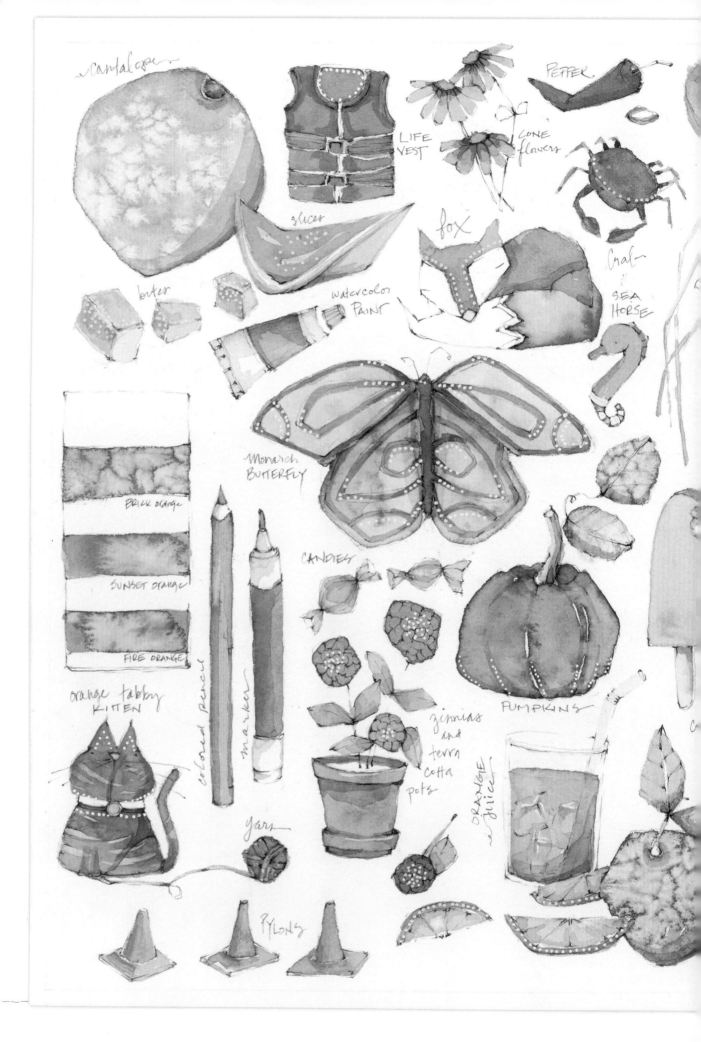

cantaloupe

LIFE VEST

slices

PEPPER

CONE flowers

fox

Crab

SEA HORSE

butter

watercolor PAINT

Monarch BUTTERFLY

CANDIES

BRICK orange

SUNSET orange

FIRE ORANGE

orange tabby KITTEN

colored pencil

marker

zinnias and terra cotta pots

PUMPKINS

ORANGE juice

yarn

PYLONS

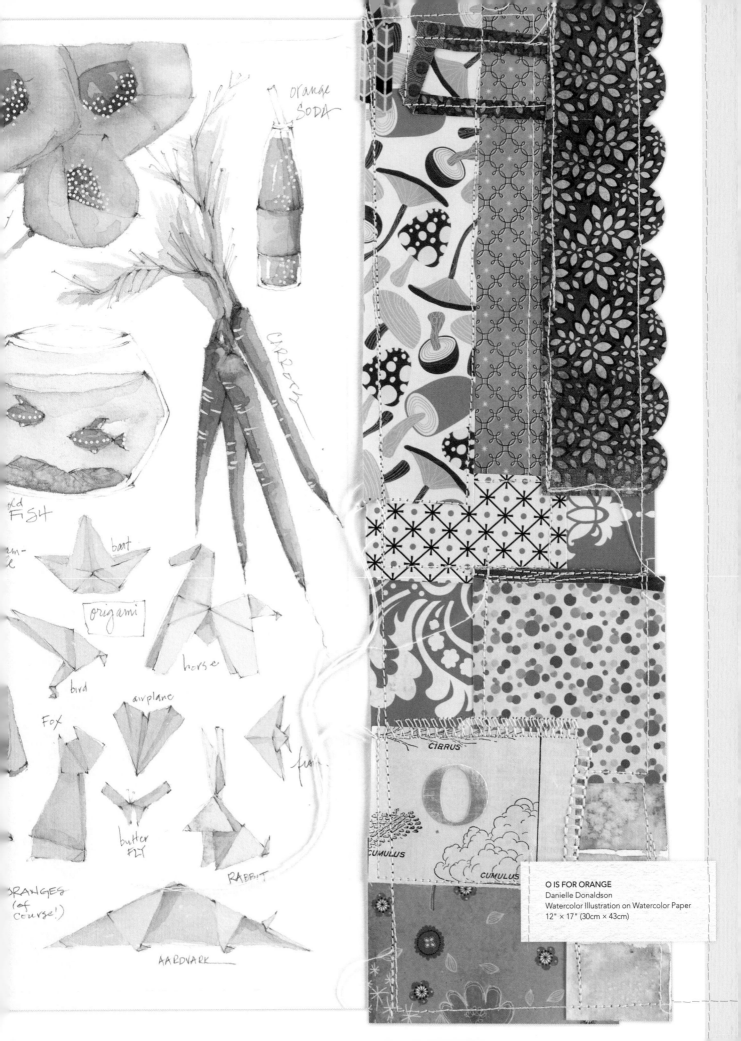

orange
SODA

CARROT

old
FISH

boat

origami

horse

bird

airplane

Fox

fish

butter
FLY

RABBIT

ORANGES
(of
course!)

AARDVARK

CIRRUS

O

CUMULUS

CUMULUS

O IS FOR ORANGE
Danielle Donaldson
Watercolor Illustration on Watercolor Paper
12" × 17" (30cm × 43cm)

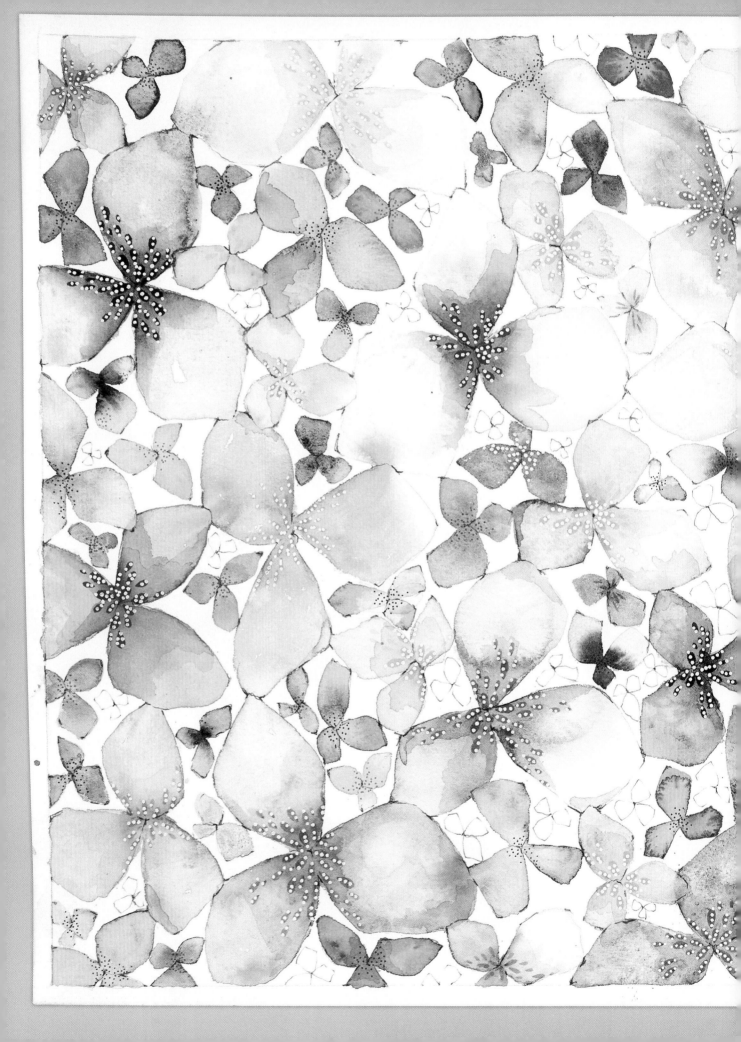

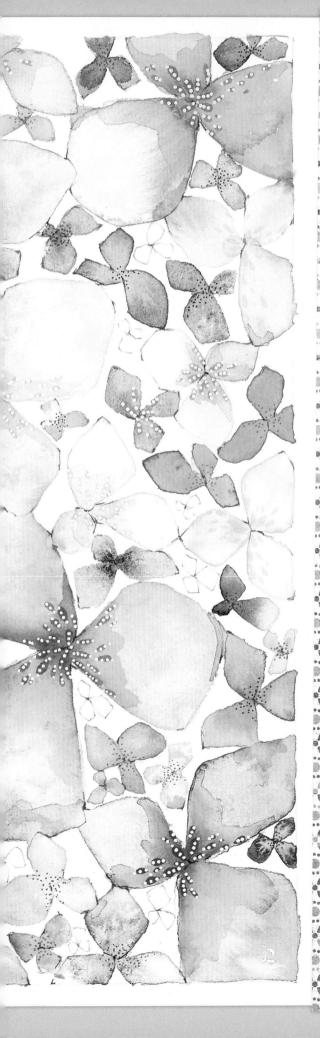

p is for posies

P IS FOR POSIES
Danielle Donaldson
Watercolor illustration on watercolor paper
12" × 17" (30cm × 43cm)

P IS FOR POSIES

Imagine yourself in fields of sunshine-filled flowers. Now imagine them bursting with so many colors you lose count. This project is great repetitive practice and holds so many colorful blossoms, it will be hard to choose a favorite.

In this chapter, we'll work on a repetitive pattern of connected petals. It will really help build your awareness of the pace you need to keep when working with watercolors, and how beautiful and spontaneous the process can be when you go with the flow.

STUDY | *pretty posies*

Notice that I chose a stitch pattern that ties into the "XO" pattern of the background paper.

I added dots of white ink to tone down the black ink and infuse more white into the piece, tying in the exposed white paper.

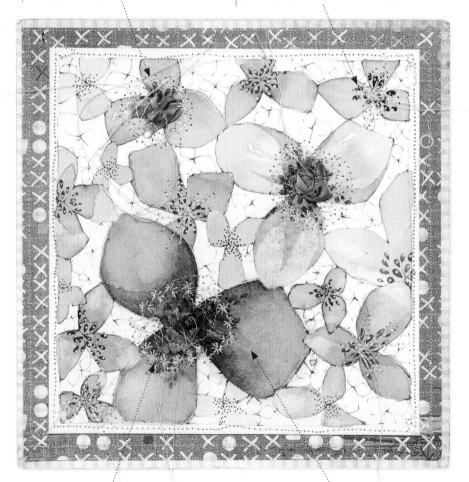

Once you have finished this project, you'll figure out that I added stitching and ribbon. After sitting with it for a while, I realized that the penwork was beautiful but needed to be toned down a bit to create a better focal point.

(Dang it! In an attempt to add more focus to the large posy, I overdid the glazing and created a yucky color. A little stitching and a pretty ribbon will fix it.)

IMAGINE | *pretty posies*

This project is like watching fireworks. As you paint each posy, the color will mix and mingle and quietly burst with beauty. If, after reading through the steps, you are concerned it might be too difficult for you, that's understandable. Take a step back and practice this technique on small scraps of paper, one posy at a time.

PREPARE | *supplies*

This list includes everything you need for all the projects in this chapter.

Craft Dryer (optional)

Creative Essentials (page 10)

Faber-Castell Pitt Pens

Patterned Paper

Sewing Machine (optional)

Sketch or Bristol Paper

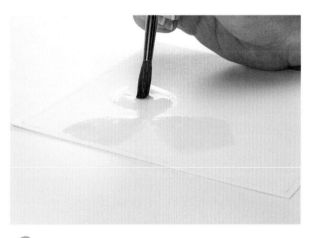

1 Prepare Your Palette

Prior to premixing your colors in the wells of your palette, choose two pieces of patterned paper larger than 6" × 6" (15cm ×15cm). After you complete your illustration, you'll use them to create a double-mat for your finished piece. I am sure you are a pro at this process by now, but try changing up your choices to be sure you are giving equal playing time to all the colors on your palette. Be sure to keep them close by as a reference throughout the project.

Premix at least six colors of your choice in the wells of your palette. Because we are using a wet-in-wet technique, mix a bit more paint in the water to be sure you can see the beauty of intermingling colors in the following steps. After mixing your colors, start the project with a jar of clean water.

Oh, and this is a fast-paced project so be prepared!

2 Paint the Shape With Water

The focal point for this composition is a large, medium and small posy. The remainder of the posies will be filled in later, so refer to the example for approximate size and placement.

Rather than using a pencil to define the first posy, use clear water to paint three large petal shapes that connect in the center on your 6" × 6" (15cm × 15cm) paper. You should be able to see the petal shapes and how they connect in the center. Add a bit more water if the paint has already dried a bit.

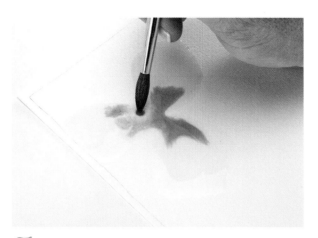

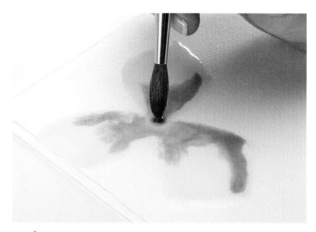

3 Drop in Color

Fully load a round brush with paint from one of the wells of your mixing palette. Holding your brush perpendicular to your paper, touch the paper with the tip of your brush, dropping color in the center. Watch how it blooms outward from the center toward the middle of the petals. Cool, right? If it isn't moving a lot, you can give it a gentle push outward with your brush.

4 Drop in Additional Colors

Drop a second color in the center. Notice how wet or dry your original clear wash is. This will change how your second color will react. If it is almost dry and not moving around much, try dropping in clear water to the center to see what effect it has. These blooms take some practice, so go easy on yourself.

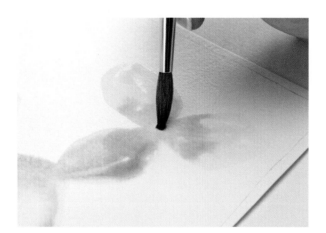

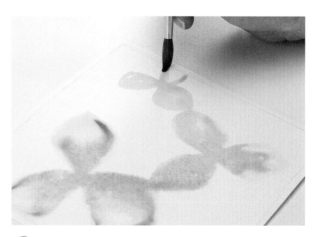

5 Add the Medium Posy

Before your first posy dries, paint a medium-size blossom with clear water connected to one of the outside points of the large petal. If the connecting petal is too dry and the edge looks harsh, you can add water to soften it and help it connect to the petal next to it.

6 Add the Small Posy

Repeat the process for the third posy to complete the focal point.

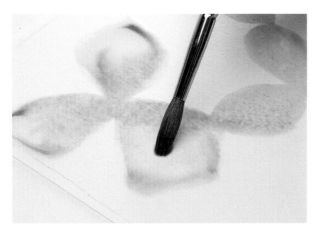

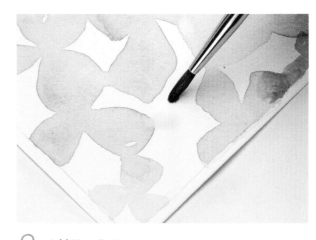

7 Drop in More Color and Fix Trouble Spots

If you like, drop in additional colors to all three posies. Notice how the colors mingle together where the petal of the large and medium posies meet. Pretty, right? If there are areas where the paint has not moved into the clear water, gently swirl your brush to cover the clear area. If you have excess pools of water, take the corner of a paper towel, and without touching the paper, let it soak up excess water.

8 Add More Posies

This is the step where you'll want to downsize your brush and reactivate petal tips with water to connect them. Don't worry if some of the transitions are wonky; the next step will make them look better.

Using the same process, add even smaller posies to fill in the spaces between the focus posies. Be sure to include the edges—don't try to smoosh the whole posy into the boundaries. Remember, we want our viewers to think that if they climbed into this illustration, they could walk in a field of posies forever!

This is the fast-paced part of the project. While you connect new posies with clear water, you'll need to drop in additional colors from your mixing palette to the previous posies before they dry.

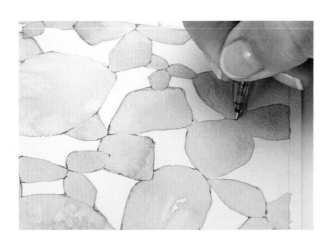

9 Define Individual Petals and Posies With Visual Tension

Once the illustration is dry, use your pencil to add visual tension by tracing over some, not all, of the original pencil liness as shown. Start by adding a bit more pencil where lines join, intersect or overlap. Resist the urge to trace over all your original pencil work. This will create a harsh outline of pencil and overwhelm your beautiful painting.

10 Add Pencil Posies

Using your pencil, draw tiny posies to fill in the blank areas between all the painted posies. Take a moment to look at your overall composition after drawing each one. This isn't about filling in every nook and cranny; it's about making the white space work with your illustration instead of against it. Use the spacing and scale of the penciled posies in the final piece as a reference.

11 Add Marker Details

To create some serious pops of color in the details, use the side of a brush marker to add dots from the center of some of the posies outward. Finish by adding tiny dots with a fine-tip colored marker to some of the smaller posies.

Trim, layer and stitch your background papers to your finished illustration. Add your signature and date, and your pretty posies are complete!

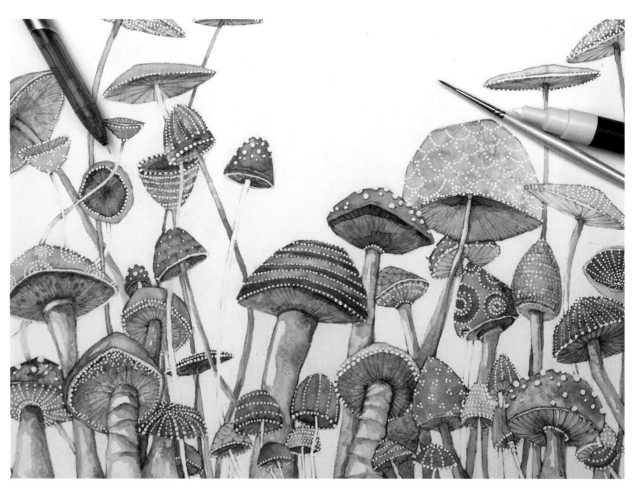

DOWN TO EARTH
Danielle Donaldson
Once you have mastered posies, try other
nature-inspired repetitive practice!

IMAGINE | *marker posies*

Try this fun and easy variation. You may have just found
a new way to use that stash of markers you have.

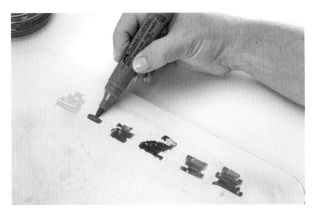

1 **Create a Marker Mixing Palette**
Create a mixing palette by scribbling several India ink brush
markers directly onto your white erase lapboard.

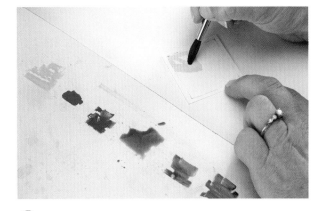

2 **Paint the First Layer of Color**
In this example, I have drawn a single posy on a 3" × 3" (8cm
× 8cm) square.

Load your brush with clean water. Swirl it into one of the
marker colors on your mixing palette to load your brush with
ink. Using a controlled wash, paint the entire posy.

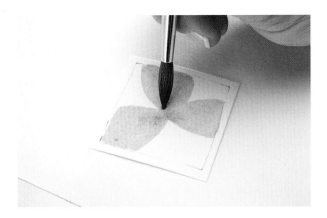

3 **Drop in Color**
Clean your brush, add water and pull a different color from
your mixing palette. Holding your brush perpendicular to
your paper, touch the paper with the tip of your brush,
dropping color in the center.

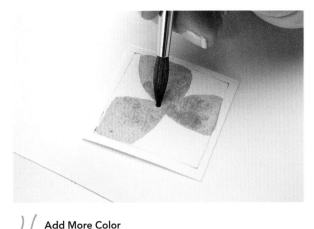

4 **Add More Color**
Drop in additional colors as the posy dries. You'll find that
this process gives you a totally different effect than tradi-
tional watercolor. As an experiment, try combining the two
mediums to see how it can fit into your own process.

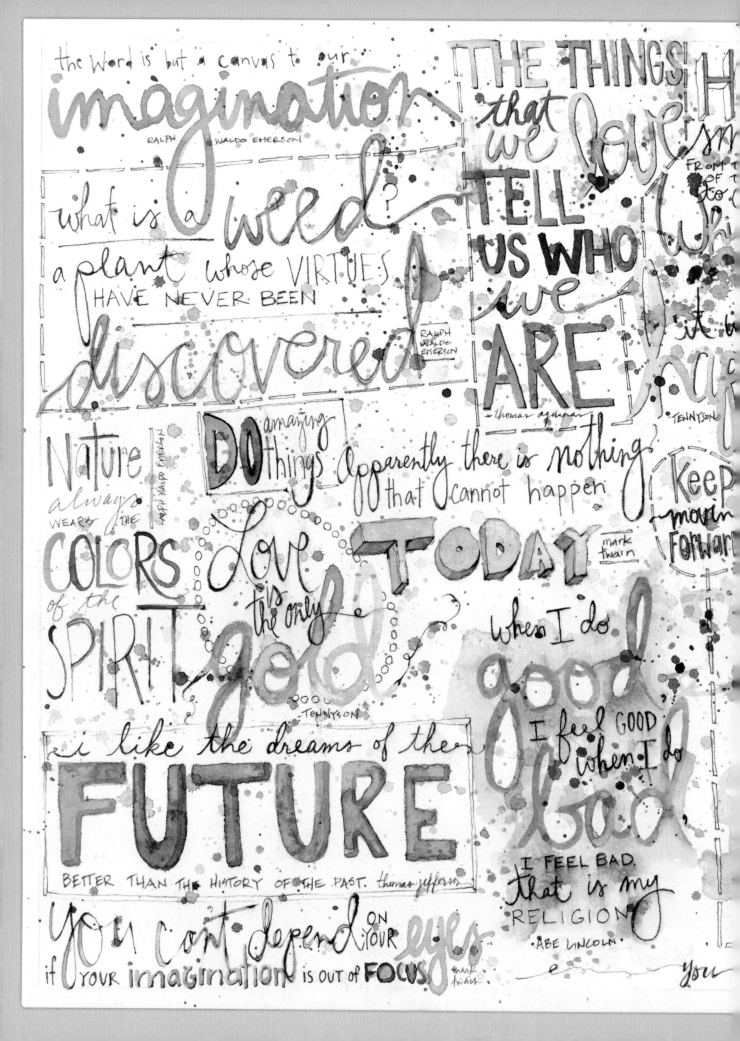

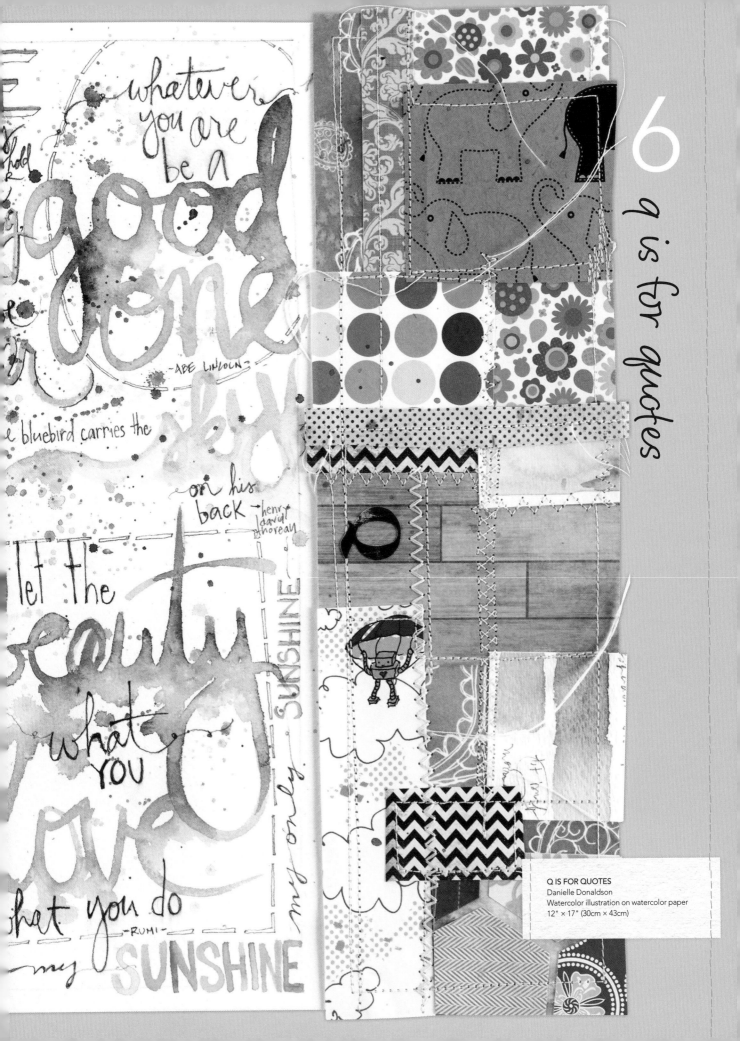

whatever
you are
be a

good
one

—ABE LINCOLN—

e bluebird carries the

on his
back →henry
david
thoreau

let the

what
you

hat you do

—RUMI—

my SUNSHINE

SUNSHINE

Q IS FOR QUOTES
Danielle Donaldson
Watercolor illustration on watercolor paper
12" × 17" (30cm × 43cm)

Q IS FOR QUOTES

I am at a point in my watercolor journey where I don't have to warm up before diving right in to most projects. Word painting is NOT one of those projects. It requires a good attitude, practice, patience and preparation. But, it's *so* worth it. Let's try out a few techniques on a whole bunch of leftover scraps of watercolor paper, shall we?

In this chapter, you'll find that ther are a ton of working parts to this word-painting process. It may seem overwhelming at first, but don't give up. If you put the time into studying and practicing, you'll love it.

STUDY | *always*

When I add patterned paper and stitching, I try to add a heart with a compass pattern. It symbolizes where my heart lies—with myself and my family—wherever they may be. I just love hidden meanings—stories my work shares that only I know about.

This lettering style was a new (and very exciting) discovery for me. And I have been lettering for a ***long*** time. Yay for taking the time to practice! Failure, patience and imagination often lead to the very best success stories.

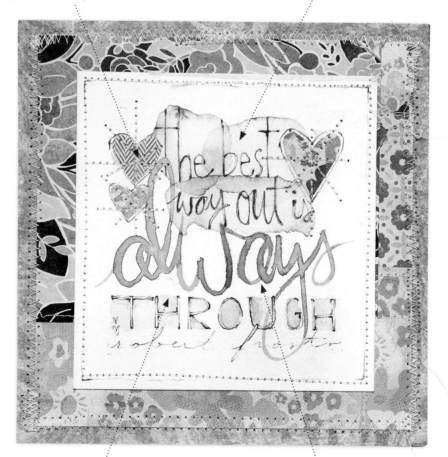

Readability should always be the priority. Keep those fill-in washes really light or you'll lose readability.

Connecting the letters is the hardest part. Remember, it's really important to leave off the tails when you are forming the letter so you can get the correct curve when you add the connectors.

STUDY | *when watercolor meets words*

BRUSHES—Try out several different brush sizes and shapes and study how each works with script and print letters. When painting in script, I like using round and liner brushes. You may find that a dagger brush feels better as you turn it. If I am filling in block letters, an angle brush works like a charm. An oval brush will make a soft print, but won't turn well if you try to connect the letters. Learn to load your brush with the right amount of paint+water to be sure script letters look like the letters they are supposed to be. It's easy to fill in areas accidentally—especially the loops.

PREPARATION—Premixing paint and water in the wells of your palette ahead of time is a *must*. If you are planning to paint in script, it is important that you have enough to paint the word in one pass. Or at least have enough paint+water to pull from the well of your mixing palette if you need more. If you are planning on transitioning several colors within one word, it's even more important.

STYLES—Focus on script, block and print lettering, using uppercase and lowercase letters. We'll also use combinations of uppercase and lowercase letters. Practice different lettering techniques with words you write all the time—like your kids' or pets' names or hometown. You already know how these letters fit together. And remember to use scraps of paper—it will get you in the habit of fitting words into a specific space.

QUOTES—Choose a favorite quote and keep it under ten words. Any longer than that and you're likely to get halfway through the quote, love it, then make a mistake and have to toss it. As soon as you mess it up, set it aside for reference or throw it away and start over. Your time is more valuable than trying to save a practice piece. It may be helpful to practice each word separately before you work on an overall composition.

FOCUS WORD—When creating a pleasing composition of words, it's important to think of each letter as a shape, then each word as a shape, and finally, the quote as a shape. Your first step is to choose a focus word—the word that will be the centerpiece of your illustrated quote. Next, decide what type of lettering you will use. Does it make more sense to use all lowercase or block letters? Are there lots of loops in your focus word if you paint in script? How will the remainder of the quote fit around it? Is there another word that you want to have secondary focus? How big or small should each word be?

THUMBNAILS—Thumbnails are squares or rectangles no larger than a couple of inches with a bunch of tiny quick (and messy) sketches of your ideas. In the visual communication world, they are still (even with computers) an effective tool to brainstorm composition on paper. In my illustrative world, I have implemented them as a way to take a series of separate objects and ideas and switch them around until I feel like the composition is worth trying out as a full-size illustration. More often than not, I end up with several compositions that turn into an illustrative series.

PREPARE | *supplies*

This list includes everything you need for all the projects in this chapter.

Cotton Swab

Craft Dryer (optional)

Creative Essentials (page 10)

Glue

India Ink Marker

Liquid Frisket

Microsize Eraser Pen

Patterned Paper

Rubber Cement Pick-Up Eraser

Sewing Machine (optional)

Silicone Color Shaper
(in place of a brush for frisket)

Washi Tape

Watercolor Paper

PREPARE | *inspiration and mixing palette*

Prior to starting the project, choose your quote and focus word. Prior to premixing your colors in the wells of your palette, choose two pieces of patterned paper larger than 4" × 4" (10cm × 10cm). After you complete your quote, you'll use them to create a double-mat for your finished piece. Be sure to keep them close by as a reference throughout the project. Feel free to sew your mat ahead of time if you like.

Using the patterned paper as inspiration, premix a generous amount of several colors in the wells of your mixing palette. Each well can contain just one color or a custom mix of colors. When painting letters, the last thing you want to do is run out of paint in the well in the middle of the word or phrase.

PRACTICE | *break it down*

COMPOSITION THUMBNAILS

On sketch paper, draw a series of thumbnail boxes and practice the overall composition with pencil. Even at this tiny size, remember to make marks on each side of your quote area to preserve white space. Using your composition practice, this is where you will figure out what style and size each word will be and how they will nest together. Be sure to try this out with some of the other projects in the book—it will help tremendously.

COLOR THUMBNAILS

Another interesting way to infuse thumbnails in your practice is to take your favorite sketch from the previous exercise and draw another series of thumbnails. Fill each thumbnail with a quick sketch of the same composition. Based on the paper you chose as inspiration and the colors you added to your mixing palette, grab some coordinating colored pencils or markers. Make quick marks of color on each thumbnail to decide which color should be placed where. What color will draw the viewer's eye to your focus word? Where do you want their eye to go next?

WORD BREAKDOWN

On small strips, squares and scraps of paper, try out each word using different techniques. Think of the word as an object and each letter as a component. How do they fit together? Are there lots of upper and lower loops? Does it lend itself to all caps or all lowercase? Think of each word in terms of scale. Do you want to give it more visual weight? Or is it a supporting word that needs to be read for the quote to make sense? Where will the word nest into the words around it? And last, consider the tool you will use. Mechanical pencil, marker, watercolor or colored pencil? Remember, some of the best ideas come from ugly mistakes.

IMAGINE | *the best way out is always through*

The best way out *is* always through. Very sage advice from Robert Frost. It is one of my favorite quotes, although I changed it a bit after I repeated it about a million times for my kids throughout their childhood. I was quite adamant about it, too. My version is, "The only way to the other side of this is through. Not around." It worked for them and works for me, even with my art process. (And, yes, I have been told I am stubborn and possibly overachieving.) In this project, I'll refer to my quote in the steps below. It might be helpful to try my quote prior to working on another quote you have in mind.

1 Composition, Color and Word Practice and Preparation
Using small scraps of watercolor paper and the techniques and ideas from the Study and Practice portions of this lesson (previous three pages), break down my quote and create a series of composition and color thumbnails. Once you have decided on compositional placement and what colors will be used where, practice each of the words using different techniques.

On a 4" × 4" (10cm × 10cm) piece of watercolor paper, pencil a small mark on all corners as a reminder to keep your illustration within the marks and preserve white space around it.

2 Add the Name in Pencil
Using a ruler, draw a guideline approximately ¼" (6mm) from the bottom of the quote box. Using your mechanical pencil, handwrite *robert frost* underneath the guideline. Notice that I have used all lowercase letters and added space by lengthening the connectors of the letters to make sure it covers the length of the box. Using a microsize eraser pen, carefully erase the guideline.

3 Add a Word in Pencil

Using two lengths of washi tape, create a horizontal space for the word *through*. Count the letters in the word to find the approximate center. In all capital letters, pencil in the first letter, *T*, then the last letter, *H*, followed by the center letter *O*. This will give you a good idea of how big and far apart the remaining letters should be written. Notice my letters aren't perfect—I am OK with that. Remove the washi tape.

4 Paint the Focus Word

Using the word breakdown practice as a guideline for letter placement, load your brush and paint your focus word, *always*, in script. Paint your first letter, leave a space and paint your second letter. Now paint the connector between the two letters. Continue this process until you have finished your focus word. Notice the little mark just under the *l*—I painted the "tail" of the *l* rather than waiting to connect it to the *w*. If you happen to make this mistake, simply use the side of a microsize cotton swab to lift it up right away.

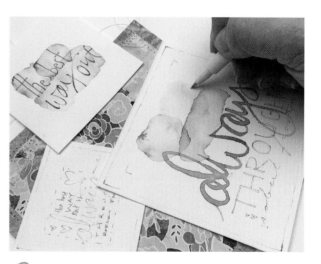

5 Add a Marker Shape

Using a round brush fully loaded with clear water, paint an irregular-shaped oval. While the wash is still very wet, gently make contact with it using the tip of your brush-tip India ink marker. Repeat on various parts of the wet shape. If you like, drop in a second color. Use your round brush to gently push the ink toward other parts of the wet shape. Let dry.

6 Add More Marker Shapes

Using additional marker colors that coordinate with your inspiration and color practice, add two more marker shapes. Let dry.

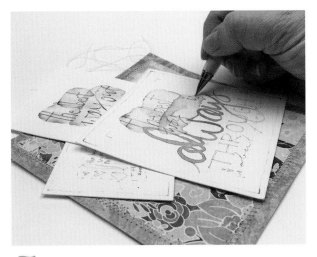

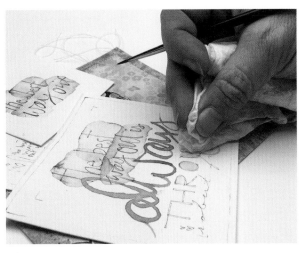

7 **Pencil Words Into the Marker Shapes**
Using your word practice as reference, pencil in *the best* to the top marker shapes. In the bottom marker shape, write *way* on the left side and *is* on the right. This will give you a better idea of how much space you have for the word *out*. Notice that I alternated lowercase print with cursive.

8 **Add a Wash to the Word Shapes**
Using a small round brush, fill in the empty spaces of the word *THROUGH* with light washes. After filling in each letter, use a scrunched-up paper towel to lift most of the color.

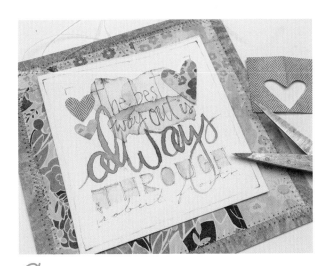

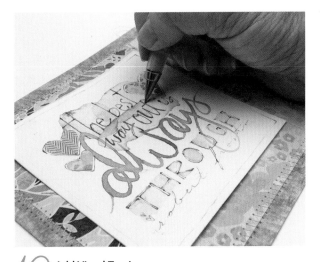

9 **Add Heart Shapes**
Cut and adhere three hearts based on the composition practice completed at the beginning of the project. Notice I have used the Rule of Odds by adding three hearts. Odd numbers equal energy!

10 **Add Visual Tension**
Erase the corner boundary marks. Add visual tension to the words written in pencil except for *robert frost*. Why? I want the author's name to be readable but not to have as much visual weight as the quote.

Sew your finished project to your assembled inspiration mat and, using a straight stitch, sew asterisk shapes to the hearts.

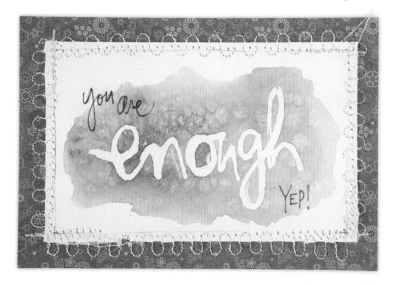

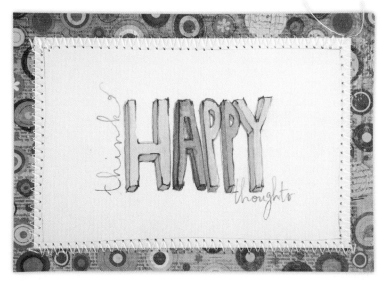

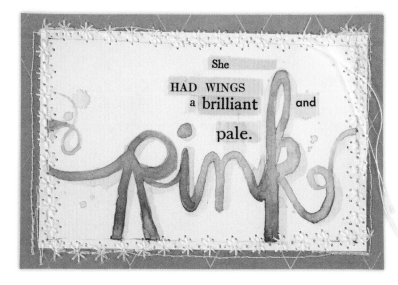

YOU ARE ENOUGH. YEP!

(Using Liquid Frisket)

To create a reverse of a word, simply write it lightly on the paper. Next, using a silicone color shaper tool rather than a brush, trace your pencil line with liquid frisket. The head of the brush is made of an easy to clean, flexible piece of silicone. This is a great alternative to almost certainly ruining a brush. Once the liquid frisket is completely dry, paint a multicolor wash with loose edges right over it. Once the watercolor is dry, use a rubber cement pick-up eraser to remove the frisket and reveal the word.

THINK HAPPY THOUGHTS

(Block Letters)

One of my favorite lettering styles is block lettering with dimension. Once you have mastered drawing a box (page 56), you'll be able to create this style, too. Lightly draw the outlines of your block letters between two horizontal lines. This will keep them approximately the same height. I suggest drawing from one of the letters in the middle of the word, then add a letter on either side until your word is complete. Add one-point perspective to create the boxes for each letter. Next, paint a light wash over each letter, including the box portion. Follow with a second wash of the same color to the sides and bottom of the box. Last, glaze a third wash over the bottom portions of the box only.

PINK

(Cut-and-Paste Words)

I have a big jar filled with words that I have cut up from old storybooks, novels and classics. It's fun to piece together my own stories. In this example, I painted my focus word and nested the remainder of the story around it. Notice how the swirls at the beginning and end of the word seem to continue off the page?

IMAGINE | *monthly practice planner*

Add this fun planning calendar to your monthly creative practice. Plan the days you'll work in it and the subject matter you want to practice. Think of how cool it will be at the end of the year when you have twelve of these to look back on and see how hard you have worked to grow your art.

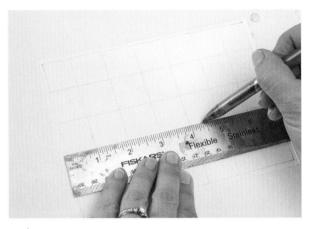

1 Measure Your Paper

Using a 5" × 7" (13cm × 18cm) piece of watercolor paper, lightly draw a series of vertical lines an inch (3cm) apart, creating a column for each day of the week. Next, draw a series of horizontal lines an inch (3cm) apart, creating five weeks.

2 Hand Letter and Add Visual Tension

Draw a horizontal line under the top horizontal line to create a narrow row. Hand letter the days of the week. Number the days of the month and add visual tension to the corners and intersections of the boxes.

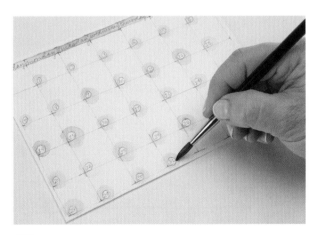

3 Add Color

Paint a transitional wash across the narrow column at the top. Mine is painted in the following order: yellow, orange, red, violet, purple, blue, teal and green. Using a round brush, paint small circles around each of the dates in various colors included in the transitional wash.

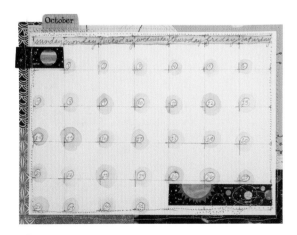

4 Add Details

Add some of your favorite washi tape to mark off the empty dates at the beginning and end of the calendar. Add a tab (using a punch or a premade or hand-cut tab) and hand letter or use a sticker for the designated month. Choose several scraps of patterned paper and sew them to make a patchwork background. Trim the background to 5½" × 7½" (14cm × 19cm) and layer underneath the calendar. Using various stitches, sew the tab, background and calendar around the edges.

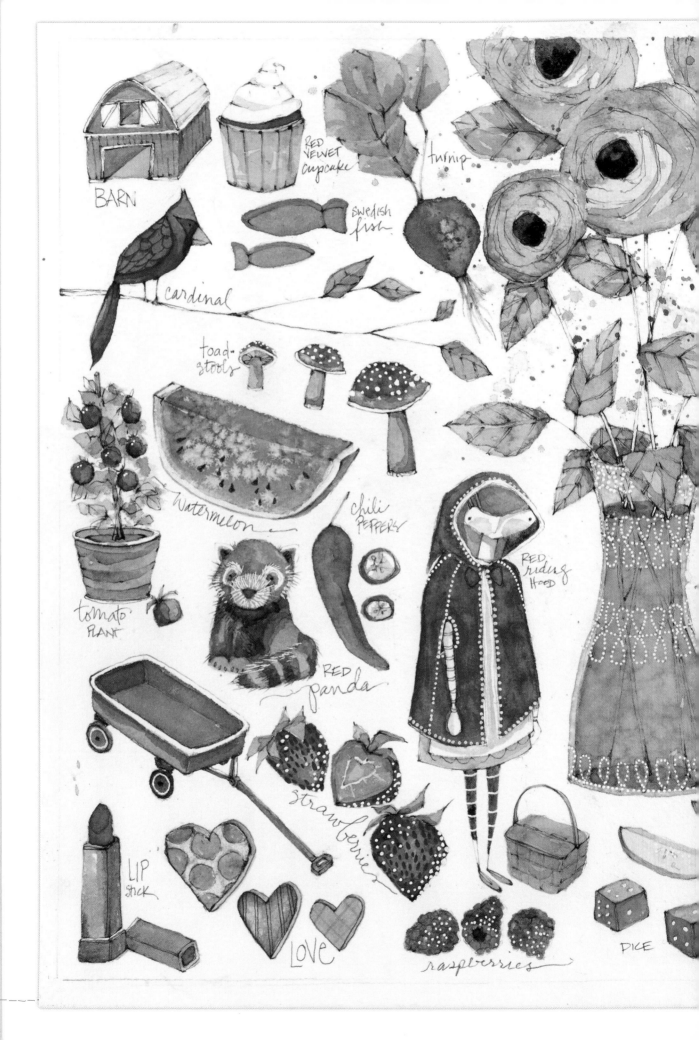

BARN

RED
VELVET
cupcake

turnip

swedish
fish

cardinal

toad-
stools

Watermelon

chili
PEPPERS

RED
riding
HOOD

tomato
PLANT

RED
panda

strawberries

LIP
stick

LOVE

raspberries

DICE

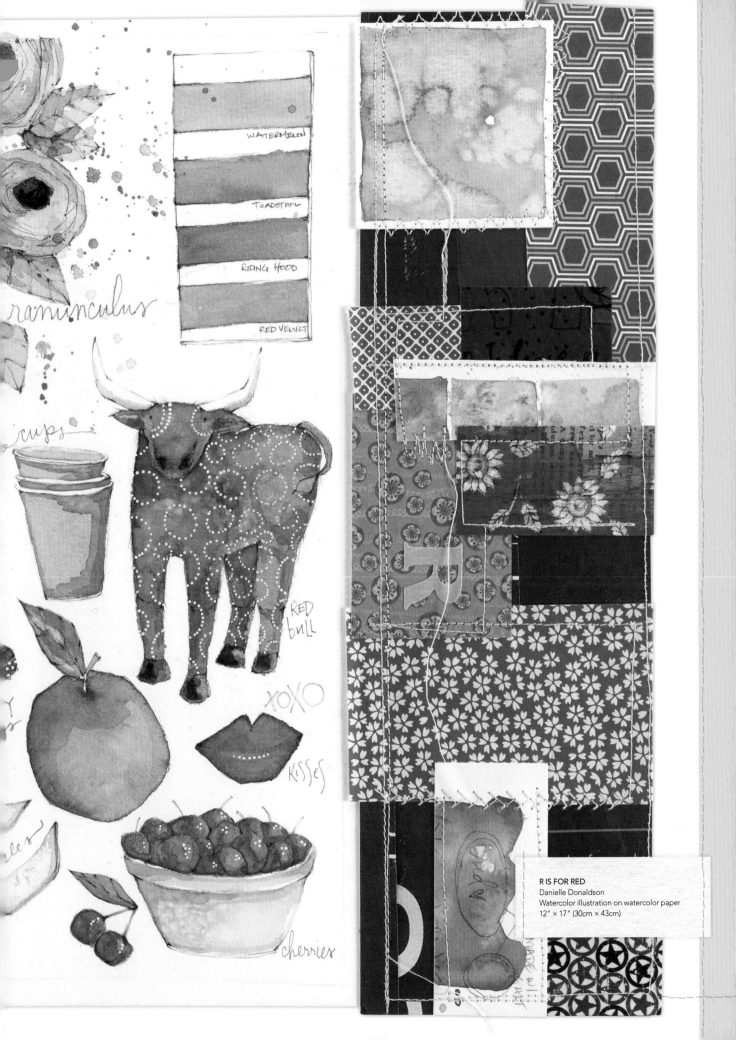

ranunculus

WATERMELON

TOADSTOOL

RIDING HOOD

RED VELVET

cups

RED bull

XOXO

kisses

cherries

R IS FOR RED
Danielle Donaldson
Watercolor illustration on watercolor paper
12" × 17" (30cm × 43cm)

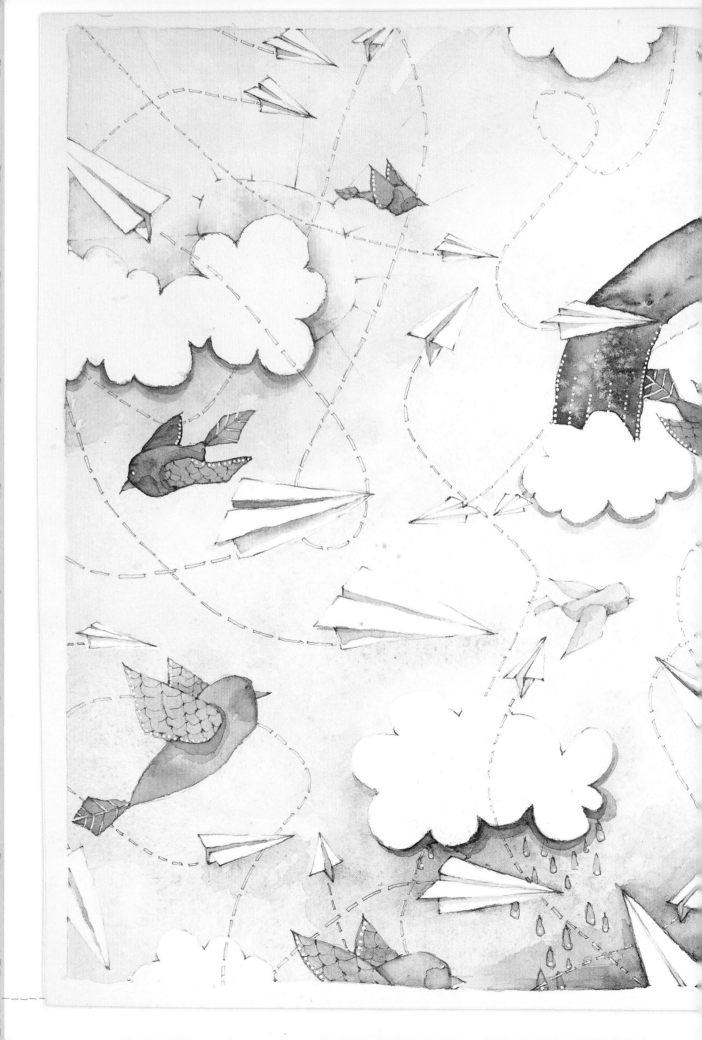

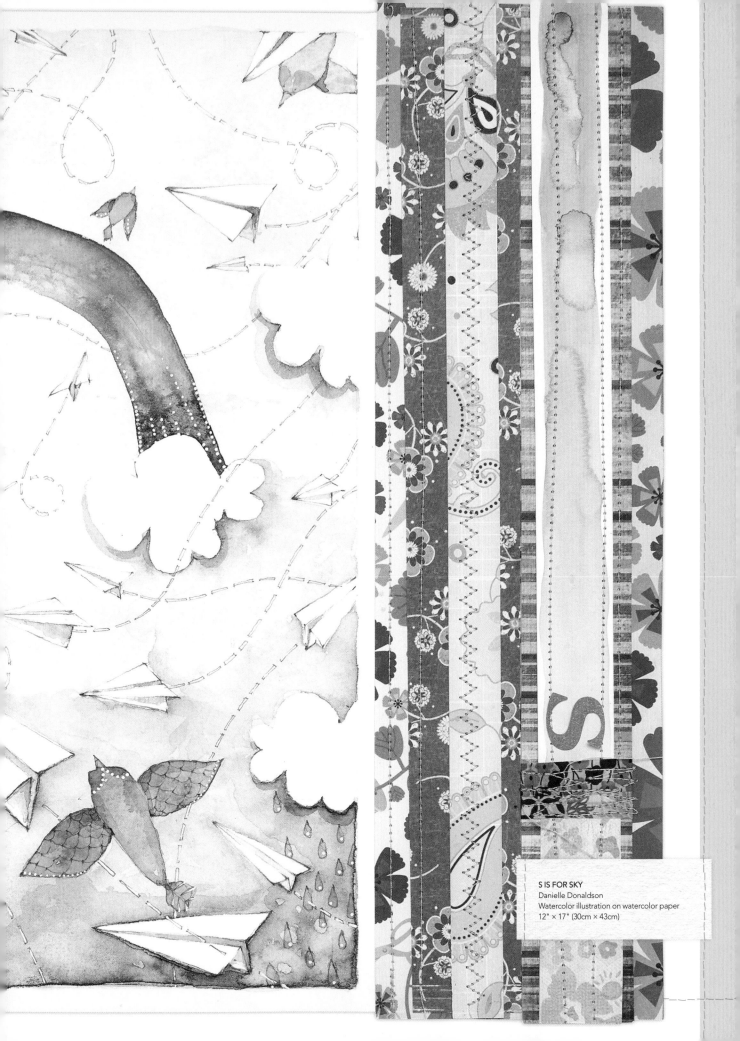

S IS FOR SKY
Danielle Donaldson
Watercolor illustration on watercolor paper
12" × 17" (30cm × 43cm)

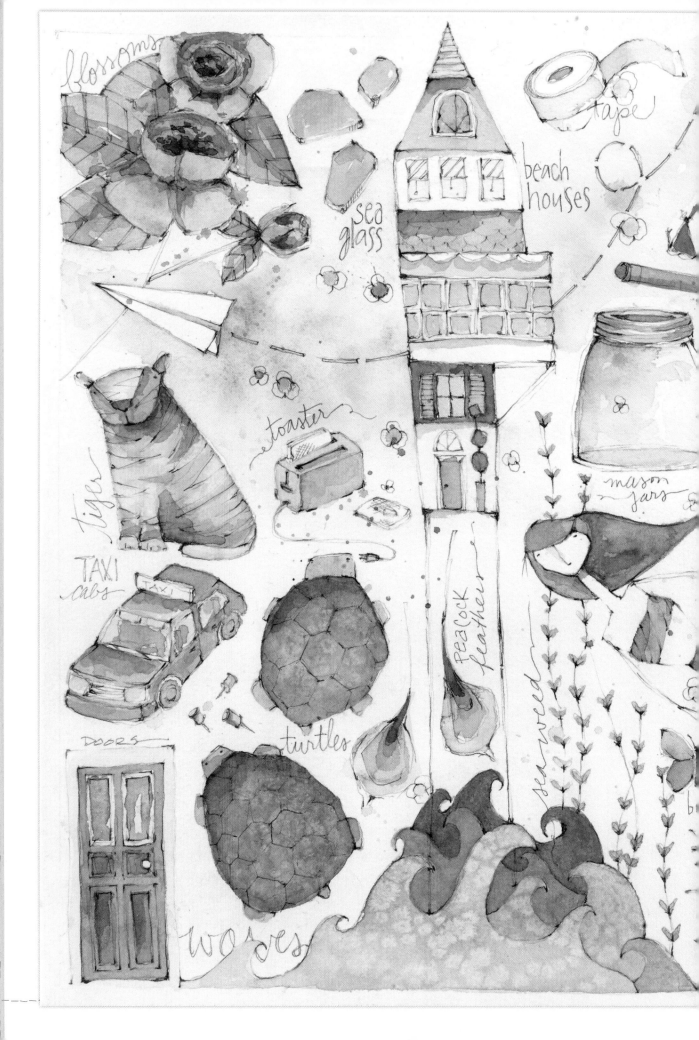

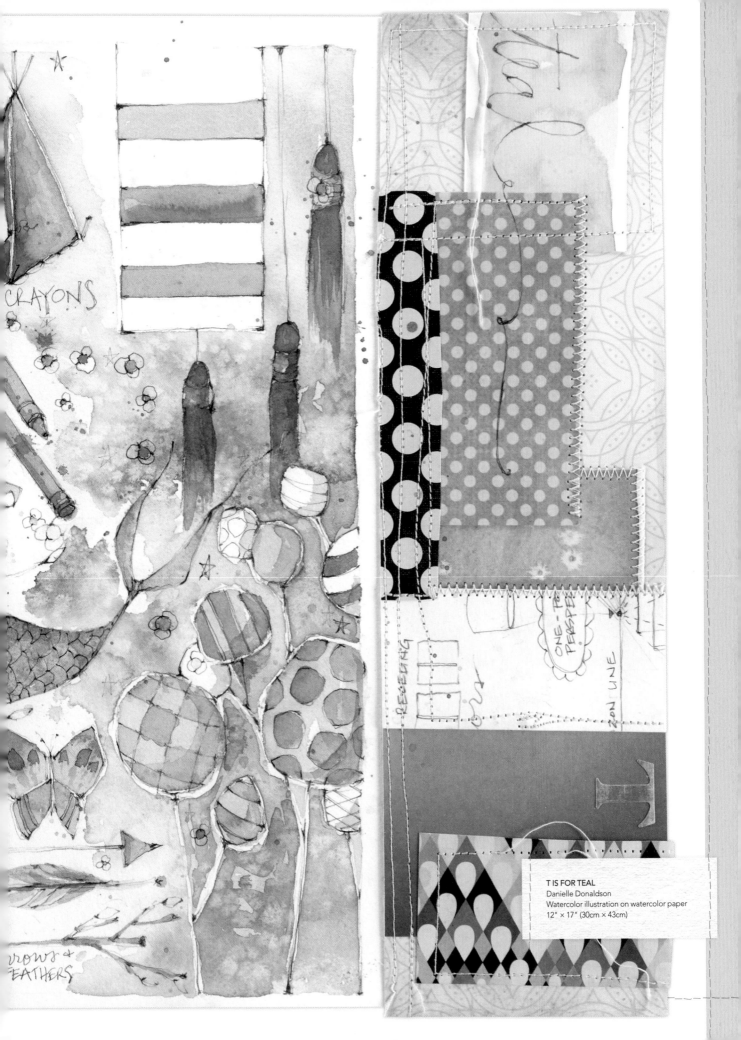

T IS FOR TEAL
Danielle Donaldson
Watercolor illustration on watercolor paper
12" × 17" (30cm × 43cm)

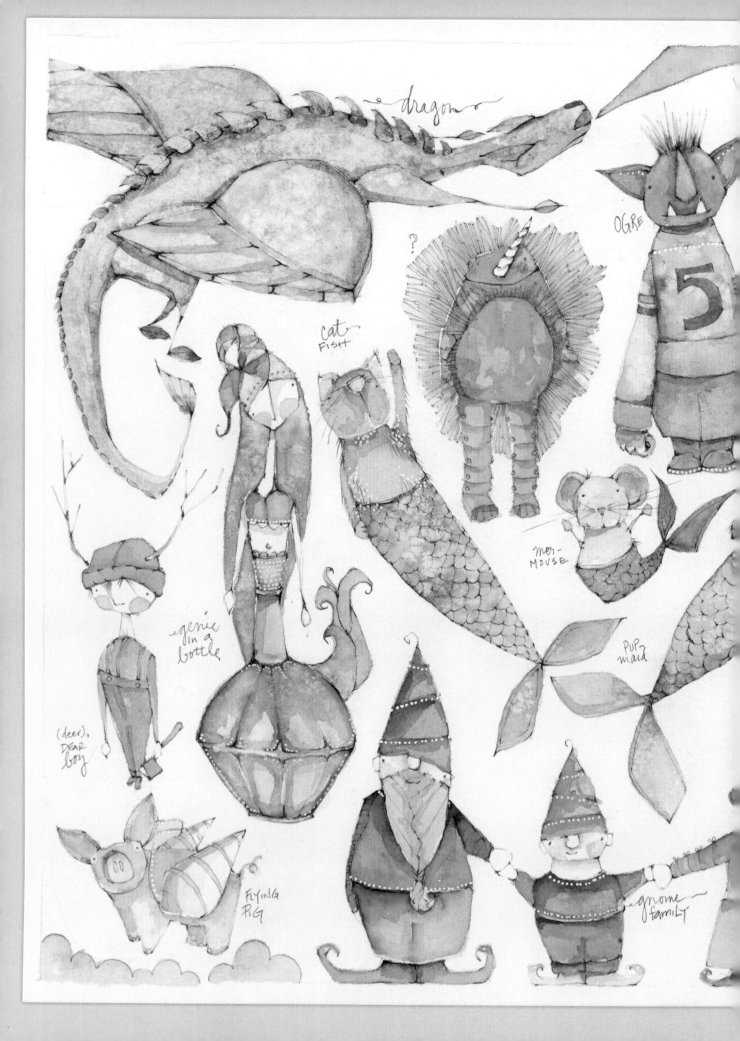

UNICORN
(OF COURSE)

fairy

U IS FOR UNICORN
Danielle Donaldson
Watercolor illustration on watercolor paper
12" × 17" (30cm × 43cm)

U IS FOR UNICORN

Quirky illustrated creatures are sweetly illustrated animals with a ton of inspiration and imagination thrown in the mix. Turn a horse into a unicorn with just a couple of extra lines! Take a magical trip with me as we learn how to infuse a rainbow of colors into a carefully illustrated, very sassy and amazingly loyal unicorn named Umberto.

In this chapter, we'll focus on adding perspective to our illustrations while practicing multicolor washes and glazing to add imagination and depth.

STUDY | *umberto the unicorn*

Did you know "Umberto" means "reknowned warrior?" Get creative with naming your work to give the story behind the illustration more meaning.

I'll admit, the placement of the horn is a little wonky. But I am OK with it because it gives him a little Danielle-ish flair and it would have been hard to distinguish the ear from the horn if it were placed in its proper place.

I kept Umberto's head gray to draw the viewer into his sweet face after soaking in all the colors of his rainbow coat. I also tied the same gray into his hooves and tail. Even color can be used in groups of three to create an exciting balance.

The graphite-colored mat is a great choice because it ties in with the pencil work and it serves as a buffer between the illustration and the bold stripes.

PREPARE | *inspiration and mixing palette*

Prior to premixing your colors in the wells of your palette, choose three pieces of patterned paper larger than 5" × 5" (13cm × 13cm). Between the three papers, all the colors of the rainbow and gray should be included. After you complete your unicorn illustration, you'll use them to create a triple-mat for your finished piece. In my example, I have a rainbow stripe, a taupe print and a rustic gray paper. Be sure to keep them close by as a reference throughout the project.

Using the patterned paper as inspiration, premix a small amount of the colors of the rainbow and gray in the wells of your mixing palette. Each well can contain just one color or a custom mix of colors.

PREPARE | *supplies*

This list includes everything you need for all the projects in this chapter.

Craft Dryer (optional)

Creative Essentials (page 10)

Patterned Paper

Sewing Machine (optional)

Small-Tip Eraser

Watercolor Paper

White Marker

PRACTICE | *break it down*

CREATIVE MUSCLE MEMORY

Having trouble with the dimension of the unicorn? Lay a sheet of tracing paper over my unicorn on page 120. Trace over the lines that make up the large shapes: the head, neck, body and legs. Repeat the tracing motion until it feels more natural to you.

OBJECT BREAKDOWN NO. 1

To begin, try breaking down a unicorn, or any other animal or imaginary creature, just like we did for our Little's project on page 85. When you practice the shapes of animal heads, you'll discover that bulldogs and bears share the same shape. Horses and giraffes have the same necks and legs, just different lengths. And the body of a hippo is like a pig. You get the idea.

OBJECT BREAKDOWN NO. 2

If you have completed the one-point perspective practice in *C Is for Chairs and Couches* on page 56, it's helpful to practice breaking down dimensional objects into boxes, as shown here Once you can visualize how an object is broken down, you'll learn how to draw with more confidence and dimension. If you like, try breaking down some of the illustrations into boxes on my ABC pages.

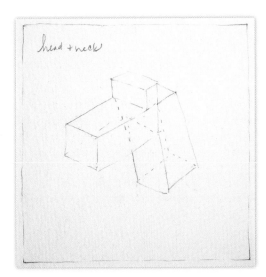

IMAGINE | *umberto the unicorn*

Unicorns truly are magical creatures, especially when you paint them with every color of the rainbow!

1 **Mark Your White Space and Draw the Head**
On a 5" × 5" (13cm × 13cm) piece of watercolor paper, pencil a small mark on all four sides as a reminder to keep your illustration within the marks and preserve the white space around it. Using my example, draw the unicorn's horn first (upper-right quadrant) to give yourself a guideline for placement of the head. Next, draw the oval shape of the head, followed by the ears and nostrils. Add the forelock (the tuft of the mane between the ears) and little dots for its eyes.

2 **Begin Drawing the Body**
Draw a soft, rectangular shape to form the front of the chest. Connect two long rectangular shapes that taper down to form the front legs. Add hooves as shown.

3 **Draw the Rest of the Body**
This step is a tricky one! To get the correct dimension for the remainder of the body and back legs, it's helpful to draw it as a long, rectangular box. Once the box looks right, it's much easier to shape the hindquarters and add the legs. Notice that if you were to draw a line from the unicorn's front right hoof to the back right hoof, it is parallel to the line that forms the horse's belly and back. Mine is a bit wonky, but striving for perfection is not the goal—we just want it to look like a unicorn, right? Add the tail and the mane to complete the drawing.

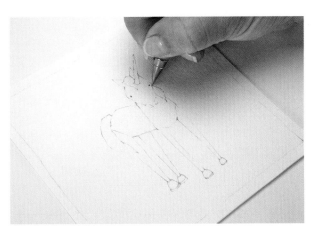

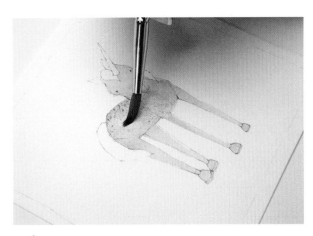

4 **Clean Up the Drawing and Add Visual Tension**
By now, you probably have quite a few pencil marks and lines you don't need. Use a small-tip eraser to clean it up prior to painting your first wash. Once the lines are clean, add visual tension. Typically, I wait to do this after painting my first wash, but it helps to see the overall shapes you need to paint.

5 **Add the First Wash and A Glaze**
Load your brush with paint+water from your mixing palette and paint a controlled wash only on the head, body and legs of the unicorn. Leave the horn, forelock, mane and tail white. In my example, I use Payne's Gray. While the wash is still wet, use a detail brush to remove any trapped white space between your wash and illustration lines. Then sprinkle some salt and let the paint dry.

Once it's dry, brush off the salt and glaze a layer of clear water from the hindquarters to the neck. Do not glaze the head, mane, tail or hooves. Begin adding a rainbow of colors to the body by dropping in blue paint to the hindquarters. This wash is continued in Step 6.

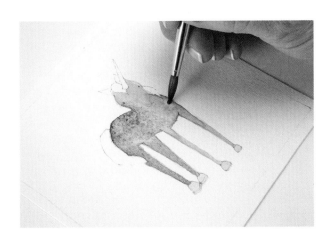

6 **Continue to Glaze More Colors**
Moving from the back of the unicorn to the front, continue to drop additional colors on the previous glaze. Transition from blue to purple, and end with violet right behind the unicorn's neck. Glaze more water on the front if necessary and drop in warm colors: yellow, orange and red.

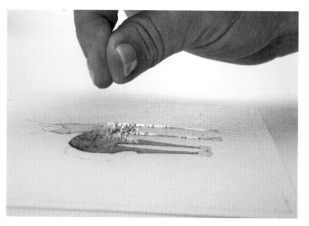

HINT | *the right way to remove salt*

After you apply salt, it's easy to get impatient and brush it off before it's completely dry. I have done it many times! If it is still wet and you try to remove it with a long swiping motion, you will have pulled the wet paint outside of your illustration. And it is almost impossible to fix! If a spot is not completely dry, rubbing in circles within the wash keeps the paint in the area it's supposed to be.

7 **Sprinkle in Salt**
Sprinkle in a small amount of salt to the areas that are still wet. Once dry, gently brush off the salt using a circular motion.

8 **Add More Visual Tension**
Add more visual tension to further define the unicorn. Add knees to all four legs and a thin line at the bottom of each hoof to indicate a horseshoe, if you haven't added them already.

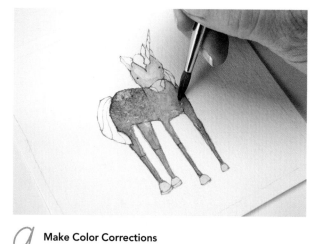

9 **Make Color Corrections**
After reviewing my unicorn, I felt that the front was still too cool in color and not advancing enough. Take a moment to review your illustration. Does the back of your unicorn recede? Is the head popping forward from the neck and chest? Do the chest and front legs advance? If you need to adjust or add color, now is the time. In my example, I added a light wash of reds and oranges to one side of the unicorn's chest and both front legs, blending them into yellow. What could you do to yours?

Add Shadows

Mix the leftover paint on your mixing palette to create a shadow color. Sometimes one color dominates the shadow color. In this example, my shadow color looks quite blue. And I am totally OK with that. Shadows don't have to be gray to work. Add shadows behind the neckline, in the nostrils, in the mane and tail, on the hooves, the edges of the face and the horn.

This unicorn is very colorful and happy, so don't overdo it on the shadows. If you're still not sure where or how much, just replicate mine—you'll catch on in no time.

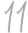**Add Final Details**

Using a fine-tip white paint marker, add dots to the unicorn's hindquarters, nostrils and kneecaps.

Trim, layer and stitch your background papers to your finished illustration. Add your signature and date, and your magical unicorn is complete!

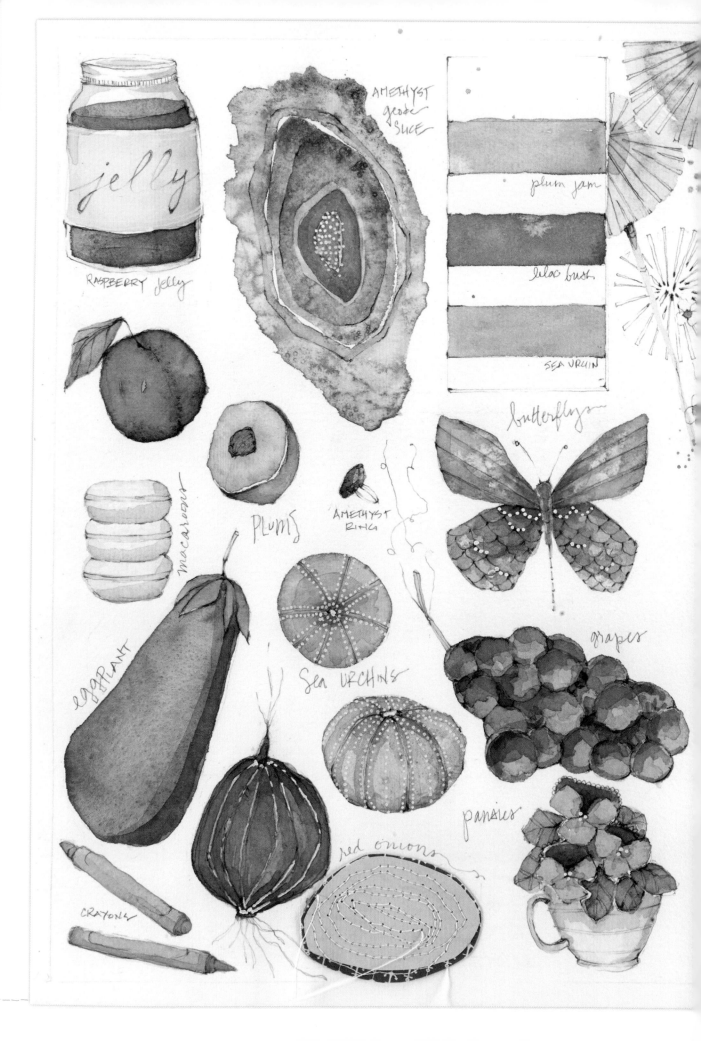

jelly

RASPBERRY Jelly

AMETHYST geode SLICE

plum jam

lilac bush

SEA URCHIN

butterfly

PLUMS

macaroon

AMETHYST RING

eggplant

Sea URCHINS

grapes

pansies

CRAYONS

red onions

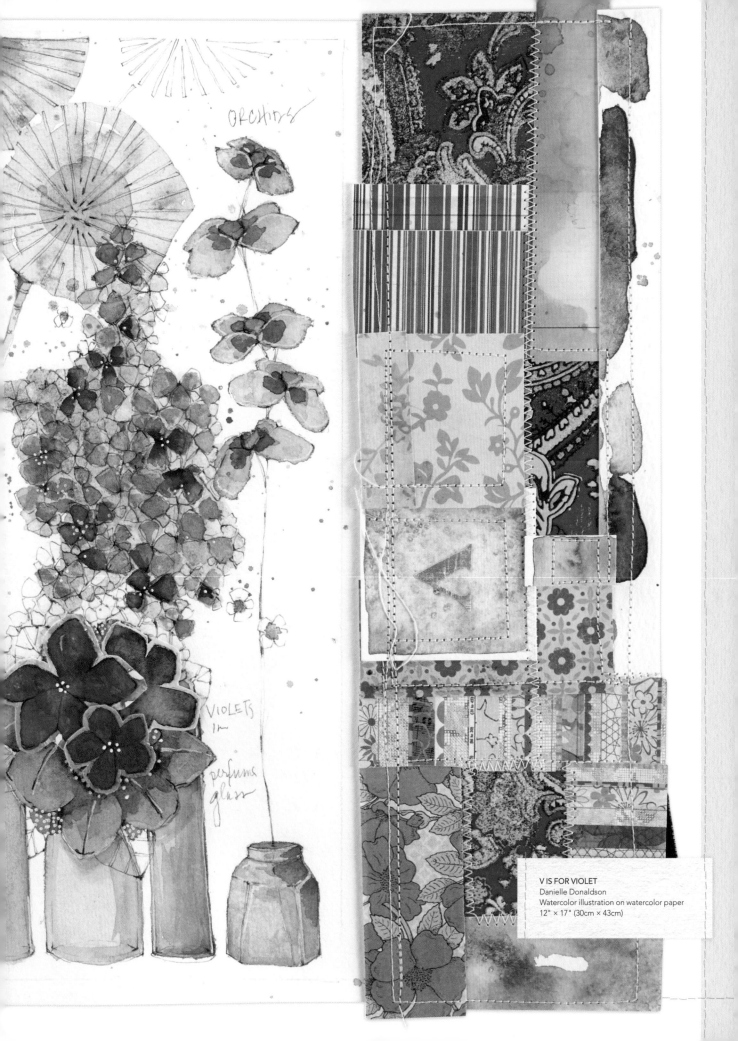

ORCHIDS

VIOLETS in

perfume glass

V IS FOR VIOLET
Danielle Donaldson
Watercolor illustration on watercolor paper
12" × 17" (30cm × 43cm)

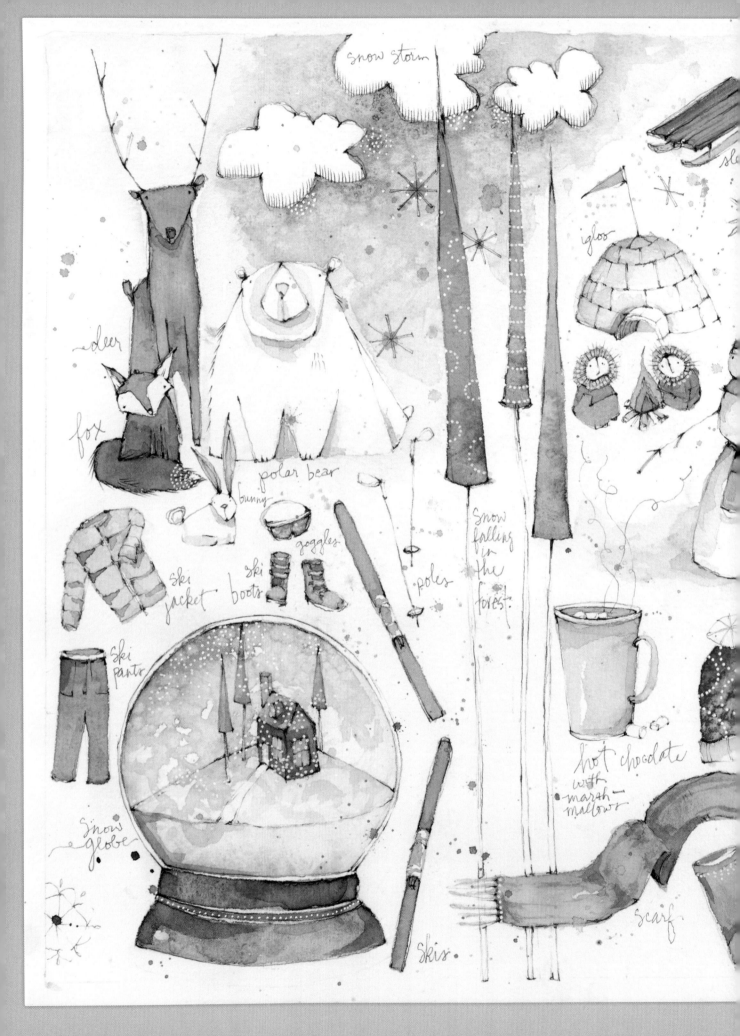

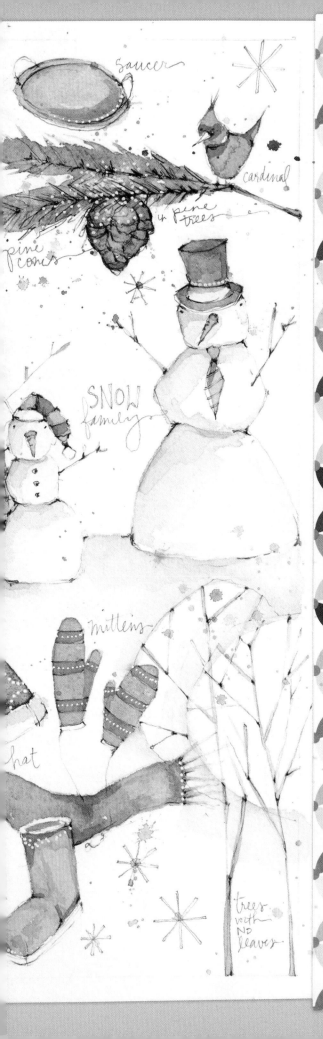

8

w is for winter

W IS FOR WINTER
Danielle Donaldson
Watercolor illustration on watercolor paper
12" × 13" (30cm × 43cm)

W IS FOR WINTER

My little scenes always tell my story, just not with words. They convey my emotions through the composition and colors I choose. They beckon the viewer to imagine what it would be like to live in my tiny-but-mighty illustrated world. Each illustration has visual pathways, and I get to be the leader of the tour. And the best part is that each person who takes the time to look, hears and sees little snippets of their own story. And I get to keep my story a secret. Woot!

In this chapter, we'll practice building a contained scene with thoughtful composition and depth using thumbnail practice and careful color choices.

STUDY | *lucky girl island*

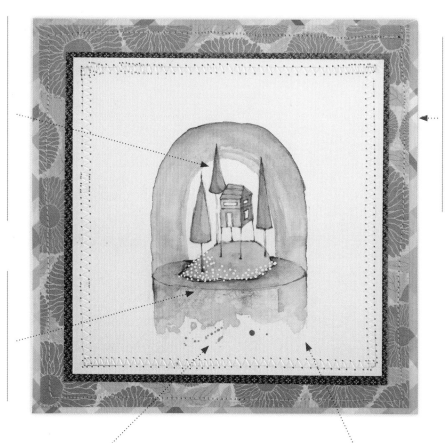

I wish I would have added a little more purple to my house and the water to tie in the color to the rest of the illustration. Luckily there isn't very much so it's not too obvious to the viewer. But, I'll remember to check for each color next time.

Notice the ellipse shape I have drawn around my island. Can you see how drawing the mason jars in boxes (see page 49) applies to this illustration?

Although I used the patterned paper as my inspiration for my palette, I chose the more natural paper for my largest mat to be sure it didn't distract from my sweet little rainbow.

These tiny little splashes of color are my favorite part of the illustration. Paired with the uneven edges of the water at the bottom, it feels like the water has movement.

The white space on the bottom of my illustration is smaller than the other three sides. If I had it to do over again, I would have shifted the illustration up a bit. I thought about disassembling the piece, cropping three sides and matting again. But I didn't let my need for perfection get the best of me. I am glad I did it because I love it just the way it is!

PREPARE | *inspiration and mixing palette*

Prior to premixing your colors in the wells of your palette, choose three pieces of patterned paper larger than 5" × 5" (13cm × 13cm). After you complete your island illustration, you'll use these papers to create a triple-mat for your finished piece. Any color combination will do, but be sure to mix up the odd pattern shapes and sizes, because coordinating paper isn't nearly as fun to pull inspiration from. Be sure to keep them close by as a reference throughout the project.

Using the patterned paper as inspiration, premix a small amount of several colors in the wells of your mixing palette. Each well can contain just one color or a custom mix of colors. I have included the colors of the rainbow, but your rainbow can be made up of any colors you like.

PREPARE | *supplies*

This list includes everything you need for all the projects in this chapter.

Craft Dryer (optional)

Creative Essentials (page 10)

Patterned Paper

Sewing Machine (optional)

Sketch or Bristol Paper

White Marker

PRACTICE | *break it down*

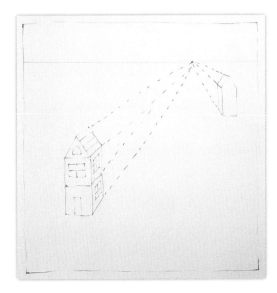

Using a 5" × 5" (13cm × 13cm) piece of bristol paper, draw a series of 2" (5cm) square thumbnail boxes. In the boxes, try out combinations of different elements to finalize the composition of your illustration. For the sky, try rainbows, sunshine, clouds or a moon with stars. For the base, try an island, a field, a lake or ocean. For the elements, try a house or a sailboat. And don't forget about extras like birds, trees, flowers, bushes and fish. Last, consider the surrounding shape your illustration will be contained in. Think squares, rectangles, ovals or circles.

Using a 5" × 5" (13cm × 13cm) piece of bristol paper, draw a horizon line and vanishing point and practice adding dimension to a simple house shape with minimal detail on the actual house. It's important to practice drawing the house on a small scale.

IMAGINE | *lucky girl island*

In our final project, we are going work on building a scene. Building a scene is just a way of my saying, "Hey, let's illustrate a story!"

A scene doesn't necessarily mean you need to cover an entire blank page, at least not in my world. In my world, it's about taking a bunch of different objects and piecing them together in a pretty way on some pretty darn small scraps of paper—with a ton of white space, of course.

1 Draw the Illustration
Based on your thumbnail practice, choose a scene you want to use. On a 5" × 5" (13cm × 13cm) piece of watercolor paper, pencil a small mark on all four sides as a reminder to keep your illustration within the marks and preserve white space around it. Lightly draw your illustration.

2 Paint an Island and Trees
Load a small round brush with a small amount of paint+water from your mixing palette. Carefully but quickly, paint each tree. Drop tiny amounts of additional color to one side of the trees to create depth. If they dry too quickly for you to drop in color, glaze layers over it to get the same effect. I did not paint the trunks of the trees because the shape is too small to preserve transparency with a wash.

Using a warm color from your mixing palette, load the same brush with a small amount of paint+water. Carefully but quickly, paint a wash on the island. Drop another warm color to one side and the front of the island to define the shape and add depth.

3 Paint the House
Load a small angle brush with a small amount of paint+water from your mixing palette. Carefully but quickly, paint a light wash over the roof, front and side of the house. Let it dry.

Once dry, reload your brush with the same color and glaze the roof and side of the house, leaving the front as it is. Let it dry. Once dry, add one more glaze of the same color to the side of the house.

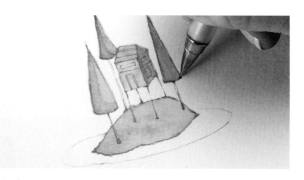

4 Add Visual Tension and Details
Check your work for trapped white space within the shapes you have painted. If you find some, either reactivate the wash and fill the trapped white space or erase your original illustration line. Lightly pencil in windows, rooflines and a door on the house. Add visual tension to the house, island and trees.

5 Paint the Water

Load a round brush with a moderate amount of paint+water from your mixing palette. Paint a controlled wash into the shape of the water around the island. Reload the brush with a similar, but different color, and mix it into the bottom edge of the water to create a transitional wash. Reload your brush with water and soften the bottom edge once more.

Using a small round or detail brush, drop tiny specks of the previous elements' colors into the water to tie the composition together. While it's still wet, sprinkle a small amount of salt in the wash and let dry.

6 Reactivate the Edge of the Water

To blend the rainbow into the water, load your brush with a little water and reactivate the top edge on both sides of the water. Keep checking this area to make sure it stays wet while you paint the rainbow.

HINT | rainbow painting

Typically, it's best to start with a light color and to build up to brighter colors by using a series of glazed layers or by dropping in additional color while the wash is still wet. But in this case, it's better to start with more intense colors. When preparing your palette for the rainbow, use the same amount of paint but less water. This step is a multitransitional wash in a very small area, so you'll need to work quickly. It will be helpful if you read through Step 7 and practice painting your rainbow at the same scale your final illustration will be.

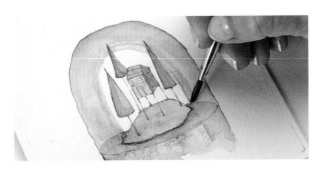

7 Paint the Rainbow

Starting with the outside color, load a round brush with a moderate amount of red paint+water from your mixing palette. Paint the outside stripe. While the first stripe of color is still wet, clean and load your brush with orange paint+water. Paint your second stripe of color just overlapping the edge of the previous layer. The stripes should blend together slightly. If you find that the stripes are drying prior to adding the next, load your brush with clear water and rewet the edge of the previous stripe to reactivate it. With each stripe you paint, blend the rainbow's edges into the water. Repeat this process with stripes of yellow, green, blue and purple.

Once the rainbow is dry, clean and reload your brush with the color you used to paint the water in Step 5. Glaze a second layer of color on the water where it meets the edge of the island. Do not glaze over the entire body of water, just a small sliver around the island.

8 Add the Final Details and Assemble

Check your work again for trapped white space within the shapes you have painted. If necessary, either reactivate the wash and fill the trapped white space or erase your original illustration line. Next, add visual tension to the ellipse in the water and the bottom edge of the island. Last, color in the windows and door and add dots to the island with your fine-tip white paint marker.

Trim, layer and stitch your background papers to your finished illustration.

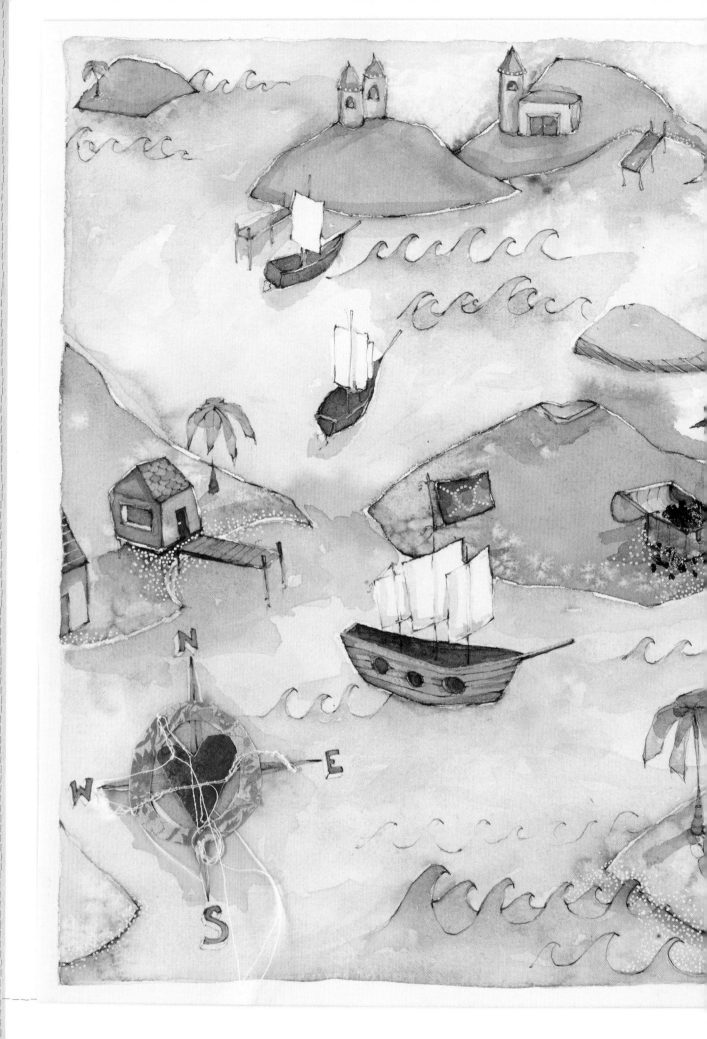

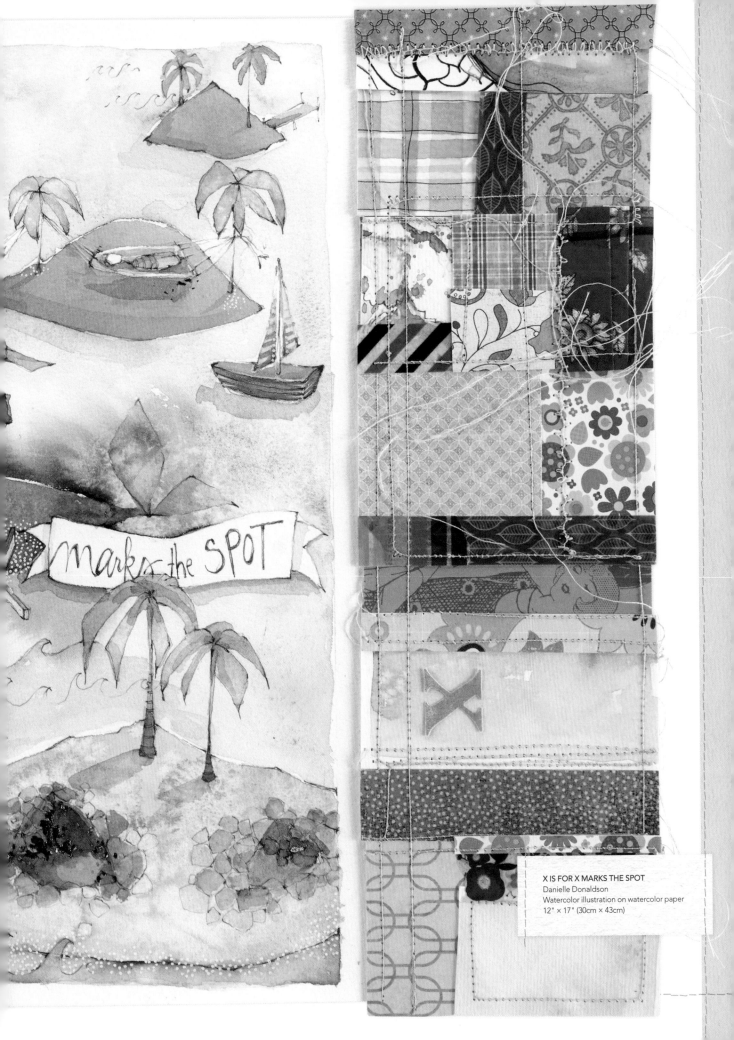

marks the SPOT

X IS FOR X MARKS THE SPOT
Danielle Donaldson
Watercolor illustration on watercolor paper
12" × 17" (30cm × 43cm)

Raincoat

lots o' BEES

happy FACE

measuring TAPE

FERRIS Wheel

bee HIVE

mustard

lemon drop

banana

lemonade

wheat

butter

CORN

PEA

GOLDEN POISON frog

lemon meringue PIE

Yellow LAB

viper snake

NO. 2 PENCILS

lemons

aspen trees

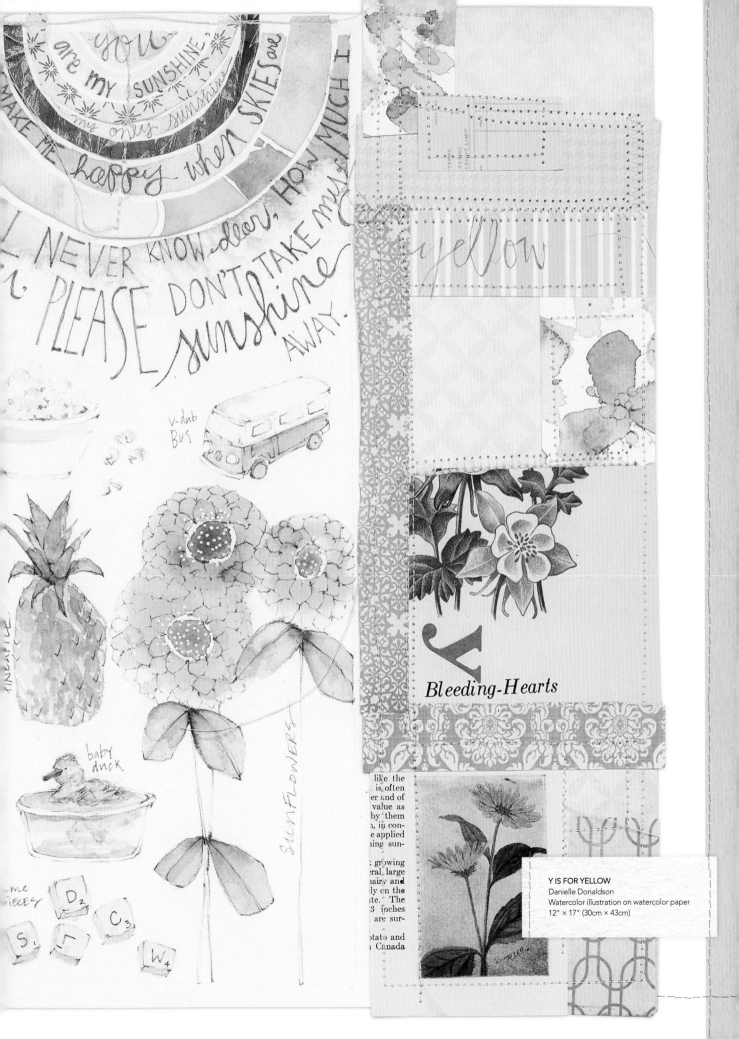

you are my sunshine, my only sunshine.
MAKE ME happy when SKIES are

I NEVER KNOW dear, HOW MUCH I
PLEASE DON'T TAKE MY sunshine AWAY.

v-dub Bus

PINEAPPLE

baby duck.

SUNFLOWERS

D₂

C₃

S₁

W₄

yellow

𝒴
Bleeding-Hearts

like the
is often
er and of
value as
by them
, in con-
e applied
ning sun-

growing
ral, large
airy and
ly on the
te." The
inches
are sur-

tato and
Canada

Y IS FOR YELLOW
Danielle Donaldson
Watercolor illustration on watercolor paper
12" × 17" (30cm × 43cm)

coffee and DONUTS

PENCIL and ERASER

NEEDLE and thread

yin and yang

cut and paste

left and right

bow & arrow

toothpaste

paste

birds and BEES

toothbrush & toothpaste

salt & pepper

lock and key

sticks & stones

Cats and DOGS

Cookies AND MILK

PEN + PAPER

shoes & socks

lawn mower and grass

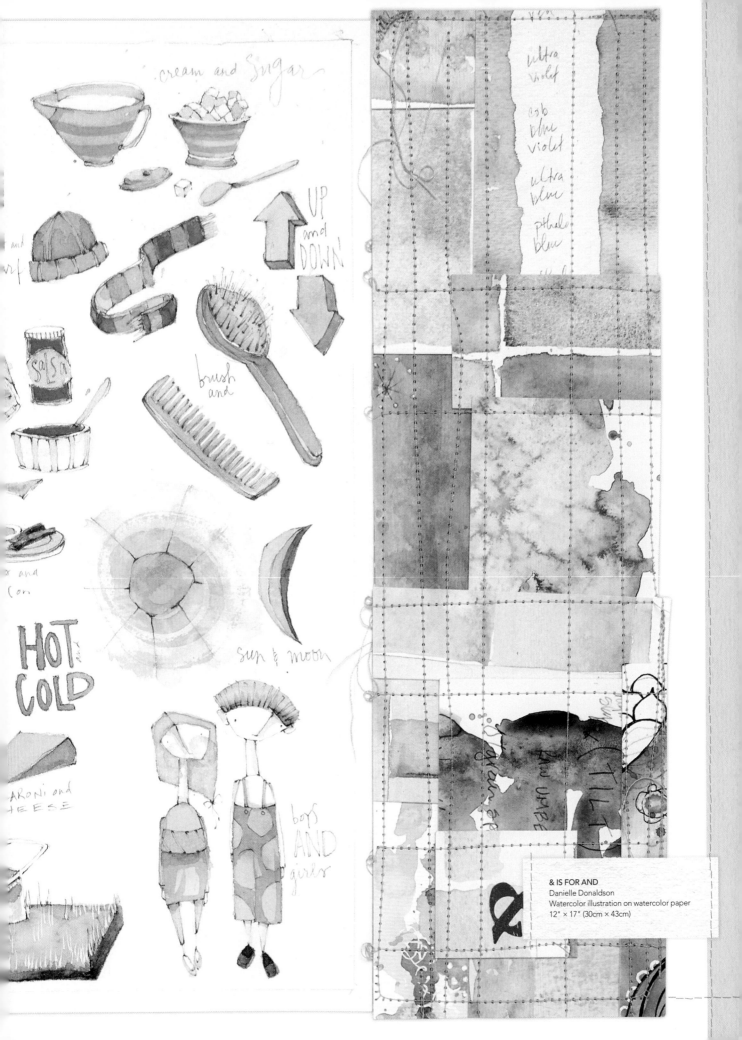

cream and sugar

UP
and
DOWN

brush
and

salsa

HOT
COLD

sun & moon

ARONI and
HEESE

boys
AND
girls

ultra
violet

cob
blue
violet

ultra
blue

pthalo
blue

& IS FOR AND
Danielle Donaldson
Watercolor illustration on watercolor paper
12" × 17" (30cm × 43cm)

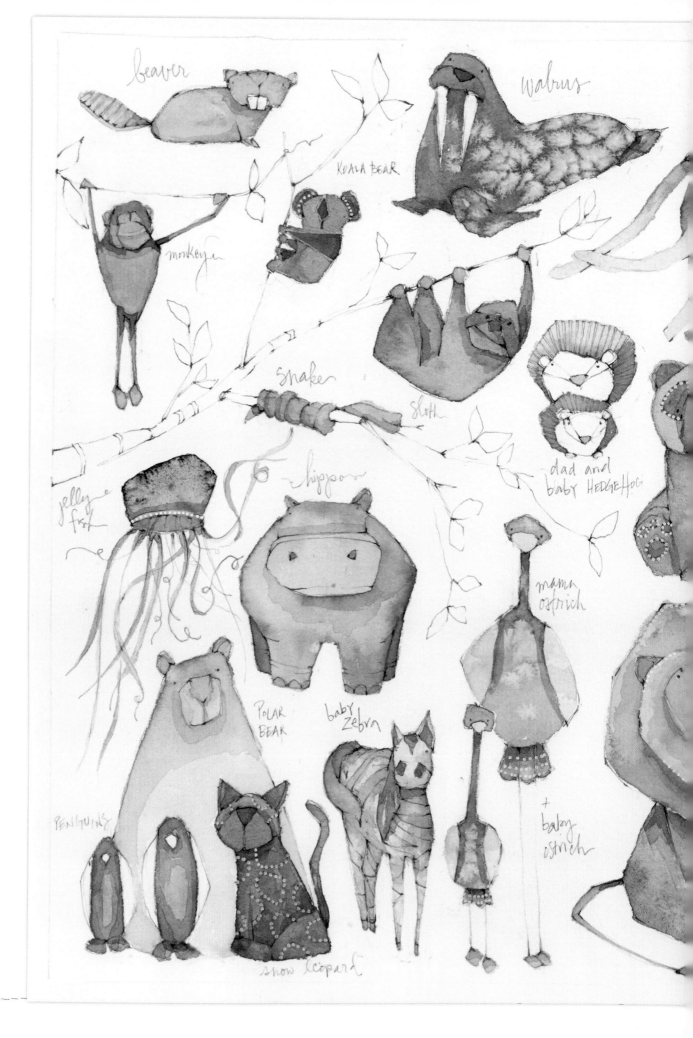

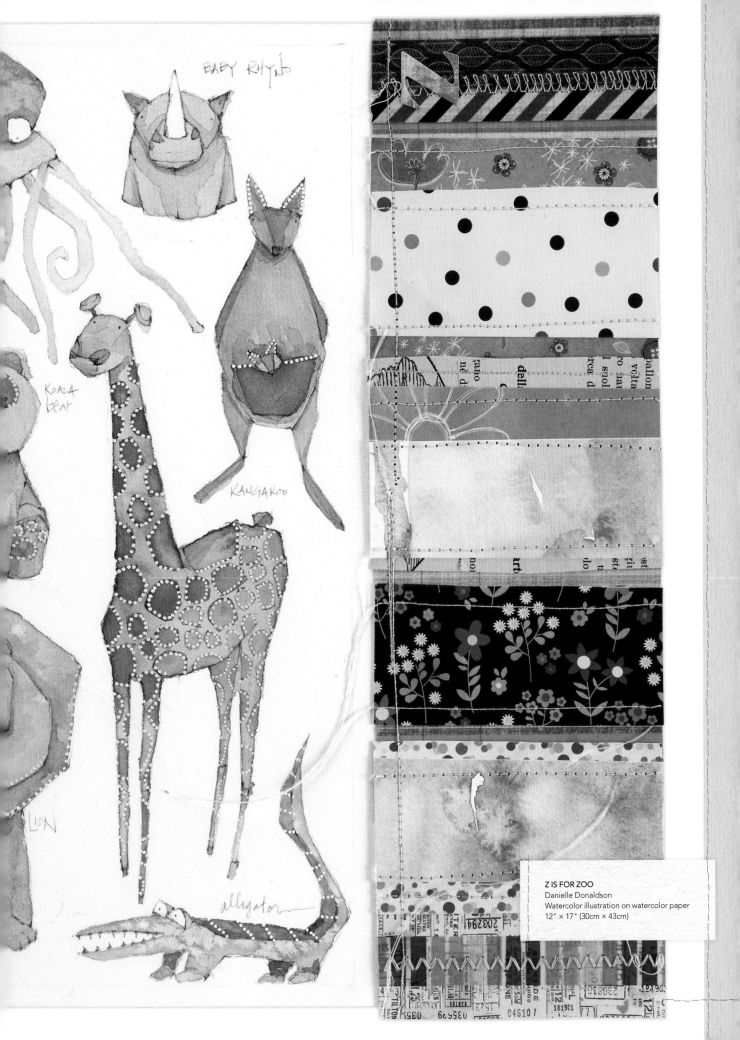

BABY RHYNO

KOALA
bear

KANGAROO

LION

alligator

Z IS FOR ZOO
Danielle Donaldson
Watercolor illustration on watercolor paper
12" × 17" (30cm × 43cm)

INDEX

Acknowledgments

A *big* thank you and lots of love to my family, friends, the multitude of creative souls in my little social media world and the staff at North Light. Each one of you is in this book—our stories hidden in the love that I poured into it.

NORTH LIGHT BOOKS

An imprint of Penguin Random House LLC
penguinrandomhouse.com

ISBN 978-1-4403-5094-8

Printed in China
10 9 8 7 6

Edited by Amy Jones
Production Edited by Jennifer Zellner
Designed by Tara Long

ABOUT *the* AUTHOR

Artist Danielle Donaldson has walked a creative path for as long as she can remember. Her love of art began, as with most young souls, with a big box of crayons and a stack of coloring books. Over time, she focused her artistic efforts on watercolor and graphite drawing techniques, and eventually received her degree in graphic design. Her love of fine art paired with her skills as a graphic designer have provided her with an uncommon partnership of intuition and practicality. Her use of big color palettes and delicately drawn details allows her to spin the ordinary into imaginative, well-balanced compositions. She continues to grow as an artist by fully embracing the creative process in all she does and with each story she tells. She thoroughly enjoys sharing her process and imagination through online classes, in-person workshops, social media and in her first book, *creativeGIRL: Mixed Media Techniques for an Artful Life*. Visit Danielle's website, DanielleDonaldson.com.

METRIC CONVERSION CHART

TO CONVERT	TO	MULTIPLY BY
Inches	Centimeters	2.54
Centimeters	Inches	0.4
Feet	Centimeters	30.5
Centimeters	Feet	0.03
Yards	Meters	0.9
Meters	Yards	1.1